D1598671

Illinois Studies in Communication

Illinois Studies in Communication

Gender on the Line

Gender on the Line

Women, the Telephone, and Community Life

Lana F. Rakow

University of Illinois Press
Urbana and Chicago

© 1992 by the Board of Trustees of the University of Illinois
Manufactured in the United States of America
C 5 4 3 2 1

This book is printed on acid-free paper.

Library of Congress Cataloging-in-Publication Data
Rakow, Lana, 1952-
 Gender on the line / Lana F. Rakow.
 p. cm. — (Illinois studies in communications)
 Includes bibliographical references (p.) and index.
 ISBN 0-252-01807-9 (acid-free paper)
 1. Rural women—Middle West—Case studies. 2. Telephone—Social
aspects—Middle West—Case studies. 3. Women—Communication—Case
studies. I. Title. II. Series.
HQ1438.A14R35 1992
305.42'0977—dc20 91-6318
 CIP

To my mother, Vera Rakow

Contents

Preface

In 1985 I conducted an ethnographic field study of women's use of the telephone in a small midwestern community. That experience changed both my life and the way I think about research. Of course, scholars in some disciplines have used ethnographic research methods for a long time, and feminist researchers in many fields of study have found these methods attractive. I am encouraged by the widening interest in ethnographic research in my own field of communication studies. Yet from my own experience I know that, though many of us may be interested in these methods, the issues, rationale, problems, and practical know-how of conducting this kind of research are not easy to grasp from a how-to manual. Each study requires decisions and involves dilemmas only that researcher can make and face.

As recounted in the following pages, my research experience in the town that I named Prospect may seem a relatively uncomplicated and straightforward process. Actually, this recounting does not capture the uncertainties, perplexities, guilt, and even terror that accompanied my journey through the project, nor does it capture the pleasure and satisfaction that I found in being a part of the community and becoming friends with these women. What should I do about my feminism—reveal it to them and put my standing in the community at risk? Who was I doing this project for—them or me? How was this project going to change anything for women? What effect was I having in the community, and did I have a right to have that effect on it? How could I protect the privacy of individual residents if I made my text available to the community? How could I avoid exploiting my participants?

How could I face them with what I had to say about them and their community?

As the project proceeded, some of these dilemmas sorted themselves out; with others I still struggle. I did not identify myself as a feminist, but my sympathies with women came out clearly. The project appears to have had little effect as yet on the community and on any individuals, but I hope that it may have the positive value of generating some discussion among women (in Prospect and in academic and public policy circles) about the issues I have raised. After writing my initial text, I returned to the community, meeting with some of the interviewees over coffee and explaining my conclusions. At their request I donated two copies of the text to the community. One resides in the local historical society; the other circulates to residents—in lieu of a library, from the counter of the variety store. I have had to face the fact that, despite my perception of my own writing as understandable, the language of the academy is not accessible to my participants. Perhaps this version will be more so. My obligations to the people who gave so much to me are not over.

Whenever I have mentioned to other women that I have been studying women's relationship to the telephone, I have met an excited response. Expressions of love and hate; stories about mothers, grandmothers, sisters, and friends; confessions of obsession and avoidance—all are personal emotions and experiences related to the telephone that women want to share with me. Whether we love it or hate it, few of us are untouched by it. The strong response of so many women to my topic was important in helping me believe that it merited this book.

Besides the people of Prospect, many others deserve my thanks for making this work possible. The Institute of Communications Research at the University of Illinois–Urbana-Champaign, where research for this project began, provided me with intellectual stimulation and the encouragement to pursue my own interests. James W. Carey, Paula Treichler, and Cheris Kramarae are among the faculty at the University of Illinois who gave me support and intellectual inspiration to carry out the project. The manuscript is better for the thoughtful suggestions of earlier readers and for the thorough and expert guidance of Judith McCulloh at the University of Illinois Press.

As I worked on this project, I began to give thought to my own

telephone talk. Women telling me about their telephone relationships with their mothers made me realize that my weekly calls to my own mother are my tether to a stable point in space and time. It is fitting that this book should be dedicated to her, Vera Rakow.

Gender on the Line

In this text I invite readers to accompany me to a small midwestern community to learn as I did about women's relationship to the telephone. I lived for a short but intense period of time in the community that I have called Prospect, participating as a member of the community, making friends, and coming to understand the lives of its residents.

The title of this book, *Gender on the Line,* suggests that the story I tell about women and the telephone in Prospect is a multidimensional one. The telephone is not simply a household convenience that women in particular enjoy, as popular perception and academic speculation have it. Instead, as I explain in chapter 2, the telephone provides a network for gender work (social practices that create and sustain individuals as women or men) and gendered work (productive activity assigned to women). The telephone is, therefore, not a neutral, but rather a gendered, technology. In addition, the title highlights how, even in a rural and conservative town like Prospect, gender is at stake—is a point of contention, not pregiven or foreclosed or the same across the span of space and time. As I suggest in chapter 3, shifts in economic and political circumstances can call into question or change previous meanings of gender. These shifts are observable around the telephone. Gender is on the line, then, in more than one sense.

It is at once remarkable and unremarkable that women's relationship to the telephone should have gone so long without serious scholarly attention. It is remarkable because communication scholars and sociologists have long been interested in communication technologies and because the telephone is a communication technology assumed to

1

have great importance to women. It is unremarkable because women's communication experiences have received little attention until the past one or two decades, when feminist scholars have come to value them. That the telephone has been seen as a trivial and beneficent technology says more about scholars' perception of women than about the telephone or women's experiences with it.

But popular and academic perception cannot be dismissed simply as wrong or myopic. Popular and scholarly mythology plays an active part in sustaining and naturalizing our system of gender differences. Women, it is generally claimed, talk a great deal, if not too much, on the telephone. The figure of a woman monopolizing a telephone line or listening in on the conversations of other women on a party line is a stock image in American humor and satire. Academic literature has referred to women's telephone talk as gossip, chitchat, and chatter. Authors have claimed, without much apparent sympathy or thought, that lonely and housebound homemakers and farm women found the telephone a solution to their isolation.[1] These characterizations of women and our talk make women's use of the telephone appear to be a consequence of innate differences of responsibility, interests, and personality between women and men rather than an enactment of socially constructed differences resulting from women's assigned place.

Even before undertaking my stay in Prospect, I had come to see a variety of ways in which women's relationship to the telephone is richer and more complex than common knowledge would have us believe. The telephone is, after all, a technology like other technologies, and as such is not simply a mechanical device but a system of social relationships and practices. Technological systems in this society result from the intents and purposes of powerful social actors (private industry and government). As a technology becomes part of the material and social structure, people make accommodations in the way they get things done and the way they interact with others. As Cheris Kramarae points out, "Technological systems allow or encourage some kinds of interactions and prevent or discourage other kinds," with profound consequences for women.[2] Technologies themselves, however, do not have inherent uses or consequences. They become part of the ideological fabric that encompasses existing beliefs and practices about gender.[3] The telephone is a case in point.

When the telephone was introduced at the end of the nineteenth century, it contained a number of possibilities.[4] The most heralded by

popular and academic writers was the telephone's role in transcending space and time and in equalizing social hierarchies. Marshall Mc-Luhan, for example, claimed that the telephone bypasses all hierarchical arrangements in management and decision-making: "In an electric structure there are, so far as the time and space of this planet are concerned, no margins. There can, therefore, be dialogue only among centers and among equals."[5] Donald Ball has made the telephone out to be an egalitarian technology: "Said another way, *unequals may call, but their calls are equal* (at least until answered). Furthermore, the signs and symbols of status are difficult to communicate over the phone (except by self-profession), save possibly for class-linked speech patterns—but even here, it must be remembered that the fidelity of telephonic voice reproduction is quite low, mitigating against such identifications by the listener. Thus, the telephone can become a strategic device in the hands of the lowly, allowing for stealthy, unseen telephonic approach toward those ordinarily unapproachable, subverting hierarchical elements in social order and organization."[6]

Stephen Kern summarizes the kind of claims that other commentators have made by seeing the telephone as a metaphor for the changes in the nineteenth century that resulted in new modes of association and perception:

> If . . . I were to suggest a drawstring for this multiplicity of developments, it would be (and here technology supplies the metaphor) the miles of telephone wire that criss-crossed the Western world. They carried signals for World Standard Time and the first public "broadcasts," revolutionized newspaper reporting, business transactions, crime detection, farming, and courting; made it possible for callers to control the immediate future of anyone they wished and intrude upon the peace and privacy of homes; accelerated the pace of life and multiplied contact points for varieties of lived space; leveled hierarchical social structures; facilitated the expansion of suburbs and the upward thrust of skyscrapers; complicated the conduct of diplomacy; forced generals to leave their lofty promontories and retire behind the front lines to follow battles from telephone headquarters; brought the voices of millions of people across regional and national boundaries; and worked to create the vast extended present of simultaneity.[7]

Kern, like most other commentators, attributed a great deal to the telephone's ability to transcend inequalities: "Telephones break down barriers of distance—horizontally across the face of the land and ver-

tically across social strata. They make all places equidistant from the seat of power and hence of equal value."[8] Because the telephone *can* transcend space and time and bypass social hierarchies, these writers have made the mistake of assuming that technical possibility translated into social practice. To test this assumption, we must ask who has been able to use the telephone for these purposes, and what the consequences have been for those who have not been able to do so.

Manipulation of space and time is a resource not equally available to everyone. Even in a country as saturated with telephones as the United States, not everyone has the same access to them. We know that the poor, the white urban working class, blacks, and farmers (except in a few midwestern states where small rural telephone companies burgeoned after the turn of the century) were among the last to get telephones; and even today people most likely to be in need of telephone service—older and poorer people—are disproportionately unlikely to have it.[9]

Similarly, the telephone has been implicated in the preservation of hierarchies because it cannot exist apart from the social practices that give it shape and function—social practices that were quickly developed to maintain the social hierarchies it threatened to disrupt. Those in the upper classes were alarmed at the breach of custom and manners that the telephone afforded. The telephone industry (AT&T as well as independent telephone companies) and etiquette books admonished users on the "proper" use of the telephone, warning those with poor manners, poor pronunciation, and unpleasant pitch that they were judged by their voices. Consternation was expressed over men's foul language on the telephone, which telephone operators (mostly women) were able to overhear, and over a growing practice of young women calling young men on the telephone, leading to strict reprimands in the advice columns. These strictures were obviously linked to a concern that gender distinctions were not being maintained. Women in particular were praised for cultivating pleasant telephone voices, which they were advised could lead to romance, and they were chastised for talking too much on the telephone.[10] The practices of using servants, secretaries, unlisted numbers, and answering machines developed to screen and limit social access. Middle- and upper-class men were sold business and residential telephone service with the suggestion that servants, wives, and secretaries could perform more work for them in a more efficient manner.[11] In other words, because the

telephone could transcend the social order of class and gender, steps were taken to ensure that it did not.

Carolyn Marvin has described in more detail how technologies such as the telephone were used to enhance rather than change the existing social order, stripping the technologies of the power to endanger the status quo by anchoring them in safely established notions while presenting them to the public as revolutionary.[12] For example, by taunting women's technical ignorance of the telephone and their disregard for it as a scarce and expensive commodity, men used ridicule to justify the control they exerted over women's talk on the telephone.[13] Women did manage, however, to put the telephone to their own uses, as Michèle Martin and Claude Fischer have pointed out.[14] Despite initial telephone company admonitions against nonbusiness uses of the telephone, women came to use it for talking to other women, keeping in touch with their families, and coordinating their domestic responsibilities—uses that eventually affected the subsequent development and marketing of telephone services.

If we are genuinely interested in learning how gender differences are carried out in and through communication technologies, clearly we must investigate the uses of the telephone. Also, even more than other technologies, the telephone must be examined in relationship to the network of people it holds together.

I entered my research project with these thoughts about the telephone in mind. As a consequence, I looked for an arena in which women use the telephone in a traceable pattern of activity, in which meanings about gender and the telephone circulate and are generally known, and in which social relationships could be illuminated and displayed. A geographic community is a field of interaction in which just such phenomena occur. Although I could have chosen other kinds of settings, the community seems to have particular relevance for studying women's private-sphere use of the telephone. It certainly includes substantial numbers of women engaged in domestic and family responsibilities.[15] I looked for a small community in which most people know each other, have the potential for interactions on the streets, in stores, in churches, and over the telephone, and generally understand the practices and meanings of the telephone and gender of the rest of the community. That consideration set the stage for my choosing Prospect as the site for this study.

Prospect, a rural town of under one thousand residents in a mid-

western state, met my initial criterion of a small town. Otherwise, its choice was in the main serendipitous. Searching for a research site, I discovered that for over forty years Prospect's telephone company had been owned and operated by a woman, who had recently sold the company and retired at age eighty-four—a fact that piqued my curiosity. An on-site visit to Prospect confirmed both Prospect's advantages and my own interest in studying a rural community.[16] Ultimately, in addition to making ongoing one-day visits, I spent six weeks in the community in the fall of 1985. During my stay there I lived as a member of the community, shopping in the small grocery store, buying fresh meat at the meat market, having coffee in the cafe, picking up my mail in the morning at the post office with the rest of the community, getting my car fixed at the local garage, "visiting" on the sidewalk and in the stores with people I had come to know. I attended the local senior citizens' noon lunches on a weekly basis to meet people, chauffeured older people around the community, and joined the local historical society. I was invited to dinner and to attend church, which I did.

While living in Prospect I had three major tasks to accomplish: to learn relevant information, both current and historical, about the community and its members; to learn about the telephone company and its possible connection to the experience and practice of gender and the telephone in the community; and to gather information from women through interviews.[17] The first task I approached through my role as a participant observer in the community; through interviews with key community members (church pastors, the village president, the village clerk, officers of the local historical society, the banker, shopkeepers, and so forth); and through use of the resources of the local, regional, and state historical societies. The second task—of learning about the telephone company—I approached primarily through interviews with members of the family who had owned the telephone company, including four hours of interview with the woman who owned and managed the company for over forty years; through interviews with community members who could provide historical information about the company; and through records kept by the company and the historical society.

The third task—of learning about how women experience gender through the telephone—I approached by interviewing women in their homes or local businesses. Finding interview participants was not difficult. People I met gave me more than enough names to contact, and

almost everyone I contacted agreed to an interview. In the interviews I encouraged each woman to talk about several major topic areas: her own biography, her memories of using the telephone, her present use of the telephone, her relationship to the community, and her understanding of gender. The interviews varied in length from one to four hours each. When my interviews began to repeat already established patterns without producing new information, I stopped interviewing.[18] At that point I had interviewed forty-three women. They ranged in age from fourteen to ninety-one years and represent full-time homemakers and those employed outside their homes; women who are married, widowed, single, and divorced; some who have lived in Prospect all their lives and others who are new to the community; some in ill health and some in good health; some low in status and others high; and some poor and some wealthy. All but one of the participants are white, reflecting the racial composition of the community (only one black family and no other people of color live in the community).

While I was a functioning member of the community during my stay in Prospect, I never lost my identity as a researcher. Most members of the community quickly became aware of my presence and my purpose (in fact, I came to be known in the community as "the telephone lady"). They were curious about why I had chosen Prospect and seemed proud that I had (small communities like Prospect get very little attention from the rest of the world). They volunteered names of people for me to interview and inquired about my work and if I were learning anything interesting. My success in winning acceptance into the community and acceptance for the project seemed to reside with the sanction I and my project were given by respected members of the community: the family who had owned the telephone company, the manager of the bank, and the manager of the business from which I rented an apartment, who became an invaluable source of information.

The identity that I was assigned by community members and that I comfortably assumed was constructed from several important identifiers—I was a woman, white, married, a student, from a rural background. These characteristics allowed the community to place me in a category that made sense to them and to accept me into the community. I became part of the "woman's sphere," which entitled me to participate in certain circles of talk and to occupy certain physical and social spaces. It permitted me to talk to women in their homes on a

wide range of topics. (One interview, in fact, was accompanied by a
lesson in baking apple pie, after my hostess discovered that this skill
was missing from my domestic repertory.) It prevented me, however,
from traveling in other circles and spaces that are the province of men,
such as the men's coffee table at the cafe, the bars, and fire department
meetings.

My feminism was the one aspect of my subjectivity that did not
find a home in the identity I had in Prospect. Although I felt accepted
into the community as a woman, I felt cautious about discussing my
opinions as a feminist, perhaps more than I needed to be. As a woman
I developed comfortable relationships with many other women in the
community. As a feminist I worried about my responsibility to these
women and about my ability to resolve the conflict (of which they were
for the most part unaware) between our interpretations of the world.[19]
As a woman I was the participant; as a feminist I was the observer. I
am aware that the story I am about to tell is one of only many that
could be told about Prospect or about women's relationship to the
telephone in general.[20]

Chapter 1 introduces readers to the community and the women
who live there. Because of a series of changes the community has
undergone over the past century, it no longer serves as an autonomous
social and economic center of life for its residents and the surrounding
area. Changes in communication and transportation, such as in the
telephone company and the services it offered, were involved in the
transformation. Notions of appropriate spheres for women and men
have had to shift to accommodate these changes, and definitions of
gender have become unsettled in their wake. Chapters 2 and 3 suggest
that women's use of the telephone in Prospect should be seen in the
larger context of the talk that women do in the community, how it is
viewed and the functions it serves, and of women's social and physical
location in the private sphere and in the family. Chapter 2 examines
where and about what women talk and the gendered work and gender
work this talk accomplishes to maintain relationships, perform ongo-
ing activity of the community, and facilitate care-giving and -receiving.
Chapter 3 notes that women's use of the telephone is related to their
restricted mobility and to decisions, often not of their own making,
about where they will live and what opportunities are available to
them. The telephone may serve as compensation for these restrictions
and for separations from family and friends, and it may be used cre-

atively to help transcend the physical and social boundaries of their domestic and economic lives. Yet women's use of the telephone remains largely confined to a private sphere whose boundaries have changed shape, as a larger public world of power and politics passed over the horizon when the community itself lost its autonomy.

The second part of this text is given over to the stories of several individual women. My decision to do so arose out of my interest in recovering women's voices and experiences; however, I realize that giving other women voice in the text is not unproblematic.[21] My authority can never be fully transcended. The role of narrator I have chosen is to incorporate a stream of different voices into the first three chapters, where I explore two central concepts about gender and the telephone that were present in the community and in the research. In the second half of the book, I present full interviews with six of the participants so that their stories, read as a whole, can provide a richer understanding of individual women's lives. The interviews were chosen on the basis of their diversity and the insight they provide, but they do not exhaust the interesting, varied, and complex data provided by all of the interviews. They do illustrate how social practices relating to the telephone have changed over time, how meanings of gender have changed over time, and how use of the telephone is related to a woman's social location and opportunities and her uses of talk. They illustrate how the telephone is subtly woven through the lives of women and the life of the community and must be understood within those broader contexts.

Nettie represents the voices of women who expressed their disapproval of so-called idle talk, who use the telephone for gendered community work and for care-giving, and who believe women's physical and social location in the private sphere is natural and appropriate. Ethel—like other, but not all, women who have restricted mobility because of age or disabilities—has found the telephone an important source of emotional support from her friends and children and a link across time and space to a larger world of the community and demographically dispersed family and services. Carolyn, on the other hand, does not have the stable community ties that provide Ethel with her base of comfort and support. Having moved over a dozen times because of her husband's job, she derives stability from her relationship with her daughters, carried on in the main by telephone. Despite some loneliness and boredom, she does not engage in local community tele-

phone talk, suggesting that telephone relationships are not easily struck. Gayle, divorced with four children, uses the telephone much less now than she did as a housebound mother whose telephone calls were her escape. Despite her still frequent telephone talk with family and friends, she misses the person-to-person visiting of her mother's era, when women seemed to be more available for talk. Kristin and Ami, teenage sisters, are restricted in their use of the telephone by their father's occupation, for which he is occasionally on call, and by his dislike of their use of the phone. Their fears of staying alone at night reveal an ugly manner in which women learn early their social place relative to men and the physical restrictions the threat of assault places on their movements. The telephone is a means by which those fears can be either exacerbated or lessened, but the telephone fails to compensate for women's differential relationship to space.

The important lesson to be learned from this text is not about the telephone; it is about gender. Social science research on gender has assumed gender to be pregiven biological categories, perhaps modified by culture but something we immutably *are,* rather than a set of social practices and a system of cultural meanings, something we do and believe.[22] In this study I was not looking for how women and men use the telephone differently as a result of pregiven differences between them. I was looking for how gender is both accomplished and thought about; from this vantage point use of the telephone is not a reflection of differences but an instance of them.

NOTES

1. I have discussed this literature at greater length in "Women and the Telephone: The Gendering of a Communications Technology," in *Technology and Women's Voices: Keeping in Touch,* ed. Cheris Kramarae (New York: Routledge & Kegan Paul, 1988), 207–28. For a representative look at how popular and academic authors have discussed women's relationship to the telephone, see the two collections edited by Ithiel de Sola Pool, *The Social Impact of the Telephone* (Cambridge: MIT Press, 1977), and *Forecasting the Telephone: A Retrospective Technology Assessment* (Norwood, N.J.: Ablex, 1983).

2. Cheris Kramarae, "Gotta Go Myrtle, Technology's at the Door," in

Technology and Women's Voices: Keeping in Touch, ed. Cheris Kramarae (New York: Routledge & Kegan Paul, 1988), 2.

3. I discuss the gendered nature of technology more thoroughly in "Gendered Technology, Gendered Practice," *Critical Studies in Mass Communication 5* (1988): 57–70.

4. The political, economic, and social history of the telephone has not yet been well told, but for representative examples of what has been published, see John Brooks, *Telephone: The First Hundred Years* (New York: Harper & Row, 1976); Henry M. Boettinger, *The Telephone Book: Bell, Watson, Vail and American Life, 1876–1976* (Croton-on-Hudson: Riverwood, 1977); Harry B. MacNeal, *The Story of Independent Telephony* (Chicago: Independent Pioneer Telephone Association, 1934); and N. R. Danielian, *AT&T: The Story of Industrial Conquest* (New York: Vanguard Press, 1939).

5. Marshall McLuhan, *Understanding Media,* 2d ed. (New York: Mentor, 1964), 239.

6. Donald Ball, "Toward a Sociology of Telephones and Telephoners," in *Sociology and Everyday Life,* ed. Marcell Truzzi (Englewood Cliffs, N.J.: Prentice-Hall, 1968), 65.

7. Stephen Kern, *The Culture of Time and Space, 1880–1918* (Cambridge: Harvard University Press, 1983), 317–18.

8. Ibid., 316. For other examples see Herbert S. Dordick, "Social Uses for the Telephone," *Intermedia* 11 (May 1983): 32; Hans Magnus Enzensberger, *The Consciousness Industry: On Literature, Politics and the Media* (New York: Seabury Press, 1974), 166; Ivan Illich, *Tools for Conviviality* (New York: Harper & Row, 1973), 22; and Pool, *Social Impact,* 4.

9. Rakow, "Women and the Telephone," 20.

10. Early telephone industry journals are replete with examples. *Telephony,* a major journal of the independent companies, carried such articles as "Bad Telephone Manners" (1904), "Etiquette on the Telephone" (1906), "Telephone Good Form" (1907), "Educating the Public to the Proper Use of the Telephone" (1913), and "Limiting Party Line Conversations" (1914). *Bell Telephone News* also contained many examples, such as "Courtesies by Wire" (1912), chastising women for being rude on the telephone. Popular magazines, too, ran such stories. *The American Magazine* considered "How We Behave When We Telephone" (1918) and *Woman's Home Companion* discussed "Telephone Courtesy" (1913).

11. As an example, an 1878 advertisement in New Haven, Connecticut, instructed men in the convenience afforded them by the telephone: "Your wife may order your dinner, a hack, your family physician, etc., all by Telephone without leaving the house or trusting servants or messengers to do it." Quoted

by Claude S. Fischer, "Educating the Public: Selling Americans the Telephone, 1876–1940" (Paper presented to the Social Science History Association, Washington D.C., October 1983).

12. Carolyn Marvin, *When Old Technologies Were New: Thinking about Electric Communication in the Late Nineteenth Century* (New York: Oxford University Press, 1988), 205.

13. Ibid., 24.

14. Michèle Martin, " 'Rulers of the Wires'? Women's Contribution to the Structure of Means of Communication," *Journal of Communication Inquiry* 12 (Summer 1988): 89–103; and Claude S. Fischer, "Gender and the Residential Telephone, 1890–1940: Technologies of Sociability," *Sociological Forum* 3 (1988): 211–34.

15. I am aware that the notion of community has a number of feminist implications. It can be evoked as a utopian alternative to contemporary social arrangements in a useful or in an overly romanticized way. For three quite different discussions of the importance or overimportance of community to feminists, see Jean Bethke Elshtain, "Feminism, Family, and Community," *Dissent* 29 (Fall 1982): 442–49; Iris Marion Young, "The Ideal of Community and the Politics of Difference," *Social Theory and Practice* 12 (Spring 1986): 1–26; and Sandra A. Zagarell, "Narrative of Community: The Identification of a Genre," *Signs* 13 (Spring 1988): 498–527.

16. We are, of course, drawn to study that which interests us the most and which most has resonance for us. The choice of a small rural community matched my own nostalgia for the midwestern community in which I grew up. My affinity for the setting turned out to be an asset to being accepted into the community, and my "native" familiarity with community life gave me insights that saved me a great deal of time and error.

17. This research approach was particularly compatible with my interest in making the project a self-reflexively feminist one. Feminist methodologies are generally concerned with women's experiences and definitions. As a consequence, feminists are particularly drawn to such approaches as in-depth interviewing, ethnography, life histories, and story telling. See Ann Oakley, "Interviewing Women: A Contradiction in Terms," in *Doing Feminist Research,* ed. Helen Roberts (London: Routledge & Kegan Paul, 1981), 30–61; Brigitte Jordan, "Studying Childbirth: The Experience and Methods of a Woman Anthropologist," in *Childbirth: Alternatives to Medical Control,* ed. Shelly Romalis (Austin: University of Texas Press, 1981), 181–216; Susan N. G. Geiger, "Women's Life Histories: Method and Content," *Signs* 11 (Winter 1986): 334–51; Hilary Graham, "Surveying through Stories," in *Social Researching: Politics, Problems, Practice,* ed. Colin Bell and Helen Roberts (London: Routledge & Kegan Paul, 1984), 104–24; Kathryn Anderson, Su-

san Armitage, Dana Jack, and Judith Wittner, "Beginning Where We Are: Feminist Methodology in Oral History," *Oral History Review* 15 (Spring 1987): 103–27; and Sherna Gluck, "What's So Special about Women: Women's Oral History," *Frontiers* 2, no. 2 (1977): 2–17.

18. This sampling technique has been called "snowballing" by Steven Taylor and Robert Bogdan, *Introduction to Qualitative Research Methods,* 2d ed. (New York: John Wiley & Sons, 1984), 24; "theoretical sampling" by Barney G. Glaser and Anselm L. Strauss, *The Discovery of Grounded Theory* (Chicago: Aldine, 1967), 49; and "creative sampling" by Jack D. Douglas, *Creative Interviewing* (Beverly Hills: Sage, 1985), 49–50.

19. Feminists engaging in important discussions of the problems of methodology and the role of the researcher have demonstrated that research is not gender-free. See Tony Larry Whitehead and Mary Ellen Conaway, eds., *Self, Sex, and Gender in Cross-Cultural Fieldwork* (Urbana: University of Illinois Press, 1986). Other useful discussions of the problems and imperatives of feminist research appear in Barbara A. Babcock, "Taking Liberties, Writing from the Margins, and Doing It with a Difference," *Journal of American Folklore* 100 (October/December 1987): 390–411; Gloria Bowles and Renate Duelli-Klein, eds., *Theories of Women's Studies* (London: Routledge & Kegan Paul, 1983); Marcia Westkott, "Feminist Criticism of the Social Sciences," *Harvard Educational Review* 49 (November 1979): 422–30; Janice Radway, "Identifying Ideological Seams: Mass Culture, Analytical Method, and Political Practice," *Communication* 9 (1986): 93–123; Angela McRobbie, "The Politics of Feminist Research: Between Talk, Text and Action," *Feminist Review* 12 (October 1982): 46–57; Janet Finch, " 'It's Great to Have Someone to Talk to': The Ethics and Politics of Interviewing Women," in *Social Researching,* ed. Bell and Roberts, 70–87; Shulamit Reinharz, *On Becoming a Social Scientist* (San Francisco: Jossey-Bass, 1979); Dorothy Smith, "A Sociology for Women," in *The Prism of Sex: Essays in the Sociology of Knowledge,* ed. Julia A. Sherman and Evelyn Torton Beck (Madison: University of Wisconsin Press, 1979), 135–87; Liz Stanley and Sue Wise, *Breaking Out: Feminist Consciousness and Feminist Research* (London: Routledge & Kegan Paul, 1983); Ann R. Bristow and Jody A. Esper, "A Feminist Research Ethos," *Humanity and Society* 8 (November 1984): 489–96; and Vera Whisman, "Lesbianism, Feminism, and Social Science," *Humanity and Society* 8 (November 1984): 453–60.

20. A particularly useful discussion of the role of subjectivities in shaping our research experiences and the stories we tell about them can be found in Alan Peshkin, "Virtuous Subjectivity: In the Participant-Observer's I's," in *Exploring Clinical Methods for Social Research,* ed. David N. Berg and Kenwyn K. Smith (Beverly Hills: Sage, 1985), 267–81.

21. See Susan Krieger, *The Mirror Dance: Identity in a Women's Community* (Philadelphia: Temple University Press, 1983), for her account of why she chose to "disappear" as the narrator and to orchestrate the voices of her text as she did.

22. Lana F. Rakow, "Rethinking Gender Research in Communication," *Journal of Communication* 36 (Autumn 1986): 11–26.

Prospect's Story

The following chapters give an account of the collective lives and experiences of Prospect women and the community context within which they function. To protect the identity and hence the privacy of the community and its residents, I have given fictional names to people and places (including the name Prospect), and I have omitted certain revealing details. Information that would reveal the identity of the community or state has not been provided.

1

The Community

Prospect is not the sort of town a traveler is likely to seek out or even happen across on the way somewhere else. As I drove along Highway 38, part of the sparse traffic of local farmers, factory workers, homemakers, and school children shuttling between towns, farms, and neighbors, I hardly noticed the town cradled along the slope of a ridge. The turn-off on the top of the hill took me past a well-cared-for Holstein farm on the right, past a lane branching into what I could see was a subdivision of ranch houses and the Catholic Church, past the Church of Christ on the left and the Methodist Church on the right, past the brick grade school and the war memorial on a triangle of grass and bushes, and onto the main street. I drove through a short row of businesses along the main street, which is flanked by a few more streets lined with very modest but mostly well-kept houses with front porches. I could see that if I took the street up to the new bank at the top of the ridge, past the ranch houses of the second subdivision, I would join Highway 38 again at a point farther down the road. In the span of a few minutes and the space of a few miles, I had seen Prospect.

But appearances do not tell the whole story of a community. Prospect is a predominantly white, Christian town with a population under 1,000, located in a midwestern state that has a mixed economy of agriculture and industry. While this characterization has changed little over time, the Prospect I saw on the day that I first made its acquaintance is not the same Prospect of a former time. Though the main street has a steady movement of cars and of people picking up their mail from the post office, stopping at the cafe for coffee or lunch,

shopping for a few things at one of the stores, Prospect is not the self-sufficient hub of business and social life it once was.

Now it has two beauty shops, two real estate firms, one lawyer, three bars, two restaurants, a small grocery, a variety store, a lumberyard, a feed mill, a bank, an insurance agency, a service station, a florist, a thrift shop, a meat slaughtering company, a telephone equipment installation company, an implement dealership, a lawn and garden equipment dealership, some minor manufacturing and service firms, and a large trucking company. It has a post office, a volunteer fire department, a village-owned water and electric utility, a telephone company, an American Legion post, three churches, a historical society housed in a building listed on the National Register of Historic Places, and an elected village board. Since 1944 the town has not had a high school. After sixth grade Prospect students are bussed to a consolidated high school in the neighboring village of Olsonville. Prospect does not have its own movie theater, newspaper, library, doctor, or ambulance service. Most residents make regular trips to Valley City, a community of about 50,000 residents ten miles away, to see a doctor or dentist, to do the majority of their shopping, and to find entertainment.

Prospect residents, many of whom have lived here all or most of their lives, are aware of the sharp contrast between this Prospect and the Prospect of the past. The history of Prospect is passed on to successive generations in a manner different from that of large cities, which have museums, universities, libraries, newspapers, city records, corporate records, and other sources for the collection and preservation of facts, figures, and memories. In Prospect, history lives on in the stories and memories of its oldest residents, in the few scrapbooks and photographs and oral histories collected by the local historical society, and in the few official accounts written to observe the passage of important historical markers, such as the centennial of the community in 1954. Some residents are uninterested in the community's past, feeling no particular use for it or having little fondness for what has been left behind, but other residents, observing so much change in the community, are concerned that an understanding of the past is being lost.

When I asked Prospect residents to tell me about the town's history, they always included a reference to its founder and developer, Elias Prospect. Prospect moved from an eastern state to the area in the 1840s. He and others, generally called Yankee capitalists by townspeo-

ple, started the Methodist church, opened a school, and persuaded the railroad to pass through the village. The railroad company gave the station the name Prospect, which was legalized by the recording of the village plat in 1854. Elias Prospect went on to the state assembly and the state senate, helped organize the Whig party in the county, and served as the justice of the peace.

The railroad brought the Irish to the county, and specifically to Prospect. In 1860 there were 3,300 Irish in the county, and for a period of time Prospect was the end of the railroad line, so that many Irish working on the railroad settled in Prospect. From its founding in 1896 until 1900, when German Catholics began arriving in the area, the Catholic church of Prospect had an exclusively Irish membership. Eastern Yankees, the Irish, and the Germans, then, came to be the primary ethnic groups of the community. Olsonville to the west was Norwegian and Lutheran, and the Scottish and others settled to the east.

Over the years changes in communication, transportation, and employment affected the patterns of association among Prospect residents and with the outside world. For a time the community developed into a thriving center of social and economic life and then receded in prominence as residents came to identify less with each other and more with people and events farther away. Mail service was the first method of contact the earliest residents had with the outside world. The post office opened in 1845, before Prospect was officially platted, and service reached the settlement by stagecoach twice a week. With the introduction of the railroad through town, mail service was stepped up to twice a day in 1879, once from the east and once from the west. In 1903 outlying farmers finally got Rural Free Delivery service.[1]

Beginning with the first train service in 1854, passenger- and freight-train service provided Prospect with vital social and economic links to the outside world. Passenger service was seriously affected in 1886, however, when a railroad company built a line between two larger cities, cutting Prospect out of the route. Other passenger lines continued to run through Prospect—up to four times a day at one point—but eventually even freight-train service was discontinued in the 1960s after the closing of Prospect's major industry, a condensed milk plant. The losses of both services and the town's major employer were blows to Prospect's social and economic vitality.

The first automobiles arrived in Prospect about 1909, but automobiles were not commonplace until much later, probably not until the end of gas rationing following World War II. A paved version of Highway 38 was built through the town in 1924, but years later, when traffic became heavy, a mandate from the state took the highway out of the town. The Highway 38 bypass also had its effect on the economic vitality of Prospect.

For a brief period of time, beginning in 1912, the community had its own newspaper—four pages of news, church notes, train schedules, and advertisements. For the most part, however, the community only had its own column in the *Valley City Herald*. The column has since been discontinued, so any news about Prospect of interest to Prospect residents must compete for space with news from all the surrounding towns covered by the *Herald*. A weekly community newspaper in nearby Olsonville publishes Prospect's village board minutes, but few residents read them. Despite such a lack of formal means of communication, community residents have had other means of keeping in touch with each other. In 1897 the Masons built a two-story building with the first floor, which included a stage and a dance floor, designed to be a community center. The hall was a mainstay of community events until it burned in the 1930s. The stores and restaurants used to bring the community, particularly the farmers, together on Saturdays, "going to town" day. A ball park and a championship ball team brought the community together, as did Saturday night movies shown outside in the 1920s and 1930s.

Influential investors and community leaders were responsible for much of the development of Prospect over the years. The names of a handful of prominent men appear over and over in association with important community projects and businesses. They were involved in the organization and leadership of the churches, the development of the ball park, the building of the Masonic Lodge, the founding of the Prospect Telephone Company in 1902 and the bank in 1910, and the building of the condensed milk company in 1912. They served on the boards of the telephone company, the bank, and the churches. While community-mindedness may have played a role in their motivation, the investors also made themselves wealthy in the process.

The history of Prospect's telephone company illustrates both the changing character of Prospect over the years and the role of these investors in the town's development. When several of these investors

organized the Prospect Telephone Company in 1902, they were aided by boosterish reports in the Prospect news column in the *Valley City Herald*. The column reported progress on the setting of poles and stringing of wire. It urged readers to buy stock in the company and order a telephone for one dollar a month. By January 8, 1903, thirty-two miles of line and sixty telephones were in place. The company apparently was a money-making proposition for its investors because of low overhead (at one time they paid $85 a month to the general manager, who slept at the company and provided his two daughters to work as well, and they put little into the upkeep or improvement of the equipment) and because of a state regulatory commission generally supportive of their rate increases.

Customers were not without complaints about the company and its service. A group of farmers living between Prospect and Valley City complained in 1915 that they were forced to get their telephone service from the Prospect company when they preferred the Valley City telephone company. They argued their school, business, and social connections were with Valley City, but the state regulatory commission ruled against their petition on the grounds that it would cause an economic loss to the Prospect Telephone Company. Telephone service in Prospect, and undoubtedly in other places, created its share of discrepancies between preferred and imposed communal relationships.

A second complaint to the regulatory commission in 1915 was also dismissed. The complaint came from a group of farmers maintaining that the company was providing poor service on overloaded party lines, which did not justify the higher rate being charged them. (Throughout the history of the telephone company farmers generally endured higher rates and more crowded party lines than their counterparts in town because of the higher expense involved with running lines to geographically dispersed homes.) Others may have felt the same way, because the company reported that as a result of the rate increase approved by the state commission the number of their subscribers dropped from 314 to 275. Because of the large number of parties per line, service must have been very poor and use of the telephone reserved only for business and emergency calls. In 1915 the company reported it had eleven one- and two-party lines but twenty-four lines with anywhere from eight to thirteen parties on each of them.

By 1939 the board of directors of the Prospect Telephone Com-

pany was looking for a buyer. Ninety of their 268 subscribers were behind on their bills (it was common practice for delinquent subscribers to be in debt and paying interest to the Prospect bank, which was run by some of the same people who owned the telephone company), and the system was in poor physical condition. The company was sold to the Jacks family from a neighboring town, perhaps with the intention of repossessing the company when it failed under their ownership. But the Jacks family went to work.

The company changed from a magneto switchboard to a common battery board in 1950, meaning that subscribers no longer had to crank their own telephones to reach the operator but only had to pick up the receiver. In 1954 the company changed to a dial system, and the community function filled by the operator was gone. In the late 1950s telephone companies such as the Prospect company began offering Extended Area Service, which enabled subscribers to call surrounding communities without paying a toll charge because they were not using long-distance lines. In 1959 Lydia Jacks became solely responsible for the company when her husband died. Under her leadership the company worked with 3M in 1978, hoping to become a field trial for a system that would allow subscribers to have cable television and single-party telephone service from a single cable. The regulatory commission expressed concern that the cost of service would be too high to be borne by all its subscribers. In the end 3M decided against developing the new system. It was not until 1980 that all Prospect telephone subscribers had one-party rather than multiple-party lines. In 1983 the Jacks family sold the company to a regional, non-Bell, telecommunications company, and Lydia Jacks retired at age eighty-four.

The changes in telephone service over the years paralleled, if not contributed to, the changes in a sense of community experienced by Prospect's residents. The introduction of telephone service bound the community and surrounding farm families together, albeit in a sometimes undesired and inequitable way. The central operator functioned as its nucleus; party lines functioned as connecting links between families. As Lydia Jacks described it, the telephone system initially provided a community, not simply an individual, service. "If we had a fire," she explained, "the operator would ring the fire ring and all the receivers would come down on that line, and you would say, 'John Smith's barn's burning.' You had all that comradery there—everybody was willing to help everybody." The operator would forward a cus-

tomer's telephone calls when she knew where the customer could be found, and she was someone to ask if a customer was trying to find her children. The loss of the operator meant information no longer passed through one place, one persona that gave the community a sense of shared personal relationships.[2] The loss of party lines (undoubtedly long-awaited by some) meant a further atomization and privatization of households, and extended area calling expanded residents' boundaries of attention.

A few vestiges of the telephone company's old role in the community remained until recently. Lydia Jacks is known affectionately by everyone in town as "Grandma Jacks," but since the sale of the company in 1983, the personal, almost familial, relationship customers and villagers had with the head of the local telephone company is no longer possible. As Lydia Jacks told me proudly in pointing out the advantages of local ownership, no one knows the name of the president of the state Bell Telephone Company. The woman who is office manager of the telephone company (she had been working there for twenty-six years when I interviewed her) has sometimes filled the old operator role. She cited an example of a recent call from a man looking for someone from the village water-and-light utility. She told him since it was morning he could probably find the person he was looking for down at the local cafe having coffee. Until the company was sold, this woman wrote out the monthly telephone bills—to over 700 subscribers—by hand.

Along with the loss of train service, the advent of the automobile, the bypass of the highway, and the closing of the town's major employer, the condensed milk company, these changes in telephone service and ownership contributed to the community's loss of cohesiveness. The town has very slowly changed from being a thriving center of economic and social life to being largely a retirement community and a bedroom community.[3] The most tangible evidence of the change was a small real estate boom resulting in the development of two subdivisions of new houses built in the 1960s and 1970s, as people working in other communities looked to Prospect for inexpensive housing. As people from elsewhere have moved in, however, the grown children of local residents have moved out. As a woman in her twenties put it, "It seems to be a town for people who've lived here all their lives. It's not really one for younger people." Few jobs exist in Prospect even for those who would like to stay.

As one village officer explained to me, people who live in Prospect but work elsewhere do not give the community their total loyalty. "If you work elsewhere, you really don't have the roots here. And if the guy's working in Valley City or somewhere else, he might buy his gas there, pick up a loaf of bread, pretty soon all the groceries. It takes him out of the community." Long-time residents complained to me that they no longer know everyone in town. They are concerned that the community does not seem to be pulling together, that it is difficult to get people to volunteer their time and effort for community projects.[4] Organizations have a difficult time finding members and workers. Some blame the residents for not supporting local businesses; others put part of the blame on television. One resident said, "It's easier, especially for older people, to sit home and watch a show they like than go out to a meeting." A business owner said: "People just don't know each other like they used to. I often wonder how much television affected it. You used to go down to the ball park and meet people. Now people stay in and watch TV. They aren't out on the porch to say hello to. The only thing that's really changed is communication. There just isn't a place where you can go in the evening and sit down and talk, outside of a tavern."[5]

This woman is among several women who have attempted to replace these lost opportunities for interaction. She spearheaded an annual all-community rummage sale in the spring to give people a chance to get out of their houses and over to meet their neighbors. Two other women have begun an annual ladies' luncheon, as they call it, attended by over sixty women of the community. Though efforts such as these hold the community together and make the lives of residents more pleasurable, the old community cannot be resurrected.

The changing economy of Prospect, over the years increasingly dependent upon a larger national economy, contributed in a profound way to the changes that have affected the lives of its residents and the community as a whole. While the financial fate of Prospect was for some time tied to its influential investors, that handful of men who led the community with their financial undertakings and long-term decision-making, the families have died out and the children moved on. The financial fate of its residents is now tied to two industries—the dairy industry and the manufacturing industry—that are dependent upon larger unseen national and international forces. The struggling dairy farmers outside the town's limits are vital to the town's busi-

nesses, and the dairy industry provides the primary products hauled by the town's largest employer, the trucking company. While some residents are employed by the small manufacturing firms that come and go in the town, many commute to factory jobs in other cities, primarily to two major manufacturers in Valley City. The fate of these residents, and hence of the town, resides in the decisions made by the management of these large corporations. In recent years extensive layoffs at one of the two major employers affected so many families that the churches (primarily women members) in the community organized a food pantry. During my visit a decision by this manufacturer to move one of its plants to another state was uprooting and even splitting up several Prospect families. The other major manufacturer had temporarily or perhaps permanently laid off a number of residents because of cutbacks resulting from automation.

Aside from dairy farming, trucking, and manufacturing jobs, few other job opportunities are available to Prospect men. Women have even fewer opportunities, since farming and trucking are two occupations women tend to marry into rather than enter on their own. Some women have found work in offices, hospitals, and grocery stores in other communities. A few teach, some babysit, some start their own small businesses. Others are full-time homemakers. While the homemakers are likely to insist that what they are doing is their choice, they are also likely to confess to feelings of boredom, entrapment, and uncertainty about any other attractive options.[6]

Educational options are as limited as income options. Few young people return to Prospect after getting a college education, for, as in most small towns, there would be little for them to do. Those who plan to stay in the area and want job skills and those who need to upgrade or change their skills for different job opportunities must commute to the nearest technical school. The incidence of high school graduates going on to college has increased over the years, but even so, young women seem less likely than young men to go to college. Older women generally lacked the money or family support to go to college when they were younger, even when they wanted to. Many did not even finish high school. One woman, almost eighty years old, told me, "I didn't get to go at all—eighth grade was as far as I got. . . . I was the oldest in this family, on a farm, all the little kids, my mother wasn't well. It was a new little baby or another one [to take care of]." A sixty-year-old farm woman completed a high school equivalency after her

own children graduated from high school. "That's how rough [financially] things were," she said. "I had a father who was very opposed to going on to school. He thought that girls didn't need an education anyway." Even women in their thirties reported dropping out of high school, but the reason for this generation of dropouts was generally a different one—they were pregnant.

As women moved away from home and farm production and the number of men entrepreneurs in the community decreased, women's increased interest in and need for local income opportunities has led to a striking increase in the number of local businesses owned and managed by women. Though business owners historically have been leaders in Prospect, the women who have assumed a greater role in local businesses while continuing their extensive volunteer work for the community do not have a substantial role in decision-making in the community.[7] They suggested several possible reasons to me: (1) resistance in the community to women as leaders; (2) the marginal success of most of the businesses run by women, which has not led to their wealth and influence; (3) the lack of time and energy of women struggling to maintain business and family lives; and (4) a fear that becoming too vocal on community issues might adversely affect their businesses. The owner of the cafe said: "I don't have time to get involved [in running the village]. I don't have time to even get involved in the church. If I'm not working at [the restaurant], I'm thinking about it." This woman, a single parent, does not have the resources of a spouse to put to work in the family business or to rely on for handling domestic responsibilities as male small-business owners so frequently do. Another business owner said the women business owners in Prospect came along at a time when women in businesses were thought of as being O.K., but perhaps the more important impetus behind women business owners is that "for a lot of the women it's more a matter that men have gone into the jobs that pay more." Women may not do as well at their businesses as men might, she added, because they are afraid to take risks that might jeopardize their jobs; they cannot rely on finding a good-paying job like men can. She also cited the case of a woman business owner who served on the village board. When people did not like her actions on the board, it hurt her business. Eventually the business failed.

Grandma Jacks is the one businesswoman who seems to have wielded considerable influence in Prospect. Her political success may

have stemmed in part from the economic success of the telephone company, built with the hard work of the entire family and providing a service that customers could not get elsewhere, but she also seems to have established a gendered persona that made her position of leadership palatable. She was Grandma Jacks, the consummate matronly and kindly familial figure, but her interest in business led her out of the domestic sphere and into a world of business deals and physical equipment that earned her the respect accorded a man. Few other Prospect women have managed to, or wanted to, blend masculine and feminine in such a way.

While many Prospect women of working age may bemoan the lack of job opportunities for them, Prospect women do not necessarily feel women should occupy a different social place than they do. Though none considered themselves knowledgeable about feminism, a few women expressed to me their approval of the women's movement and changes in women's roles in recent years. A farm woman in her seventies said she supports women in leadership roles in the community and the progress in women's position: "I think that the women have shown that they have the ability to do things that they never got any recognition for before at all, and I think maybe they take it a little more seriously if they are given some position that has authority. They appreciate it more. . . . The women have worked their way up to this."

Other women offered some degree of support but expressed strong concerns about how children are raised when women leave their homes for jobs and politics. They may say they support equal rights, or equal pay, or women working, but not "going off the deep end," as one woman put it or "taking over," as another said. "I've never been one to believe women should have more power," commented an older woman who had worked most of her life. "I do believe in the equality of payment for men and women. But I do like to have men in leadership." A full-time homemaker in her forties said, "Sometimes I wonder if people don't spend too much time clawing and fighting for women's lib and not enough time enjoying their role as women."

The youngest women I talked to looked forward to having some kind of career as well as a marriage and children. In general, they identified little with the women's movement yet have accepted a new definition for being a woman. Said one, "I'm not a real feminist at all. I just don't think there should be any restrictions placed on you because

you're female." For most women in this community the women's movement is translatable into women not working or working for income, at what, for how much. The dilemma they see for women, whether faced personally or only philosophically, is how women can reconcile their economic and family lives. Even women who are working for pay or who are now retired from outside jobs express the same general sentiment. An elderly woman who had worked when her children were home said she had been made to feel a little guilty about working when she had children. She thought it unfair that working women are blamed if their children get into trouble but still said it was too bad women have to work. Another working woman with grown children said many women work who do not need to, depriving men who need to support families of those jobs. When she realized the contradiction between what she was saying and what she does, she explained that she works because she enjoys it and that a man could not support a family on what she makes.

Prospect's three churches may have something to do with perceptions of what is appropriate for women. The churches are integral to the community and to almost all its residents. Through the clergy, church doctrine and practices, and member interaction, the churches play a prominent role in negotiating the meanings—particularly the meaning of gender—in circulation in the community. The churches and their clergy range from theologically and politically conservative to liberal; the biggest congregation is the most conservative. According to one pastor, members of the three churches disagree less on religious doctrine than they do on social issues. There is no doubt some relationship between the conservatism of a large portion of the town's church members and the political conservatism of the town: it has been solidly Republican throughout its history.

The Methodist church, established by the town's founder, Elias Prospect, is the oldest, but also the smallest, congregation in the village. The Methodist denomination is the most liberal of the three. Official church doctrine supports shared responsibility for parenting by men and women, recognizes the necessity for divorce and in some cases for abortion, supports the rights of racial and ethnic minorities, religious minorities, children, youth, the aging, women, and the disabled. In this congregation women occupy positions on the board of trustees, serve as lay speakers, and are active in service work. The pastor at the time of my visit was supportive of feminism and con-

cerned about the problems of women in the community who face loneliness, economic distress, and limited options after divorce.

The Catholic church is the second largest congregation. The priest of this parish told me of his congregation's conservatism. They resist changes in church doctrine and church practice and have not been active on social issues. Though women play an active role doing the work of the parish, they are either not allowed or not encouraged to play decision-making roles. This priest must deal with women parishioners' loneliness and the traditional expectations that they are responsible for taking care of the family even when they work.

The Church of Christ has the largest active congregation (about 175 attend services, about one-fifth of the town's population) and is the most conservative of the three churches. It is a fundamentalist church, believing in a return to a literal interpretation of the scriptures. Both women and men are active workers in the church, but women do not have active leadership roles as elders and deacons. They teach and even on occasion serve as ministers, but decision-making is deemed a role that God granted to men. The minister expressed to me his preference for a nuclear family with one wage earner, the husband, but acknowledged that such an arrangement is no longer generally practical.

The role of Prospect's three churches in women's lives—furnishing an organizational structure for community work with each other, establishing norms of behavior, and providing a meaningful existence for many of them—illustrates how fundamental it is to understand the context within which the women I came to know experience their lives. In short, they live in a community that has undergone slow but dramatic change from an economic and social center for its residents to a loosely connected collection of homes and families. One-time wealthy and influential investors have disappeared, and the fate of the community and its residents is increasingly determined by larger outside political and economic forces. The development of a telephone company and alterations in its services parallel these other transformations. Changes in women's economic role have not brought comparable improvements in their family or community power. While the churches remain influential forces in giving shape and meaning to the lives of Prospect residents, the conservative and subordinate role for women preferred by some church doctrine and some church members is not unchallenged. As I came to know Prospect women and men

more personally and as women told me their own stories about Prospect and women's use of the telephone there, I began to discern shifting and contested definitions of gender.

NOTES

1. On January 28, 1903, the Prospect news column in the *Valley City Herald* welcomed the coming of Rural Free Delivery: "The farmers and citizens in this vicinity hail with delight the prospect of having free delivery of the mail in this section in the near future. This is something that has been a long felt want and many efforts have been made to accomplish this result." A year later, February 25, 1904, the same column reported, "The rural mail delivery is giving excellent satisfaction in these parts since it got thoroughly started."

2. The role of women as telephone operators is another arena for investigating gender. I have argued elsewhere that operators may have served to bridge an increasing gap between public and private spheres, embodying new and old values and mediating new social relations over the telephone wires. Rakow, "Women and the Telephone," 211–15. See also Marvin, *When Old Technologies Were New*, 26–30; and Martin, " 'Rulers of the Wires?' "

3. Prospect is, of course, not the only rural community to have undergone such changes. The complex and asymmetrical relationship between rural and urban areas and the effects of larger patterns of social organization on rural communities are discussed in Art Gallaher, Jr., and Harland Padfield, eds., *The Dying Community* (Albuquerque: University of New Mexico Press, 1980); Stephen B. Lovejoy and Richard S. Krannich, "Rural Industrial Development and Domestic Dependency Relations: Toward an Integrated Perspective," *Rural Sociology* 47 (Fall 1982): 475–95; and Richard Whipp, "Labour Markets and Communities: An Historical View," *Sociological Review* 33 (November 1985): 768–91. Whipp makes the excellent point that "classes and communities are continually made, remade and unmade" (785).

4. Though this sentiment was often expressed, the community seemed to me as an outsider to be very close-knit, with a genuine sense of community spirit. I had to remind myself not only that these residents were making comparisons to a time when the community was the center of life for all its residents but also that I was making comparisons to a noncommunal way of life experienced by mobile professionals like myself.

5. It is interesting that so many Prospect residents share the nostalgia for face-to-face communication that has characterized so much of the research in the field of mass communication. For related discussions, see James R. Beniger, "Personalization of Mass Media and the Growth of Pseudo-Commu-

nity," *Communication Research* 14 (June 1987): 352–71; and Michael Schudson, "The Ideal of Conversation in the Study of Mass Communication," *Communication Research* 5 (July 1978): 320–29.

6. Women's labor-force participation in small rural towns has been a subject of interest to rural sociologists. For a pertinent study, see Moshe Semyonov, "Community Characteristics, Female Employment and Occupational Segregation: Small Towns in a Rural State," *Rural Sociology* 48 (Spring 1983): 104–19. Semyonov concludes that, even as their labor-force participation in these towns rises, women remain occupationally segregated in low-status jobs.

7. It may be useful to think of two networks of people in Prospect, a power network and an action network, a distinction made by Lionel J. Beaulieu and Vernon D. Ryan, "Hierarchical Influence Structures in Rural Communities: A Case Study," *Rural Sociology* 49 (Spring 1984): 106–16. The action network does the work while the power network, such as it is, makes the decisions. Even as business owners, women do not generally move into the power network in Prospect.

2

The Telephone and
Women's Talk

During my stay in Prospect I quickly learned that the telephone is a gendered, not a neutral, technology. Both women and men readily identify the telephone as part of women's domain, and indeed, because of the social and economic world inhabited by Prospect women, which differs from that of Prospect men, the telephone is a technology particularly relevant for them. But women's use of the telephone is not simply a consequence of gender relations or a simple reflection of differences between women and men, even if those differences are understood as culturally created. The telephone is a site at which the meanings of gender are expressed and practiced. Use of the telephone by women is both gendered work—work delegated to women—and gender work—work that confirms the community's beliefs about what are women's natural tendencies and abilities.[1]

Women's telephone talk in Prospect is related to the role women's talk fills in Prospect in general—part of the work women do to confirm their gendered identities and the work they do for their families and the community. Pamela Fishman, in her study of women's interactional work in mixed-gender talk, has focused attention on how women's talk is gender work:

> To be identified as female, women are required to look and act in particular ways. Talking is part of this complex of behavior. Women must talk like a female talks; they must be available to do what needs to be done in conversation, to do the shitwork and not complain. But all the activities involved in displaying femaleness are usually defined as part of what being a woman *is,* so the idea that it is work is obscured. The work is not seen as what women do, but as part of what they are. Because this work is

obscured, because it is too often seen as an aspect of gender identity rather than of gender activity, the maintenance and expression of male-female power relations in our everyday conversations are hidden as well. When we orient instead to the activities involved in maintaining gender, we are able to discern the reality of hierarchy in our daily lives.[2]

As I came to know Prospect, I came to realize that the gender work of talk occurs not only in mixed-gender talk but also in same-gender talk—talk between and among women that reveals, sustains, makes sense of, and in some cases challenges gender relations. Women's talk occurs largely in different places, about different things, for different purposes than men's talk, both as perceived by community members and as actually practiced by women and men. Women's talk holds together the fabric of the community, building and maintaining relationships and accomplishing important community functions, which, like women's interactional work in mixed-gender groups, is gendered work. Women's talk fulfills important personal needs for individual women as well—needs arising from their social and economic position. Yet women are not free to talk whenever, wherever, and to whomever they please. Women's talk is set largely within the boundaries of the private sphere and is limited by economics, technology, and social conventions and sanctions.

Talk occurs in a variety of places in Prospect. Women and men talk in the churches, at the post office, in the stores, at the ball park, and at senior citizens' meals. These locations and occasions are acceptable for the attendance and participation of both women and men, albeit in often different capacities. In addition, men's talk occurs at the feed-mill, in the lumberyard, in the taverns, and in the cafe. Women's talk occurs in church groups, at the beauty shop, and on the telephone. Some women's talk—a daily coffee klatsch, as residents call it, involving seven or eight women—takes place in the cafe, a controversial location for this activity.

Prospect women and men learn early that there are and should be differences in their talk—differences of style, content, and location that are part of the work of gender. By their teenage years Prospect women already have a clear understanding that men's and women's talk are different, that men and women have different speaking rights and obligations.[3] Two teenage sisters who participated in the study described how "girls and guys" talk differently, one of them explaining: "If you

have a boyfriend, they'll call you and they expect you to talk. They don't seem to have anything to say. They call you because, I guess they think it's an honor for you or something. [Laughter from both sisters and agreement from the other]. I think if you talk to a girl you can say I went shopping today, but with a guy you'd say I didn't do anything today." These young women attribute these differences in talk to men's and women's physical differences, primarily women's lesser strength, which they believe results in their different interests. Another young woman reflected this belief in an innate difference between boys and girls: "Girls *talk* on the telephone, guys say what they have to say and get off. Girls are different. That's the way girls are."

Some mothers of boys offered their observations that girls now call boys. One said, "I tease my son. When we were that age, we didn't call the boys. The boys called us. Now the girls call them." Even though some girls may call boys, girls and boys are both given clear messages that the behavior is amusing or inappropriate. One young woman said she talked to her sixth-grade boyfriend for hours on the telephone. Her mother "didn't care when he called me, but she didn't like it if I called him. Girls aren't supposed to call boys." I was given other indications that girls still call boys only at the risk of their reputations. A high school girl told me that girls who call boys are not considered "tasteful."

Despite the fact that some of the young women in the study do not enjoy or engage in lengthy conversations on the telephone with friends or are not allowed to have them, popular perception in the community is that young women spend long hours on the telephone. Those who do talk regularly to close friends often do so despite seeing them in school and after school, a source of puzzlement and amusement (if not exasperation) to adults. Many parents actively discourage or forbid their daughters from using the telephone in certain ways. One woman acknowledged that her thirteen-year-old daughter talks to a circle of friends and receives a number of calls, but she and her husband "don't believe in letting her hang on the phone." Some mothers reported that their sons make and receive numerous calls, but boys' use of the telephone seems of little concern to them or other adults. They were likely to report that boys use the telephone more for making plans than for long conversations. One woman described how she "lived" on the telephone as a teenager, talking to her boyfriend because they did not

get to see each other often. On the other hand, her older brother seldom used the telephone. Instead he had a car and was able to get where he wanted to go.

Greater restrictions on girls' mobility and movements may help account for their telephone usage, but teenage girls have another reason for making telephone calls. Many have already developed the need for intimate and private talk with other girls—a need that cannot be met in the public context of school or in larger groups. One woman now in her early twenties remembered that in high school she and her two close friends from school would see each other every evening as well as talk on the telephone. She explained: "It was hard to get to talk to each other privately at school. There were always people around knowing you were talking and wanting to know what about." The intimate and private "girltalk" of Prospect's young women becomes the "womantalk" of their later years. Women in Prospect have little incentive or opportunity to learn and talk about concerns of the public sphere of politics, policy, and economics. They consistently told me they do not keep track of news outside of their own families and friends, expressing guilt that they do not (for example, saying, "I don't keep up with those things like I know I should"). Yet they find little public sphere news of interest or of relevance to them. This finding parallels that of David Morley, who observed from his study of family television viewing that women were generally uninterested in news programming, preferring romantic fiction.[4]

Prospect women are aware that the content of their talk is gender-specific. Lydia Jacks, the former owner of the Prospect Telephone Company and unusual in regard to her interests, volunteered this description of it: "The telephone company not only took up a lot of my time, but it took me clear outside of a woman's realm. I have no association with women whatsoever any more. I'm not interested in clothes, I'm not interested in furniture, I'm not interested in making a beautiful house. I was interested in buying telephones and poles and wires and automobiles and trucks and seeing that my people were getting adequate pay for adequate time. I just don't womantalk anymore. You know what I mean."

This "womantalk" is a consequence of the social places women occupy and the activities they engage in, and not, as Lydia Jacks so clearly recognizes, a consequence of biology. Given similar social places and activities, the talk of women in Prospect is similar to that of

women elsewhere. Virginia Tiger and Gina Luria describe it as "that chastising, advising, chattering talk by means of which women join together to sew and mend and patch and stitch the seams of daily life. Womantalk is this hodgepodge, the colored afghan embracing the community that is women's own. What we think of as woman's gossip, girl talk, bitchery, old wives' tales, or chattering is, seen from the generic perspective, woman's wisdom: the subterranean lore of communal life."[5]

The talk of adult women in Prospect is primarily characterized as "visiting," which is considered acceptable if not carried to excess, and "gossiping," of which residents disapprove. The content of both types of talk is about the private sphere of domestic life and relationships. Deborah Jones describes gossip as "a way of talking between women in their roles as women, intimate in style, personal and domestic in topic and setting, a female cultural event which springs from and perpetuates the restrictions of the female role, but also gives the comfort of validation."[6] Karen Baldwin describes visiting:

> "Visiting" is a social and narrative occasion that can happen anywhere for brief or extended periods of time. In the gathering and telling of family information, which are the core performances of visiting, the exchanges are several and concurrent and reflect a pattern of the daily lives of women in their homes. A visit can be easily engaged and just as easily interrupted for the doing of other things. Like cross-stitch embroidery, or pieced-top quilting, or corn shuck rug-weaving, the artistry of visiting can be put down at any time a diaper needs changing, a quarrel needs unsnarling, or a batch of chicken needs turning in the oven. A visit can be picked up again after interruption without any loss of coherence, or it can be accomplished right along with the washing of dishes after a meal.[7]

Visiting, for women in Prospect, combines elements of all three definitions. It is about the domestic, private sphere and takes place within it.[8] It creates and maintains the relationships upon which families and the community are built. It breaks up the long days of widows and those who are ill or disabled while offering a diversion for those who are tied to duties of children, home, or farm. When asked what she was talking about with another woman, a woman is likely to say "We were just visiting." Visiting implies no specific topic other than its domestic orientation, and women generally consider it unimportant, though pleasurable and emotionally necessary, talk.

While visiting itself is an acceptable activity, it must occur within

specific boundaries or it is likely to be seen as a waste of time. To have a reputation as a visitor, for example, implies that a woman exceeds acceptable boundaries. In the days of telephone party lines women could acquire this reputation by tying up the line frequently. Despite the historic reputation women have in Prospect and elsewhere for talking too much on party lines, the women with whom I talked said their mothers had been too busy to talk much on the telephone. (Of course, the accuracy of their perceptions is subject to some question, since as children they may have been at school or more absorbed in their own worlds to make accurate observations.) Most women on party lines also seemed acutely conscious of the lack of privacy and the number of people who needed access to the line. As one woman who grew up on a farm said, "There were so many people on the line, you didn't want to monopolize the line." Her mother talked to two or three neighbors and her sisters, but she did not spend much time on any one conversation. "They always called back and forth, and they always knew how everybody was. . . . They made arrangements [to visit each other]." Another woman recalled that her mother did not like to talk on the telephone and during the Depression had wanted to have it taken out to save money. Her father had kept it because their farm was on a crossroads and the telephone was needed for emergencies.

Only two recalled that their mothers talked a considerable amount on the party lines. One woman who came from a very poor family recalled that her mother used to "talk and talk and talk" to her sister on the telephone. It may be, because of her already low social status, this woman did not share the same concern for reputation as the mothers of the others. While the others did not believe their mothers used the telephone to excess, they could all recall at least one woman who was called a talker on their own telephone line. This generally meant the woman was often on the telephone when they wished to use it. There was usually no resentment held against the woman if she was "good about giving up the line" (their phrase) when asked.

With private lines the definition of a talker has changed. She is no longer someone who ties up the line so that others cannot use the telephone; she is someone who ties up her phone partner by being insensitive to her partner's response to the conversation. She may repeatedly call a woman who does not like talking on the telephone; she may call more often than the woman prefers; she may carry the conversation on longer than the woman cares to or has time to talk; or she

may talk about things the woman is not interested in or considers inappropriate. Despite the privacy private lines would seem to afford, most women who have lived in the community a long time could volunteer the names of two or three women in the community with the reputation of being visitors. Two women repeatedly identified spend nearly all their time in their homes because of physical disabilities. A third elderly woman, also restricted in mobility, had died about a year before my visit to the community. As the community adjusted to her absence, residents became aware of the role she had filled for them. A close friend of hers said: "Nelly was our lady who knew everything that went on in town, everybody that was sick. . . . Nobody [does that now], nobody. And you don't have anybody to call if you want to know how Inez is or somebody else. She loved to do it. She wasn't very active after she had quit working. She had her phone right beside her chair and it was her day." Despite the irritation or amusement generated by these few telephone talkers, they seem to fill a vital role of providing community members with information about each other that gives the community a common sense of identity and keeps people—even if against their will—tied to its network.

Though talkers are readily identified, perceptions vary widely of what constitutes an excessive amount of time and number of calls. A woman identified as a talker by others said she talked only about six or eight minutes per call (the Prospect telephone system had at one time a six-minute limitation per call after which the call was disconnected, which might account for her unusual time estimation) and made only a few calls per day. Others described their own telephone use to me as much greater than this woman did, so her perception of her own calling might be too low, or other women may perceive it as more than it actually is. Two teenage sisters argued about who uses the telephone most. One accused the other: "She—honestly—is the one who is on the phone all the time." The other replied, "I'm hardly ever on the phone. Just to Cindy, and Brenda [with whom she dislikes talking] calls me all the time." Estimations of a woman's own calling seem to depend to some extent on the purpose of the calls and how much the call is enjoyed.

The talk of women who spend too much time on the telephone (in the opinion of others) is often characterized as gossip, which, unlike visiting, is considered a bad form of talk in Prospect—a form of talk a woman might attribute to other women's talk but not to her own.

Gossip is the term sometimes given to the talk of the small group of women who meet daily at the cafe. Though coffee klatsches were common at one time in women's homes in Prospect, homes are considered appropriate places for women's talk. The controversy involving the cafe, on the other hand, is about women's presence there as a group and about their talk in a public place.

About seven or eight women, mostly retired and widowed, gather at the same round table (one of the women refers to the group as the "ladies of the roundtable" but to most of the village it is the coffee klatsch) in the middle of the cafe at about 11 A.M. every day. For most of these women the opportunity to get together breaks up long and boring days and offers companionship and an opportunity to get out of the house. For one of the younger women, a farmer, it is her one break in a day-long, year-long grind of hard work on the dairy farm. She and her husband both come in for a coffee break at the time when their respective groups meet. For an older woman who is relatively new to the community, it was a way to meet people. The telephone is neither a substitute for nor a supplement to the kind of companionship she finds at the coffee table.

Some members of the coffee klatsch told me they are aware that not everyone in the community approves of their activity, but because of the importance of the activity to them, they were willing to face the disapproval. Some members of the community refer to the group with amusement and tolerance, but several women volunteered that they did not have time for the coffee klatsch at the cafe and indicated their disapproval. As one said, "I am not one to go down and gossip. I don't need that kind of therapy." One of the town's beauticians (whose business is itself a site for women's talk but does not, ironically, come under the same disapproval) said the women who talk at the cafe are criticized because others think they gossip: "And I suppose that it is a real gossip pit. . . . But so what, if it's good clean gossip. [Laugh] I think it's nice that women in Prospect have a place to go for coffee and to talk. The people who criticize them are probably envious. I don't know why they just don't join them."

The talk that does occur among the group in the cafe is similar in content to women's talk in other arenas; it is talk about their children, the weather, shopping, their memories, waiting for repairmen, cooking, hairdos, and favorite music, for example. A daughter of one of the

regular attendees said the women do not gossip, but if they did, it wouldn't matter: "Everyone knows everything anyway." On the days I joined the group, there was a studious effort to avoid even the appearance of talking about other people in a manner that might be characterized as gossip. Despite its innocuous content, this women's talk and not other talk is subject to disapproval. There are several plausible interpretations. First, talk is the primary purpose of the activity rather than a secondary accompaniment to other-directed gendered tasks such as church work, care-giving, and domestic work. It is, then, "idle talk" and a waste of time; it is also "selfish"—that is, done by the woman in response to her own needs, which threatens the community's definition of women. Second, the talk occurs in a public setting in a public manner—that is, it involves a group of women in a mixed-gender location. Consequently, the activity threatens the boundaries of public and private and threatens the division of spheres of men and women. Third, by continuing to meet in the face of disapproval, the women are publicly declaring their need for companionship and activity, inviting the interpretation that women's role and women's sphere are not completely satisfying or time-consuming. In this manner the coffee klatsch resembles the small "declaration of independence" that Janice Radway noted in the act of reading romances by some readers.[9] Each woman is making a claim for the importance of her needs. It is in some ways minor resistance to patriarchal meanings and allotments. It is also an ideological fault, a site where the social practices and meanings of patriarchy do not fit smoothly together, and hence exposes the limitations of and dissatisfactions with a patriarchal social order.[10]

Men's talk in Prospect is not subject to the same degree of scrutiny or to the same boundaries. Men meet in the cafe three times a day—at 7 A.M., 2 P.M., and 7 P.M.—for coffee and talk. They are primarily dairy farmers who come in after milking and retired businessmen and farmers. The member of the women's coffee klatsch who is a dairy farmer sits with the men in the afternoon on occasion. They are comfortable with her joining them because she is a farmer, she told me. She seems to serve as an "honorary man" in the men's group because she can talk men's talk with them.[11] According to the cafe's owner and a member of the women's coffee klatsch: "The men talk about anything that's in the paper from Halley's comet to the Summit. They try to solve the

world's problems. And they talk about fixing their cars and tractors. It'll be quiet next week when the men are all gone deer hunting. Then they'll have to come back and tell their deer hunting stories."

For several possible reasons, men do not experience sanctions against their public talk in the same way that women do in Prospect. In the first place, the content of men's talk—certain world issues and their work and activities—is seen as more important (because of their association with men), and hence their time is not seen as being wasted in discussing them (in fact, they can feel some self-importance because of their participation). In the second place, men are not expected to be constantly engaged in meeting the needs of others (in fact, they are more likely to be accustomed to having their needs met by others) so they do not experience guilt or disapproval for claiming their own leisure time. The differences women and men experience about their public talk is related to David Morley's report of how women and men feel about leisure in the home. For men the home is a place for leisure, where they can become fully engrossed in television programming that is more prestigious (news, documentaries) than the programs preferred by their wives. However, because the home is a place of work for women, wives feel guilty watching television without doing other things at the same time. They tend to be constantly supervising children, cooking food, and engaging in other household activities even while watching television. The wives in Morley's study rarely find the opportunity for guilt-free and totally absorbing pleasures.[12] It should come as no surprise that men's and women's talk, as a pleasurable leisure activity, should be as fraught with a double standard.

The double standard carries over into talk involving the domestic or private use of the telephone. Most women reported to me that their husbands, fathers, and boyfriends generally do not use the telephone for anything other than to conduct business or to get something done or arranged. Men are likely to have their wives make even these kinds of calls if possible. One woman remarked that her husband, like many men, "shies away" from the telephone, implying that men are uncomfortable with the intimacy of the phone. Another woman, whose husband is now dead, described her experience with men's telephone usage: "About the only time he'd [her husband] call you up was when he was half buzzed-up. [Laugh] He'd call you and visit. That's about the only time he'd call you up to really talk. I find that true of a lot of men,

though. They'll call you up when they get half-drunk, or pretty well, then they'll start calling us. . . . Maybe then they've got nerve enough to tell you something they wouldn't otherwise. [Laugh]"

If some or many men avoid the intimacy of the telephone, women may be attracted to it for just that characteristic. Ann Moyal's study of women's use of the telephone in Australia points out that the telephone's intimacy—perhaps induced through the close relationship of the voice to the ear and the absence of other cues or distractions—is precisely part of its appeal to women who use it for maintaining relationships.[13] Another factor in men's avoidance may be their awareness that telephone talk is work and a skill—involving initiating a conversation, making oneself understood in the absence of multiple cues, listening carefully, coordinating turn taking, closing the conversation—at which they are not particularly adept.

A few women reported that their husbands talk more on the telephone than they do; and two others reported that, although their husbands probably do not talk more than the wives, they are likely to call up their friends and spend time talking. Two of the husbands work out of town and are on the road, one as a truck driver and the other as an installer, so their interest in talking to friends on the telephone may stem from their lack of talk on their jobs. One of the wives said she did not think that her husband's talk with his friends would be called visiting, an indication that visiting is characterized by who does it as much as by what it is. She said, "He's got three or four buddies that he talks to. I don't know if it's visiting; he usually calls when he has something on his mind, but they talk for a long time." A daughter of the other said her father calls his "buddies" and they talk about hunting and truck driving for hours. Two other husbands were reported to initiate frequent calls to adult children living out of town, and a third husband was reported to talk to his parents frequently and for long periods of time. One woman said about her husband, "When he gets on it it's hard to get him off. I think he talks more than I do. . . . He calls his pals." Another said, "I go all day long and [don't] use the phone. Him, he'll come in and the first thing he's gotta do is sit down and make a phone call."

Though women's greater use of the telephone is often attributed to essential differences between women and men, Prospect women were quick to point out to me the connection between women's use of the

telephone and the greater amount of time they spend at home. In fact, among the women interviewed, I saw a correlation between a higher expressed amount of and need for telephone calls on the part of women who were more confined to the home. Ill health, small children, lack of transportation, old age, long-term illnesses of spouses or relatives, and full-time homemaking are the kind of circumstances that restrict women's movement and companionship.

When I asked a homemaker with grown children if women used the telephone more than men, she said, "Women definitely like to use the phone more, the reason being some women are home more alone and you call just for company." A woman in her thirties described how, when she was married, caring for her four young children reduced her ability, and eventually her desire, to even leave the house. The telephone was a "lifeline" for her, she called it, because it provided the only adult companionship she had all day long. Another homemaker with a preschool child and two in school, including a handicapped foster child, said she is tied to the house, and she uses the telephone to escape it. A woman who is now working outside her home said about her earlier days at home, "At home when you're not working and you're with the kids you want to listen to anything."

Another woman reported that her daughter—who lives in another state, who has had a second baby, and whose husband works the second shift so he can take care of the children during the day—calls home about once a week in the evening. She is lonely in the evenings at home with the children: "One day her dad was teasing her. 'You know, these calls in the middle of the week really cost you money.' 'That's all right,' she says, 'It's a lot better than going to a psychiatrist, a lot cheaper.' She calls home to talk to somebody, so it's easier to call home than to go to a psychiatrist and cheaper. [Laugh] Now when she calls in the middle of the week we say, 'This is your psychiatric call.' [Laugh]"

Women who are tied to their homes because of small children often rely on their telephone relationships with their mothers for advice and companionship. A retired woman said the telephone was important when she had little children: "I'd call my mother, I'd get upset. They'd [the children] have fever or colic or something and I would call and see what to do. [Laugh] And then sometimes she would come down. I talked to her every day as well as stopping by." Another woman volunteered that her mother had had a telephone installed for

her when she was first married and had a baby, so she could call if she needed help.

Women who live alone and who have health problems or disabilities sometimes find the telephone makes it possible for them to continue to live in their own homes. A woman in her seventies who has lost her central vision is still able to live by herself in a farmhouse because her friends and family call her and keep her informed. Another elderly woman gets several calls a day from friends who are checking to make sure she is all right, and she herself calls a friend daily to check on her well-being.

Other women reported that the telephone is very important to them for calling up friends when they are bored or lonely. Said one woman, often alone on a farm, "I think even to visit with someone, that is important. Your social well-being contributes to your mental and physical health." Said an elderly woman who lives alone, "If I get lonesome or just feel depressed I go to the telephone and just ring somebody." Another woman remarked, "Sometimes I look at the clock and think, my, this day is long." Then she will do something like bake five pies and call her grown children to come and get them. This woman can "buy" social contact with her children by taking up a traditional identity of caregiver/grandmother.

Not all women who are lonely or find their mobility or companionship restricted, however, find the telephone an important compensation. It is necessary first to have other women to call. One homemaker in her thirties observed that most of her friends work at outside jobs and are not home for her to call. A very elderly woman pointed out that most of her friends and relatives are dead, so she has few people left to call. One woman who has lived in the community only a few years and who has been laid off from her factory job for several months has no one in Prospect to call. All of her friends and family are long distance. While she was working, she found her companionship at work.

Obtaining companionship via the telephone, then, is not simply a matter of calling another woman at random and striking up a telephone friendship. The particular kind of friendship that is conducive to telephone talk must already be established or be established over time in an unspoken negotiating process over the telephone. This process was highlighted by a story related by a farm woman who was lonely and wanted to get to know a new neighbor better:

I called the young lady. She's the same age as our daughter, she lives on the first farm around the corner. I called her—this was a long time ago—because when this [other] neighbor remarried, we all got together and we had a potluck and took up a little collection and gave them a card and some money. And she had such a really good casserole dish. I thought that would be a good reason to talk to Nancy, and I called her and I asked her about it. She says, "I'm so busy right now I'll call you next week. I've got company from California." And she never did call me back. So I don't feel like calling her. I feel that if I call someone they should return my call, then if they don't, they're telling me, "I'm too busy."

A woman who says she is busy, as this woman did, may be saying she is uninterested in a telephone conversation or a telephone friendship.[14]

For the telephone to be of much value to those in need of companionship, it is necessary not only to have someone to talk with but also to have something to talk about. Another participant in this study, in her eighties and in very ill-health (she has diabetes and has survived a stroke and a mastectomy), says she is "stranded" in her house. Her husband is hard of hearing, so there is little talk and little cheer at their house. She was despondent when she said, "My cousin says to me, 'Why don't you call sometime?' But I don't have anything to talk about. I don't go anywhere. I don't think I even know what the names of the stores are downtown."

It is obvious from this woman's statements that in and of itself the telephone is not a solution to loneliness and confinement to the home. She has nothing to talk about because she has no activities going on in her own world and has no access to knowledge of the activities of others. In contrast to this woman are the few telephone talkers, also confined to their homes, who have created an activity for themselves—not talking on the telephone per se, but keeping up with the lives of other community members.

Those who do use the telephone for companionship and talk do not necessarily view it as an adequate replacement for face-to-face talk. Two farm women, one a German immigrant now retired and living in town and the other in her sixties and still living on the farm with her husband, talked to me about the loss of closeness among women that characterized earlier days. The first woman said:

I didn't use the phone very much then, just to talk to the neighbors. Neighbors visited back and forth then. We did a lot of that, a lot. More than now. Now you don't know your next-door neighbor. I don't know,

it's different those years than it is now. Cars, and they have more money now than they did then. I think that has a lot to do with it. I never was very much a visitor on the phone. I never used the phone very much for visiting. The neighbors lived closer together there. And if you live so long and so close together for years in the same neighborhood, you feel so close with your neighbors. I would rather run over.

My neighborlady lived on the hill and I lived right down in the knoll. She always baked doughnuts, and she'd bake a big bunch. She and her husband lived alone too, you know; he was a farmer. And when she was done—she broke her hip and she was kind of limpin', you know—and then she'd call me and she said, "I got the doughnuts done." I'd say, "All right, I meet you half ways." [Laugh] And I walked *up* the hill and she walked *down* the hill and we met in the middle of the road. And then people would drive by us with the car, you know, and they looked, what we were doing. We stood right in the middle of the road and visited for awhile. [Laugh]

The pleasure this woman derived from relating the story seemed to match the pleasure of those "stolen moments" between two women friends who could invent a pretense appropriate to their gender for meeting. A second woman also remembered how, in her mother's era, when only one family in the neighborhood had a telephone women would walk to each other's farms. "I think my mother just didn't think of the telephone. And no one else in the neighborhood had one. The ladies all walked, you know, . . . the women walked around on the roads; they would walk to the neighbors and go and visit. I don't even know my neighbors. I don't know who lives in these houses around here. The old ones who have been here thirty years, yes, I know them. In a lot of ways we were much closer, and we depended on one another much more. A mile or two was close. You just did a lot more walking. I really don't know why it's changed. People were closer; they worked together.

Farming was a smaller, more family-oriented way of life that drew neighbors together.[15] But, as this woman explains, when the community of Prospect changed from an autonomous center of economic and social life, so did the surrounding countryside. With these changes, farm women may have gained access to a larger world through communication and transportation but at the expense of their local relationships.

Other factors besides not having someone to talk with or something to talk about—cost, lack of time or interest, inadequate tele-

phone service, and husbands and fathers—enter into women's use of
the telephone, restricting or limiting their use of it. For example, the
cost of telephone service prevented the families of some participants
from having a telephone in earlier periods of their lives. These women
recalled that telephone service was not generally missed, however, be-
cause given the quality of service and the number of people on the line,
the telephone was considered an instrument for business and emergen-
cies rather than for social talk.

Usually at least one home in a neighborhood or among a group of
farms had a telephone that could be used if necessary. A farm woman
recalled the kind of circumstance in which they might use a telephone:

> There would have never been money for a telephone. There was barely
> enough for food. There was one telephone in the entire neighborhood,
> and that was the Irvings. They were an elderly couple with a real big
> heart, and if an emergency came up, you went up to the Irvings to use the
> phone—everyone did. And they were so kind about it. You didn't go
> unless it was really an emergency. I remember one time, before '35, there
> was a real bad storm. The weather got so black and dark. We had a
> screened-in porch, and Mother had the table set, and after the storm was
> over she had to throw everything out—the dirt just sifted in. The sky to
> the west was just dark. I remember her telling my dad, I'd like to go up to
> the Irvings to call to see if the relatives are okay, and she named her
> sisters. Well sure enough, the barn did blow on one of her sister's farms.
> So those were the things—an absolute emergency—everyone walked up to
> the Irvings to use the phone. I think my mother just didn't think of the
> telephone. Food was more important.

Another woman recalled that her mother was too busy on the
farm—washing clothes on a scrub board, caring for children, cooking
for hired men—to be able to have the emotional support she might
have derived from the telephone. Some of the older women I inter-
viewed, on the other hand, reported that their grandmothers, already
older when the telephone became widespread, never fully caught on to
how the telephone worked nor had any interest in using it.

Party lines, which were not completely eliminated by the Prospect
Telephone Company until 1980, also served to deter women's talk by
telephone. While some women may have enjoyed the communal na-
ture of the system and the opportunity to listen in on other conversa-
tions, sharing a line with up to thirteen in the country in the early years
and two to four in town and in the later years in the country kept

access to the line down and access to privacy impossible.[16] Even after the telephone became more common, it was still used primarily for "important" calls by most women, except those few who earned reputations as being talkers. One woman recalled that when she had a party line she felt guilty talking too long to her mother. Another said on a party line she was always conscious of the amount of time she spent on the telephone because she was aware someone else might want to use it. "It's nice now to be able to talk confidentially," said someone else.

Neither party lines nor the cost for basic telephone service is now a major impediment for having or using the telephone for most of the residents of Prospect, though the telephone office manager reported that recipients of government aid sometimes have their telephones disconnected because they are unable to pay their bills. I interviewed one woman who has been on government assistance most of her adult life. She has lived without a telephone most of that time because, she explained, social services will not pay for a telephone unless you are incapacitated. Only now has she had one installed because she is required to have a telephone for her new license as a child-care provider, but she is indifferent to having a telephone. It's "just another bill" and the telephone can be an annoyance. When she got telephone service, she asked for an unlisted number because she did not want to get what she called crank calls. "If anybody wants to talk to me they can come over or write me a letter," she said. Social service recipients may find privacy and anonymity desirable for wholly different reasons than those in other social and economic stratas.

Aside from the poorest members of the community, most Prospect residents now take for granted the necessity of having and paying for telephone service. However, long-distance costs do enter into decisions women make about to whom they talk, how often, when, and for how long. Some women reserve long-distance calls for emergencies and special occasions. One retired woman still recalls that twenty or thirty years ago she called friends in Florida on their golden wedding anniversary—a special call even now. Women with grown children living far away are more likely to make more long-distance calls, usually timing them to coincide with special rates in the late evenings and weekends. There is no simple correspondence, however, between amount of income and long-distance calling, as one might suppose. One of the wealthiest families in Prospect (in the very small class of

professionals) lives several states away from their families but is very careful about long-distance calling. Several widowed women call their grown children around the country frequently and find the money well spent on their emotional well-being. But another woman who does not talk to her children often said, "I feel that [the phone] is a place where you have to economize like everything else."

Husbands and fathers often exert control over telephone use by determining what calls should be made, who should make them, and when. Ironically, they do this even though men in this study generally avoid using the telephone themselves, placing the telephone in an unusual position as a technology in the home. In one sense it has become a domestic appliance, much like an oven or washing machine, operated by women as an extension of their other familial responsibilities. In another sense it is a "pleasure/information machine," like a television set or computer, more likely to be controlled by husbands and fathers.[17] The domestic appliance association of the technology may make men less inclined to be involved with its actual operation, but the power dynamics of women's and men's position in the family lead to the assertion of power by husbands and fathers over the pleasure, responsibilities, and interactions of their wives and daughters.[18]

In keeping with the greater social prestige accorded to men's activities, if men's business or professional needs require the telephone at home, they are likely to take priority over women's purposes for it. One woman, for example, reported leaving the telephone clear in the mornings when her husband receives calls for his business. Another woman in her late thirties and her two teenage daughters all restrict their calls when the husband and father is on professional call, and since he does not like telephone talking, the girls are required to limit their talking at other times as well.

A woman in her late thirties, who lived with her father until she married ten years ago, did not have a telephone until the mid 1960s because her father did not want to have one, "probably because he didn't believe in them, didn't believe in the extra expense." Her father told her the telephone was not there for "chitchat," like other people used it. "I got yelled at one time for talking more than a half hour to my cousin. My dad would have killed me for visiting on the phone."

An older woman, whose husband has been dead for several years, revealed that her husband limited telephone talk by being abusive to some of her callers: "He got mad if anybody called me up to visit.

[Laugh] He did. He thought they were nosy, trying to find out something, that's why he didn't like it. [Laugh] He wouldn't be too nice to some of them. . . . Boy, my husband used to get mad when [a woman with a reputation for being a visitor] would call up. I guess she thought he was too, she hasn't bothered me much."

Long-distance bills can cause conflicts between husbands and wives, fathers and daughters. When one woman moved with her husband to Valley City, she called her home in another town frequently. "My husband was real strict about it because he was the one who was paying for it." A woman in her twenties who still lives at home while she commutes to college said she does not make long-distance calls because "my stepfather has a fit. He doesn't like the bills." When her brother and his wife moved to another city, they argued frequently about their long-distance bills. His wife called too much, her brother thought. Her sister has now moved and she calls home almost every day. "I'd hate to see her long-distance bills. She'll call either my sister-in-law or mom, just to talk, and she'll have some dumb excuse like a cookie recipe or something that she thinks she has to ask about. But we all know that she just really wants to call to see what's going on. Apparently her husband must not really mind or otherwise I think she'd be in big trouble." It is noteworthy that this young woman *assumes* that a husband has the authority to determine his wife's calling practices and that a woman is inevitably subject to his wishes about them. Only one woman reported that she gets upset with her husband's long-distance calls. Though she would like to be able to call her family, who must be called long-distance, more than she now can, she is the one who watches finances carefully.

Some women do not enjoy talking on the telephone. They avoid it because it is not a form of talk they appreciate or because they consider it a waste of time. The woman whose husband got angry at her callers said:

I don't like to visit over the telephone. I just don't like to wind up my time talking for an hour or something like that. Some people do, but not me. In fact, I don't care about calling up anybody too much. I like to have it here in case I need it, but I just don't call up. I call people just to keep track of them, but not to visit. You're always apt to say something that gets you in trouble. They misinterpret what you mean. I'm that way; I don't explain maybe what I say. Some of 'em call me and talk a half an hour and I'd just like to put the receiver right down. They need to visit, I

suppose, tell you their problems. I'm not that way either, to tell anybody my problems.

As this woman demonstrates, the intimacy of the telephone is tricky to negotiate and work that some women, like many men, prefer to avoid. A married woman in her eighties said she disliked talking on the telephone so long that it interfered with getting work done. She approves of telephoning for a purpose but not "idle talk." Some women reported knowing women who hate using the telephone. Said one, "My sister hates the telephone; she hates to hear it ring. I hate to even call her. I suppose she uses it all day at work." Rather than irritate her sister with a call, this woman walks over to her house to talk.

Guilt may serve as an effective control limiting the telephone talk a woman might otherwise enjoy. A woman who babysits in her home while her children are in school finds that she feels guilty about the telephone calls she makes to her sisters and mother. She is embarrassed about talking too much on the telephone. Women use the phone more than men, she told me, because they are lonesome and need "just to hear another voice besides a child." Sometimes she will talk while doing dishes or clearing off the counter; then she doesn't feel as guilty: "Sometimes I'll save things to do and when I have to make a call I can get it done then."

Women who are very busy with paid jobs, farming, and volunteer work were most likely to tell me they do not have the time or the need to visit on the telephone. Women who talk a great deal during the day at work, for example, say they do not feel a need to talk at home in the evenings. A business manager who had stayed home with her children before going back to work said: "It used to irritate me when my husband would come home from the store at night and he wouldn't want to talk. Now I understand after you talk all day long, you don't want to talk. I used to visit a lot more, but now I'm not in the mood to listen to somebody talk about something I'm not interested in."

While this woman is not interested in making personal phone calls, she considers business calls altogether different. She places stock orders and solves service problems by telephone, finding it more effective. But personal calls are tiring to someone who must talk the lines of a salesperson all day. "You use your wits so much, you don't want to use them anymore," she commented. This woman understands that conversation and personal relations are hard work.

Another business owner said she is so tired at night she does not like to hear the telephone ring because it means she has to move off the couch to answer it. She is not in the mood for conversation in the evening: "I have a lot of that during the day. I talk and visit from six o'clock in the morning till two and then from four until six, so I don't have much visiting left in me after that." A farmer who goes to the coffee klatsch at the cafe said her day starts about 6 A.M. and she comes back in the house about 8 P.M. "When I come in at night I'm so tired, if there's something good on TV, I'd just as soon sit down and watch a show with my family," she said. One woman who works outside of Prospect during the day, however, is still interested in talk during the evening. Her job is not as physically exhausting as farm-work, and though she answers the telephone all day long at her job, her talk has been unrelated to home and community.

Women's actual and perceived use of the telephone in Prospect is not only related to the different form, style, and content of talk that is considered appropriate and natural for women, but it is also integral to the gendered work that women accomplish in the community. Women organize significant community activities, perform work for their husbands, maintain relationships among family and friends, and perform time-consuming and little-recognized care-giving roles via the telephone.

Women's community work on the telephone includes organizing church work, calling shut-ins, arranging meetings, coordinating lunches for funerals, and notifying organization members of activities.[19] A retired schoolteacher explained to me the kind of calling that gets done:

> We're given lists of names to call. My sister has a list to call of retired teachers when we have to have reservations in for our meeting. Someone in every area has a list of retired teachers to call. We meet once a month. And she might have ten names to call. There's a funeral here Wednesday, and she was a member of our church. So they're calling to get so many cakes from each church group and so many jellos from each group and probably two workers. Sometimes I have to do that. But usually the leader of the group does it. And then we have in the case of a very sick person or the critically ill we have a prayer circle. I have four people that I must call—we have a prayer list. We ask them to pray for that person that day. Every member of the church is on somebody's shepherd list and then we are on somebody's shepherd list.

This kind of telephone work can be extremely time-consuming for women (and it is done in addition to the work of making the food and serving it and the other responsibilities that accompany the activities being coordinated). Some women, particularly those already busy with children and jobs, get frustrated with the number of telephone calls of this kind they receive and make. Those with less to do, particularly the retired and those who live alone, find this telephone calling a satisfying activity. An elderly woman finds her calling for the American Legion Auxiliary to be a somewhat trying activity but one that gives her a sense of purpose: "I have to call all them girls. I got a whole list to contact them to come. I'm the one who's supposed to call. Once a month. And sometimes I don't get them and I have to try it again. The day I call I don't get much else done. I just call and call and maybe get it and maybe don't and I have to try it again. But that's my job and I'm supposed to do that. [Laugh]"

Women married to farmers and independent businessmen reported that the phone work related to business was usually relegated to them. One woman said the period of time in which she had this kind of work to do for her husband's livestock hauling business was time she had wished she did not have a telephone: "When we had our stock business here in Prospect I had to be in the house to hear the markets and then after the market, farmers would call and ask what the market was. That's how we got our loads. They'd call in and say they had a calf to go in Monday morning and I'd have to write that down. My daughter was a baby; I had a girl come in to help because I was on the telephone most of the time."

A farmer told about having to do all the farm-related business on the telephone because her husband did not like to use the phone: "He used to just shy away from the phone. A lot of men are that way. My son-in-law used to be that way. My daughter had to do all the calling."[20] They installed a telephone in an office with easy access to the outside, and he now can come right in and use the phone at his desk, which has improved his use of it. A retired farm woman said her husband used the phone a great deal when he was farming, but actually she meant the telephone was used for his business purposes—she did the calling. Another active farmer said their telephone is used for farm-related business over half the time. She usually finds herself the one making the calls. They have a two-way radio and several mobile

telephones, which save her a great deal of time trying to locate her husband or the hired help and coordinate farm activities.

Not all of the telephone work women do for men is related to business. Women recalled that their fathers often had their mothers make their telephone calls for them. As one said, "He always hollered for my mother to do it." Several women remarked that their fathers were "not particularly verbal" or were men "of few words," which seemed to them to explain why their fathers did not want to talk on the telephone.[21] One woman said her father, since retiring, now calls them on occasion. "I think he gets lonesome, too, not being around people like he was before," she said. Men, then, may be more likely to satisfy their need for talk on the job but may feel the same need to talk as women when they do not work.

Women reported that their own husbands, too, have them make telephone calls. One woman said although her husband enjoys talking to his friends on the telephone he does not like to make other kinds of calls. "A lot of times he'll say, 'You call. I don't want to get involved.'" She told me she thinks this is because he wants to sit down and relax in the evening and not be bothered with telephone calls. Many women reported they generally are responsible for answering the telephone when their husbands are home.

The calls women make for their husbands include calls to family members, based on the assumption in Prospect that women will be the more active members of a family in sustaining relationships.[22] One woman who said women do more work keeping up contact with family members commented, "It's supposed to be part of our job." A divorced woman said that in her marriage she was the social director. She was responsible for making telephone calls and sending cards to his and her family: "To even get him to sign his name on a card was hard." A young woman still living at home said her mother keeps "bugging" her stepfather to make calls, particularly to his mother, but he just puts off making them.

By far the most frequent telephone calls to family members are made by women to their mothers and sisters, indicating often very close relationships. Outside of the circle of their own wives and children, few men maintain such close bonds, even with their own mothers. Mothers-in-law can present a special case of obligation for women. One woman told me her mother-in-law insisted on talking to

her every day on the telephone. An elderly woman recalled how she
had been the mediator between her husband and his stepmother, who
did not get along. She had to use her parent's telephone to call her
mother-in-law every evening:

> I was supposed to keep in touch with his stepmother, who lived out in the
> country two miles. She lived out there and she never was very well and she
> was one of these people who wanted a lot of attention, so I was supposed
> to call her every evening. That was his stepmother and they didn't even
> talk part of the time. I was the peacemaker and a go-between. I would go
> over to my parent's house to call, but she had no sense that it was bother-
> ing me—I was working and maybe I'd hurry supper and leave the dishes
> and go over to father's. My father used to scold because I'd be at the
> phone so long, but of course it wasn't me that was talking. Everybody
> knew that this stepmother-in-law was an awful talker. I went through
> many a supper in agony trying not to be on my folks' phone too long and
> still appease her. . . . I wonder now why we inflict ourselves with such
> things.

Maintaining relationships with their own mothers is a pleasure
and a comfort for many women, but it, too, can become obligatory
work. Mothers who have little to do or who are elderly or unwell can
require regular and lengthy telephone attention. "I get a lot of calls
from my mother," one woman said. "She gets lonesome and I'm the
only kid who isn't long distance. And she doesn't like to make long-
distance calls." Another woman whose mother is long distance is ex-
pected to maintain weekly contact: "She *waits* for that call *every* Satur-
day. And if I don't call . . . My sister-in-law's birthday party was on a
Saturday—they had an open house for her—and we didn't get home
until 5:30, 6 o'clock. The phone was ringing when I walked in. My
mother said, 'Why didn't you call this afternoon?' And I said, 'I told
you we were going to that birthday party this afternoon.' 'Oh, I for-
got,' she said. She depends on that call."

Those who are themselves mothers of adult children vary in their
own calling pattern to their children. Those who are financially com-
fortable call children who are long distance more frequently than
those in the lowest income range. Those with less income are more
likely to expect their children to call them. The woman whose mother
calls her frequently because she is the only child who is not long dis-
tance expects her daughter to call her from the east coast. She said, "I
figure I supported her phone calls for a long time and they can afford

to pay them now." The woman whose mother expects her to call every Saturday has a son and a daughter in other parts of the country. She does not expect to be able to talk to her children as often. She talks to her daughter in another part of the state about every three weeks. "The children are good about calling, and I don't expect them to call oftener." A woman who has lived alone since her husband died views the telephone calls she exchanges with her two adult children as an important form of emotional support for all of them.

Telephoning functions as a form of care-giving. Frequency and duration of calls (in addition to the significance of content) demonstrate a need for caring or to express care (or a lack of it). Caring here has the dual implication of caring *about* and caring *for*—that is, involving both affection and service. It is through their care-giving work at home and on their jobs—taking responsibility for the emotional needs of husbands, children, the elderly, the handicapped, the sick, and the unhappy—that women occupy their place in society.[23] While this role has been little recognized or valued, the caring work of women over the telephone has been even less noted.[24]

Women not only do much of the care-giving work of family relationships that involves making telephone calls, they also make calls to friends and other community members to make sure they are well and safe, to cheer them, to remember their birthdays and other special occasions, to draw them into the life of the community. But calling itself is not the only work involved in telephone care-giving. Listening to others who need to talk is also a form of care and a form of work.[25] Women frequently explained to me that they spend time listening to the talk of other women on the telephone when they do not have the time or the interest for it. They do it, nonetheless, because they feel the woman needs or wants to talk (or because they cannot find a way to extricate themselves from the conversation). One elderly woman still very busy with volunteer work outside of her home put a bird feeder outside the window by her telephone so that she can watch the birds when she has to spend time with these phone calls. "I don't visit, I just listen to others," she said. A full-time homemaker with children at home said it seems she gets these phone calls when she is the busiest and something needs to get done: "When a friend calls and wants to chat, I don't really want to say, 'I can't talk, I'm cleaning the bathroom,' but you really want to clean the bathroom floor!" Another busy older woman sees it as an obligation—perhaps a Christian duty—

to provide the service of listening to people who need it because they are elderly or shut-in.

Women in Prospect use the telephone, then, for maintaining relationships with family and friends, for accomplishing the ongoing structure of the community, for giving and receiving care and emotional support, and for doing the business work that enters the private sphere. This occurs because belief and practice about women's talk and women's appropriate sphere feed into each other in a complex cycle. Women's use of the telephone is work that derives from meanings of gender that locate them in a particular configuration of social and economic power relations in their families, in their community, and in the larger political order. It is work that then expresses and puts those meanings into practice and hence is seen to confirm them. Women's use of the telephone, consequently, can be seen as a form of talk that is both gendered work and gender work.

NOTES

1. Rakow, "Rethinking Gender Research."
2. Pamela Fishman, "Interaction: The Work Women Do," in *Language, Gender and Society*, ed. Barrie Thorne, Cheris Kramarae, and Nancy Henley (Rowley: Newbury House, 1983), 100.
3. See Paula Treichler and Cheris Kramarae, "Women's Talk in the Ivory Tower," *Communication Quarterly* 31 (Spring 1983): 118–32, for other research that reaches the same conclusion.
4. David Morley, *Family Television: Cultural Power and Domestic Pleasure* (London: Comedia Publishing Group, 1986), 162–63.
5. Virginia Tiger and Gina Luria, "Inlaws/Outlaws: The Language of Women," in *Women's Language and Style*, ed. Douglas Butturff and Edmund L. Epstein (Akron, Ohio: L & S Books and University of Akron), 2–3.
6. Deborah Jones, "Gossip: Notes on Women's Oral Culture," in *The Voices and Words of Women and Men*, ed. Cheris Kramarae (Oxford: Pergamon Press, 1985), 194.
7. Karen Baldwin, " 'Woof!' A Word on Women's Roles in Family Storytelling," in *Women's Folklore, Women's Culture*, ed. Rosan A. Jordan and Susan J. Kalčik (Philadelphia: University of Pennsylvania Press, 1985), 154.
8. Therefore it is not just the content that makes women's talk distinct from men's. This point was clearly made at one of the daily senior citizen's noon lunches in the basement of the Methodist Church. Although in Prospect

the sharp differences in women's and men's interests may fade in old age, differences in styles of talk remain. While seated at a long church table eating lunch, a recently widowed man who was learning to cook began to loudly proclaim a recipe for "tater tot hotdish," to the privately expressed amusement of most of the women. A woman simply would not have done the same thing.

9. Janice Radway, *Reading the Romance: Women, Patriarchy, and Popular Literature* (Chapel Hill: University of North Carolina Press, 1984).

10. Dale Spender notes that there is a widespread belief that "woman talk" is dangerous and that it is "quite reasonable to classify woman talk as dangerous because the whole fabric of that [patriarchal] social structure could be undermined if the expression of the subordinates were allowed free voice." Dale Spender, *Man Made Reality* (London: Routledge & Kegan Paul, 1980), 106.

11. Interesting discussions of how women can be let into the public sphere as honorary or fictive men can be found in Shirley Ardener, "Ground Rules and Social Maps for Women: An Introduction," in *Women and Space: Ground Rules and Social Maps*, ed. Shirley Ardener (New York: St. Martin's Press, 1981), 11–34; and Linda Imray and Audrey Middleton, "Public and Private: Marking the Boundaries," in *The Public and the Private*, ed. Eva Gamarnikow, David H. J. Morgan, June Purvis, and Daphne Taylorson (London: Heinemann, 1983), 12–27.

12. Morley, *Family Television*, 147.

13. Ann Moyal, "The Feminine Culture of the Telephone: People, Patterns and Policy," *Prometheus* 7 (June 1989): 15.

14. This story matches one about the telephone talk of Hungarian immigrants. One of the women, Mrs. Kováks, had once called another woman who had cut her short, saying she was busy baking a cake. Mrs. Kováks did not call her again, concluding the woman did not want to talk to her since she had met the same excuse from the woman a month earlier. Linda Dégh, "Dial a Story, Dial an Audience: Two Rural Women Narrators in an Urban Setting," in *Women's Folklore, Women's Culture*, ed. Rosan A. Jordan and Susan J. Kalčik (Philadelphia: University of Pennsylvania Press, 1985), 3–25.

15. It must be remembered that these women lived on dairy farms, which are generally much closer together than grain farms or beef ranches. Women on other types of farms have their own stories to tell.

16. Martin (" 'Rulers of the Wires?' ") makes the argument that Canadian women may have benefited from and enjoyed party lines in ways unforeseen and frowned-upon by the telephone industry. Though a few women in this study expressed a nostalgia for party-line and operator days, women were by and large relieved to be off party lines when the time came.

17. In David Morley's study husbands were more likely to control televi-

sion remote controls and video players, while controlling what was watched and when, and wives were much less likely to even manipulate the television set. Morley, *Family Television*, 36.

18. Feminists have been examining these power relations with important new insights about the family. See Barrie Thorne (ed.) with Marilyn Yalom, *Rethinking the Family: Some Feminist Questions* (New York: Longman, 1982).

19. A similar use of the telephone for coordinating volunteer community work is briefly described by Arlene Kaplan Daniels in her study of upper-class urban women (Daniels, *Invisible Careers: Women Civic Leaders from the Volunteer World* [Chicago: University of Chicago Press, 1988], 200).

20. It is remarkable that men are not said to be afraid of technology, as women are said to be, when men clearly avoid technologies intended for or associated with women (telephones, washing machines, curling irons).

21. What is called men's inexpressiveness can be a form of men's dominance. See Fishman, "Interaction: The Work Women Do," and Jack W. Sattel, "Men, Inexpressiveness, and Power," in *Language, Gender and Society*, ed. Thorne, Kramarae, and Henley, 119–24.

22. This finding supports the discussion of women's kinship work found in Micaela Di Leonardo, "The Female World of Cards and Holidays: Women, Families, and the Work of Kinship," *Signs* 12 (Spring 1987): 440–53.

23. Janet Finch and Dulcie Groves, eds., *A Labour of Love: Women, Work and Caring* (London: Routledge & Kegan Paul, 1983); and Clare Ungerson, *Policy is Personal: Sex, Gender, and Informal Care* (London: Tavistock Publications, 1987). Arlene Kaplan Daniels demonstrates that the volunteer activities of upper-class women constitute "sociability work" that is an unrecognized form of women's labor. Daniels, "Good Times and Good Works: The Place of Sociability in the Work of Women Volunteers," *Social Problems* 32 (April 1985): 363–73.

24. The fact that I am calling much of what women do with the telephone "work" does not dismiss the pleasure some or even many women may feel using the telephone. Men, too, often enjoy their work, but we acknowledge what they do as valuable and useful labor rather than assuming it to be a natural characteristic that simply accompanies their personalities, as is usually assumed about women.

25. Dale Spender notes that little research has been done on listening, a form of interactional work particularly associated with women and perhaps as complex and important as talk. Spender, *Man Made Language*, 123–24.

3

The Telephone and
Women's Place

Women's use of the telephone in Prospect is related not only to
women's talk in general—the purposes it serves, the work it accom-
plishes, and the restrictions and constraints placed on it—but also to
their physical and social location. As I came to know the community
and its residents, I came to understand that in Prospect women occupy
different spaces than men and even occupy the same spaces differently.
The tavern and the beauty shop represent examples of the different
spaces that men and women occupy; the men's and women's coffee
times in the cafe represent examples of how occupying even the same
space has different meaning and different consequences for women
and men. Understanding women's space in Prospect is a key to under-
standing women's place.

Perhaps the telephone has in some manner affected these spatial
relationships; social commentators and social scientists have fre-
quently described the telephone as a mechanism that transcends space
and time, and levels social hierarchies, making everyone equally acces-
sible and giving everyone equal control over space and time. If true,
these are promising possibilities for women's place.

Did the telephone transcend women's traditionally limited access
to other people and mobility to other places? Unfortunately, these
egalitarian claims for the telephone were not substantiated by my stay
in Prospect. The complex factors that affect who talks to whom,
where, when, and how long, discussed in the previous chapter, demon-
strate that social leveling of gender through talk has not occurred as a
result of the telephone. Moreover, although the telephone has the tech-
nical capacity for making all points in space equidistant for everyone,

this capacity is not realized in social practice. Control over space and time is a privilege that is not equally available.[1] In Prospect, women's use of the telephone is intimately connected to their restricted control over their own location and mobility, so that their telephone use is a *consequence* of social hierarchies rather than a solution to them. That women have actively put the telephone to their own uses to deal with the contexts in which they find themselves speaks more of their own creative initiative rather than of any liberating function inherent in the technology of the telephone or in the intentions of the industry's developers.

There are several ways that Prospect women occupy spaces differently than men. First, they are less likely than men to determine where they and their households will live.[2] Their husbands' preferences in location and occupation often bring women to Prospect, keep them there, move them away, and determine the kind of life they lead and its rhythms, though this of course does not mean they are necessarily unhappy about the choices or do not accept the decisions. For these women the telephone may or may not serve as some compensation for their separation from friends, family, and familiar places or as a means for creating new ties, but by and large they do not view the telephone as an equal substitute for seeing or living among those who have been left behind. Even if the telephone did make all points equidistant and of equal value for them, as has been claimed, we must consider that the point from which these women are starting is not necessarily of their own choosing.

The most dramatic kind of separation from old ties that both women and men experience results from immigration from another country. Two women in this study were brought to this country by their husbands. One, a Swiss immigrant who followed her husband-to-be to the state after he sent for her, never saw or spoke to her mother and father again after coming here. She came in 1922 at the age of twenty-two, not fully realizing what the distance and the separation would mean:

> I thought going to New York was like going to Valley City. I was young, and I didn't know. I only had one suitcase. I squashed everything in, I squashed my wedding dress. I said I can always iron that when I get there. I said I can always make clothes for myself. I had a nice great big doll. My mother said, "You've just got to take that with you, you've had that since

you were a baby." I said, "No, I'll come back in five years and then I'll take it along . . ."

I had said to Mother I would send a telegram when I got to New York, but I couldn't talk to nobody so I couldn't send a telegram. But I wrote a card. She wrote to me all the time, "I wish to be a bird, so that I could come over." I wrote to my mother all the time and said I'm all right and what I'm doing. It took two, three weeks before she got them letters. There was no airmail. I had a sister who wanted to come here and I said, "Oh, no, I don't want you to break my mother's heart. I did and nobody's going to do that like I did." It was so terrible. No telephone. I couldn't send a telegram. So I wrote to her and tried to get over it, but then fifteen years later she passed away and I never saw her.

Neither she nor her mother had telephones, but even if they had, it is doubtful that this woman would have used the telephone to speak to her Swiss family. She did not call Switzerland until 1980, when a visiting Swiss nephew showed her how to dial directly overseas. Though transatlantic communication and travel were common among certain classes of people during the years of her separation from her family, her lack of autonomy related to her struggle to survive, her lack of education, her unease with English, her social status, and her gender kept her a lifetime apart from them.

The German immigrant moved to the state in 1925, when her husband lost his job on the railroad during Germany's depression. "My husband decided to go," she said. "I didn't want to go. Good promises brought us here." She left her parents and two brothers behind and never saw them again. Though she had a telephone while she was here, her family in East Germany—even those who are living now—has never had one. She never returned to Germany, initially because she did not have enough money, eventually because she could not go to her home in East Germany.

It is only recently in Prospect that the telephone, combined with the automobile and airplane, have made family separations no longer a lifetime sentence in which a move elsewhere meant a high likelihood of never seeing those family members again. Some married couples now make frequent automobile trips to visit grown children and other relatives, while a few widows fly. (Most trips are to visit family, not to sightsee, and if a husband does not like to travel, the couple generally does not travel.) As important as visiting is the telephone contact with family members around the local area and around the country. Women

generally take on or are given the work of giving the family a sense of connectedness across generations and space, keeping up regular contact with mothers, sisters, aunts, nieces, and nephews, as well as with their own children. Frequency of contact might range from daily to annually, subject both to geographic and emotional proximity to the relative as well as the amount of money a woman feels she can spend on long-distance service. The calls these women make and the letters and packages they send literally call families into existence and maintain them as a connected group. A woman who talks daily to her two nearby sisters demonstrated the role women play in keeping track of the well-being of family members and changes in their lives. She said, "If we get a letter from any of them [the rest of the family] we always call and read each other the letters." Family crises—accidents, divorces, illnesses, and deaths—sharply increase the contact.

Despite the work of women to keep families together across the span of time and space and the less severe consequences of relocating in more recent years, moving can still be a painful experience, particularly for women who do not want to leave their family and friends. Some women in Prospect are in the community because of job and location decisions made by their husbands. One woman has gone through two traumatic moves across the country for her husband's career. Though she came to love both places to which they moved, she was miserable both times she was uprooted. She said: "I wasn't an easy mover to Massachusetts. After I got there I liked it. I wasn't easy to move out here, but after I'm here, I like it. [Laugh] We went where 'father' did. He said we're going to and we did. I had all kinds of excuses, but they didn't work. [Laugh] Everything falls into patterns [later, but] it's upsetting at the time." Fortunately, neighbors and Methodist church members (they joined the Methodist church) called and visited immediately, making the transition easier.

When another woman's husband was sending out job applications early in their marriage, she agreed to move where he found a job he wanted. When he chose Prospect, she said, "he practically had to sign in blood that we could go home every weekend." She called home frequently and still calls her parents once or twice a week. When she first moved: "There was no one in town I could call. I knew no one. I was so used to my family being all around me before, it was really a hard time. I really lived for being able to make a phone call, but of course, then thinking, shoot, they're all long distance." Another, who

left her mother and sisters a state away when her husband changed jobs about fifteen years ago, said she seldom talks to them now. She called home frequently at first—had a high long-distance service bill—but she said she "got used to it" and her calling dropped off.

When I asked the only black woman in Prospect why she lived in Prospect, she said, "Don't ask me." After she and her husband got back together after a separation, he decided he wanted to live in Prospect and buy a house. She said: "I just live here. It's a place. I think it would be nice if I did have more friends here but there aren't a lot of ways to meet people. I'm kind of a loner anyway, so it really doesn't bother me. I like being alone." This woman has little social contact with the community, in person or by telephone: "My phone doesn't ring sometimes all day and all night." Her family all lives long distance, and because finances are restricted, she has limited opportunity to talk to them. She knows she does not want to live in Prospect permanently, so she is not against her husband's interest in moving to another state because it might be closer to their families.

A woman married to a high school administrator followed her husband's career moves over a dozen times. Moving around was difficult, she told me, and if she could have made the decisions, she probably would not have made the moves. She did not make most of the decisions about the shape and direction of her own life.

A woman who has owned and managed her own business for the past few years said she will probably eventually give in to her retired husband's desire to move to a different part of the state. His decision to move brought them to the area in the first place. Though she does not want to leave her business or the people of Prospect, she said it should be husbands who make these decisions: "I feel he's spent thirty years at the plant and now retiring and if he wants to move he should have it." Her business is a silly thing to stand in the way, she said. Because of the greater economic power of men in the marketplace and the greater value placed on their work, the power they exercise in the family seems by women such as her to be a natural and justifiable exchange for their husband's "greater" contribution and sacrifice made to the household.

Other women live in the houses they do and are in the occupations they are because of their fathers or husbands. Four women in this study, for example, still live in the houses built or bought by their fathers or their husbands' fathers. Another woman lives on the farm that has been in her husband's family since 1870. Marrying a farmer

almost always carries the stipulation of becoming a farmer and living on a farm. A woman in her thirties explained she intended to marry a professional man with a college education, but the man she happened to meet and fall in love with was a farmer. As a consequence, she lives on a farm and is an active farmer herself. She and her husband also farm his parents' land, a further example of how space is patrilineal in Prospect.

Connections and sense of place can be seductive for women, however, and women's autonomy can be short-circuited by their unwillingness to give up the security of the familiar. A woman in her early twenties, living with her parents and passing time until she and her boyfriend marry, said she wants to continue to live in Prospect, explaining: "'Cause I've lived here all my life, and I don't want to move away. I don't know anybody. This is where everybody comes on the weekends and I don't want to miss out on anything." This woman's relationships with family and friends—whom she sees as initiators of activity of which she wants to be a part—indicate the extent to which many young women in Prospect (with the exceptions of Kristin and Ami, whose interview appears in the next section of this book) do not see themselves as initiators of what happens in their lives nor as at the center of importance.

Another woman said her husband had wanted to move to the western part of the country, but she would not leave Prospect. Now, divorced, she hopes she will eventually have the courage to move somewhere else where she would be less dependent on the opinions and emotional support of her family. In other words, control over a woman's place and destiny may be commanded by the men in her life or by her insecurities (and because of the economic deprivation and physical violence a woman may experience, insecurities are not necessarily unrealistic). The unknown and unfamiliar are more likely to constrain the autonomy and mobility of women than men.[3] The pull that some women feel between their desire to see and experience more of the world versus the comfort of the secure and familiar was expressed by this same woman, who grew up not far from Prospect and who has traveled very little. She sometimes daydreams about traveling across the plains in covered wagons. Though she likes being what she calls settled down, she is attracted to that time period because of the adventure and the possibility of seeing new things and new places, "wondering what it's like on the other side of the hill."

Even in Prospect women's mobility is more restricted than men's. Lack of transportation, lack of money, lack of employment opportunities, fear, and the restraints brought by age, disabilities, and caring for others keep women within a closer proximity of their homes than Prospect men. The village of Prospect has no public transportation: it no longer has rail or bus service between cities, and it has no taxicabs or city buses. Besides walking, the only means of transportation around and out of Prospect is the private automobile. Ironically, as transportation options have narrowed, the need to go farther and make more trips (for school, visits to doctors and dentists, shopping, repairs, and the like) outside of Prospect has greatly increased. The telephone has become an important means by which Prospect women coordinate their work across time and space so that the most can be made out of each local trip from home. Most younger Prospect women have access to a car on a regular basis, but caring for small children and doing domestic work keeps them close to home and makes wise planning important.

Elderly women, who may have fewer responsibilities and more time, unfortunately often have less opportunity to get out and around. They generally must count on the rides they are offered or request from others. Fortunately, Prospect women who are active in the community are considerate of the needs of their friends for rides and routinely serve as community chauffeurs. However, for those who have been accustomed to greater mobility, not having control over their travel can be a very real deprivation. An elderly woman who does historical research at the library and historical society in Valley City finds it very difficult to arrange for a ride that allows her the freedom of a full day's research. One elderly woman who could no longer drive safely sold her car because keeping it in the garage would be too much of a temptation for her. "There are days I miss it like the dickens," she said. Another woman who is losing her sight and hearing said: "I don't think anybody can really understand what it feels like to sit there and have the car sitting out here and I can't go out and get in it and drive. It's like if you take a little animal and put him in a cage. That's about the way you feel." Asking for a ride or for any of the other things that have been taken for granted can be hard on a woman's sense of dignity and autonomy, as she continued to explain: "My children say, 'If you need something, call me.' I don't do that. I would rather they would say is there something you need or something I can do for you. It's

hard to ask when you've been doing all of it. That goes with growing old."

Though restrictions on mobility caused by age and disability are not unique to women, in Prospect more women than men live to old age, and women are less likely to be drivers. (In at least one case, an elderly widower continues to drive his car and give rides to elderly women, despite his own infirmities.) Women whose husbands are living may travel long distances by car when their husbands drive, but if their husbands die, they may cease long-distance traveling or fly instead. In these cases, widowhood may actually increase the number and frequency of long-distance trips (because they have more control over money and they find traveling emotionally important) but decrease local mobility. This pattern is illustrated by a woman who has become disabled because of a loss in eyesight. She is unable to drive and gets around the local area less frequently, but she travels more by plane and makes more telephone calls. The meaning of distance for her has changed dramatically. Her children—even if they travel to other parts of the world—are as close as the telephone, but without a ride from a friend, the church might as well be halfway around the world. Fortunately, this woman has good friends and sufficient income to make distance irrelevant and to give her the mobility she wants.

Not all women share the same fortune. Another woman, who recently moved to Prospect and has adult children living in other states, is acutely aware of distinctions in distance. One child lives six hours away and one, three days, both by car. She and her husband drive rather than fly to see their children. Where she lives in relation to her children significantly affects how often she can see them. An elderly woman had her first airplane ride the year I met her. The plane ride was a gift from her daughters, who fly her out to visit them. Her lack of income and of a network of friends means that even going downtown is a major trip.

Women who care for small children or for others who are ill or disabled often experience restricted mobility. Older women in particular reported various time periods of their lives when they were tied down by the long-term illnesses of their husbands, parents, brothers and sisters, and children. One woman cared for her husband for three years before he died. She got out of the house only when her sisters-in-law came to take her grocery shopping. Another woman's children had severe allergies when they were young, so she could not take them

with her and she could not leave them in anyone else's care (and she could not drive until she was thirty-two). She missed family gatherings and holidays. "I couldn't even go to my grandmother's funeral," she told me. In such cases of restricted mobility, the telephone provides not only companionship but also a means for overcoming problems of distance. Because there are so few business and medical services available in Prospect, women use the telephone for arranging home-business transactions and calling for information, reducing the number of business and medical trips they have to make.

Women's sense of place—their feelings about their homes and community—is affected not only by their choices or lack of choices about where they will live and when and if they can move about, but also by their sense of security and safety. While I have already cited an example of a woman who feels secure in her home of fifty years, not every woman experiences her home as a safe haven. For women subject to physical or emotional abuse from their fathers or husbands, the home is certainly not a secure haven.[4] The incidence of abuse in Prospect was impossible to determine from this study. However, in two cases there were indications that the women, now widowed, had been in unhappy marriages with husbands who drank heavily. In another case a woman described how, when she was living in another city, her husband had threatened her with a gun. She used the nearest public telephone booth to call police, and she called a local women's crisis center, where she spent the night. In gratitude for the help given to her when she had nowhere else to turn, this woman now serves as a telephone volunteer for a crisis line in Valley City.

Several women expressed to me their fears of being alone in their homes. One farmer, whose husband was away on business when she was interviewed, even hesitated to set up the interview when she was called because of her reluctance to have a stranger in her home. She talked about her fear of being alone in the country—a fear that developed after their house was broken into six years ago:

> That's why my husband didn't want to be gone. "Are you sure you're going to get along all right? Should I call home?" [Laugh] He's not gone very often, this is very unusual. The last time I stayed alone was when he was in the hospital. I wasn't at all afraid last night; I'm probably getting over it, but after your house is broken into, I tell you, it takes a long time to get over it. If you leave anything outside, it's gone. We *never* used to have that, *never*. My neighborlady, she was in bed—she's past eighty, I go

to homemakers with her, she's such a nice person—she could hear some-
one knocking at her back door. She wouldn't get up and answer it be-
cause she's afraid. Then she heard the dining room door, then they came
to the north door, and she heard it open. Then she called, "Who's out
there?" They left, just like that. They were in the house. They could have
killed her; they could have *raped* her! You know! It just scares me to
death. I'm not anxious to stay alone. When he was in the hospital, I was
really upset.

In contrast, when her father died over twenty-five years ago, she and
her husband came home to find that their neighbors had brought a
kitchen-full of food while they were gone. "We never locked our door.
My husband always said after that, 'Don't lock the doors because
people bring you things!'"

The other women who expressed fears of staying alone are women
in their teens and twenties. One lives with her parents while she waits
to get married to her boyfriend, who is a trucker. For a time she
received annoying telephone calls from someone who did not say any-
thing when she answered. She expressed a concern about staying alone
when he is on the road after they are married: "I'm a chicken when it
comes to staying alone. If it's a nice house I won't be scared. But if it's
an old house, I'll probably have someone come and stay with me or
stay over here."

Her association of fear with old houses indicates her familiarity
with an icon of popular culture in which women are vulnerable to
terrorization and attack. Two teenage sisters, who live about a mile
from Prospect, share her familiarity with these cultural stories that
keep women in their place. They talked about their fears of violence, at
home or elsewhere. They are alarmed by annoying telephone calls,
associating such calls with the possibility of assault. One of the sisters
said, "If I got a call like that when I was babysitting, I'd be really
scared. Some people just do that to find out if you're home or not."
Neither like being home alone or without their parents. From their
parents and elsewhere (movies in particular), they have assimilated
messages that they are always vulnerable unless under the protection
of a male guardian—boyfriend, father, husband. Such messages inten-
sify women's economic and emotional dependency on men and justify
men's greater social status. Even when the power relations of the fam-
ily do not include overt acts of physical violence by husbands and

fathers, the implied threat of unknown terrorization to all women can still make women's own spaces seem dangerous.

Clearly, women's location and mobility are affected by the men in their lives, access to travel and means of communication, and security and safety. The telephone is related in a complicated way to women's location and mobility. It is not a substitute, but it may help compensate for the separation from familiar places and faces left behind, and for mobility restricted by lack of access to transportation and by caregiving and disabilities. It may help ease the fear and danger some women experience, yet it may in part be responsible for the fear. These observations suggest that, indeed, these women do occupy spaces differently than men—they are in them for different reasons and experience them differently—and they occupy different spaces as well, for restrictions on their location and mobility further define their physical and, hence, social place. In Prospect spaces that women occupy constitute what can be conceptualized as a private sphere, and those that men occupy, a public sphere.

The concepts of public and private to describe men's and women's differential social places have been useful for feminists.[5] In feminist thought the private sphere is generally considered the undervalued and restricted domestic life of women in contrast to the higher status and more powerful world of men's politics and economics. Arising out of nineteenth-century thinking about new roles for women and men, the concepts refer to a relationship between women and men presumed to be the natural and ideal one, which in some cases became a self-fulling prophecy. Of course, not all women stayed in the domestic sphere nor were they expected to. Women of color, for example, have had a consistent representation in the labor force, while the participation of white middle-class women has fluctuated in various time periods. Men of color, on the other hand, have not had the same access to the public sphere of politics and economics, which remains largely a white and male realm of activity and power.

As an almost exclusively white community, Prospect represents a case where the public and private ideal has become a structural—if shifting—backdrop regulating the places of women and men. I have already pointed out that women's talk in Prospect is confined to the private sphere of domestic responsibilities and relations and, except for the ambiguous and controversial site of the cafe, occurs in private

settings, such as over the telephone or in homes. The concepts of public and private are further useful as a way of understanding how spatial and definitional places of women and men have shifted and are continuing to shift over time. The telephone is implicated in an interesting way in women's creative efforts to bridge the gaps created by this shift.

The private sphere in Prospect can be characterized as a combination of place, responsibilities, values, and orientation. Women's restricted mobility accounts in part for their location in this sphere, because the private sphere is more local in focus. Jos Boys has pointed out that women tend to lead a more local existence not only because of domestic responsibilities but also because "the physical patterning of space and activities supports, perpetuates and 'naturalizes' the difficulty of getting beyond the local neighbourhood."[6] Because women are seen to be the natural and primary caretakers of home and family, their inability to transcend the spatial boundaries of home and locale appears to confirm the naturalness of their place in the private sphere. (Even their long-distance use of the telephone to maintain family relationships, which does change the boundaries of their world, nonetheless keeps it within the private sphere.) Hence, the social meaning of gender is confirmed by the experience of it, in an interactive, chicken-and-egg process.

The theme that women's primary place is in the home is emphasized by all but the younger women (primarily under thirty) in this study. While most of the older women could understand—if not approve of—women holding paying jobs, they were in the main concerned that women first devote their attention to their home and family. This was often expressed in explicitly spatial terms. A woman in her eighties was critical of those who "go off in the morning and shut the door and lock it and maybe come back at night." She wondered if they need to be that "far away from their front door."

Women in Prospect generally translate the women's movement into working for pay, which is seen as a spatial movement from the home to the workplace (considered to be men's domain or part of the public sphere). Reconciling the spatial and temporal split between these two worlds—not just philosophically but in their own lives—plagues Prospect women of working age. Of the women in this study, two in their thirties have opted to stay home, not just by choice but because of a realization that all that awaits them in the employment

market is a factory job in another town at least ten miles away. Factories that employ women generally pay low wages; factories that pay well are generally seen as male places. One of these women quit her factory job when she married in 1975, in part because she was making only $3.05 an hour after seven years and she "wanted out of that place." A second woman said if she did not have her husband she would probably try to get a job at the large plant in Valley City, the only place that pays a reasonable wage. "You'd think a woman would get tough working at a place like that, but I'd do it if I had to," she said. Her comment suggests a recognition that one way the differences between women and men are kept intact is through the maintenance of separate spatial spheres.

Other women have been creative in combining these two aspects—family and work—of what were previously women's and men's spheres, or the private and public. This has been a strategy particularly used by women who own and manage Prospect businesses. Owning a business in Prospect can mean a local job with a less rigid boundary between the spatial and temporal distinction of home and work.[7] For some of these women, the telephone has provided the link between the two.

The most illustrative case of a creative blending of public and private via the telephone is a woman who was a farmer with her husband until she earned a real estate license almost ten years ago. She got into real estate in part because she was looking for a job where her age would be an asset, then decided to open her own real estate office in Prospect so that when business is slow she does not have to waste her time at an office. The telephone makes it possible because it connects her business and home; her business number rings at her home or office. "I could not do without the telephone. It really opens up the world to you," she said. She remarked that the computer also has important capabilities for allowing women to work at home. "It really is a problem for women, isn't it," she asked rhetorically, "combining careers and a family."

The owner of the Prospect cafe also has a close business/home connection. She and her two daughters live above the cafe, and her mother and her daughters work in the cafe with her. Her apartment and her business share the same telephone line. Since her friends come to the cafe daily for coffee, there is almost complete overlap between her personal and business worlds.

The manager of the general store, which she owns jointly with her husband, has a slightly different situation, though she, too, blends home and business. While she works at the business in Prospect, she lives ten miles away in Valley City. She has her sewing machine in the store so that when business is slow she can occupy herself with a sewing project. Her home and the business are even more closely linked by the telephone, which allows her to communicate with her husband about what is going on at home and what is going on at the store, and to talk over decisions with him. "It takes away the loneliness of decisions. After awhile you get worn down with decisions. I really like being able to call my husband and say, 'Hey, what do you think?'" The decisions can be business or home-related. During my interview with her a telephone call from her husband resulted in a decision about what he would cook for supper.

One of the town's beauticians has brought the private sphere into her business but is less interested in taking her business home with her. Because the grade school is only a few blocks away from her business, she is able to go to the school if she needs to or her young son can come to her shop after school. Her dream of having her own shop came true only because she could have this flexibility provided by the location, she explained to me. Her business itself has qualities of the private sphere. It is a place for women and for women's talk. The television in the corner is tuned to daytime network television. With the long hours she puts in (she is the only beautician in the shop), this woman is not interested in prolonging her business day into her family life. She does not have a combined home/business telephone line, nor does she even take her appointment book home to encourage after-hours calls from customers.

Other women besides business owners have looked for ways to combine their personal and economic lives. After being a full-time homemaker while her children were young and having her own health problems, a registered nurse has begun part-time work as a private duty nurse. As a care-giver in private homes, she has not stepped out of the domestic sphere and role as much as added an economic dimension to it. Another woman is looking for a business to start because, she said, that is a way for women to make a good job for themselves: "I like to be free, to go to the school, to go to the children's things, their field trips. I don't want to miss out on any of it."

Within the ideology of separate spheres, fathers do not need to be

such active participants in the lives of their children. It is women who must reconcile family responsibilities and pleasures with any economic or professional interests.

The separation of the personal and the economic was a useful organizational strategy for the developers of industrial capitalism, but family farming (a fast disappearing activity) was less affected by such distinctions. Farmers are particularly conscious of the blurred boundaries of family and business, which they see as an important aspect of farming. Farming, of course, is not only an occupation but also a way of life for all members of the farm family. A young farmer with children said, about the advantages of farming: "There is always someone around—myself or my husband or the hired man—for the kids or we can be reached by two-way radio. A lot of families, like my brother in Chicago—he goes off to work on the train at 6:30 or 7 in the morning and sometimes doesn't get home until 11 o'clock at night. We spend twenty-four hours a day together. It's an equal partnership."

Another farmer, whose children are now grown, shares the sense that industrial capitalism, with its enforced separate spheres and emphasis on consumption, is not healthy for families or individuals. She said:

> Farming is hard work, it's hardships, but it's a good way of life. I always had to work in the field. We'd take the boys with us. They were only a year and twenty days apart. I can remember I'd be on a tractor and my husband would be on a tractor and we'd each take one of the boys. They'd take their little toys in a grapefruit bag and play in a furrow (they never rode along while we were working, just on the tractor back and forth to the field). They had an interest in it. We all worked at things as a family. We *worked* together, we *played* together, we went on picnics, we *made* time to do things. They even remember some of the busy times in the field when we'd pack up a picnic lunch and eat around the combine. I never had babysitters, they were with us. We could teach them. Money isn't everything, there are things money doesn't buy, and that is togetherness on the family farm. That's why I hate to see this bad farm economy. Something is going to be lost in rural America when the family farm is gone.

Another farmer with grown children expressed her concern about the public/private split that takes women out of the home but echoed the sentiment about the advantage of farming for reconciling that split: "The part that I don't like is when women leave their homes and

children. They should wait until their children are grown. I see so many of these children that just need a mother. Of course, the farmers have more chance of living with their children and working with their children than any other segment of society. All of us are farmers. That's one of the good points about farming is that you have a chance to work together and be with your family and show them right from wrong."

A woman who is not a farmer but who fantasizes about a nostalgic version of farming captures the desire women have to put together a world where the family is physically present on a daily basis and their husband's and children's attention is focused with theirs on a common purpose. She would like to live on a farm during the time setting of the popular Laura Ingalls Wilder book *Little House on the Prairie* so that the family would be together.

Women's interest in Prospect in bringing men into their world of attention to relationships parallels the desire of Janice Radway's romance readers for the private sphere of love and devotion to invert the patriarchal order.[8] For Prospect women the inversion is not only a matter of focus of attention but also includes a fusing of the spatial split between home and workplace so that women's and men's space and time can be shared.

The spatial split between home and workplace has not always been so distinct for men in Prospect, even for those who were not farmers. Little remains of a pattern of men both working and living in Prospect, where there was at least physical proximity of the two. It is now women who live and work in Prospect or would like to, with only a few men business owners and employees left in the community on a daily basis. The one striking example of a man combining home and occupation as Prospect women are trying to do is the Catholic priest. The rectory is next to the church, and as a priest he is available for church and parishioner obligations on a continuous basis. Since he has no secretary, housekeeper, or assistant, he uses a portable telephone so that he can be available even when he is working outside. This is a blending of the private world of care-giving and relationships in domestic space and time with the demands of an occupation. The blending of the two is marked by his "ever-availability."[9] The priest's ever-availability is both spatial and temporal, created in part by the telephone, and is similar to attempts by Prospect women to make their private world available when they are in a public world, and vice versa.

In contrast to the priest, the minister of the conservative Church of Christ is interested in separating his family life from his church obligations. Because his home is on the same block as the church, he must work at maintaining the distinction. When he and his wife first came to Prospect, the rectory and church shared a telephone number, which he quickly had changed. Even so, his personal and professional lives overlap more than he wishes them to. In another comparison, a professional man who lives in Prospect but works in Valley City is often "on call," meaning available by telephone through his place of employment. In his case his occupation extends into the private sphere of his home and family, but there is no reciprocal incorporation of his private life into the space and time that his work occupies. It appears that with the exception of the priest, who occupies an ambiguous gender position, women and not men are interested in reconnecting the public and the private.

The fact that Prospect is no longer a workplace for many of its male residents is an indication that the community as a whole is no longer generally men's space. In the first chapter I described how community residents say that the influential, prosperous men investors and business owners are gone and that the town lacks leadership. The community has been left for the most part to women, who run many of the businesses and most of the volunteer activities. The taverns and the cafe, though ostensibly mixed-gender, are actually the few remaining men's spaces in the community, where men's talk of politics and economics and their negotiations and decision-making get done. That these sites are men's spaces, but spaces in jeopardy because of the encroachment of women, is illustrated by comments made by the women I talked to. One elderly woman said about changes in women's roles: "Sometimes I think they go a little bit too far. One way they go too far is when they go to the taverns and make a fool of themselves. [Laugh] They do that here and all over, I think. I don't like that. I don't believe in that, that a woman should. They say we have just as much right as a man. Personally, to myself, I would feel like a fool to go and sit in a tavern among all those men. You know, that's the style now. You see just as many women going into the tavern as men." Another woman remarked that what was of most interest to her about the coffee klatsch in the cafe is that the women are so forthright about claiming their space. They sit at the same table every day, she said, and if anyone else sits at it they will come and tell them it is theirs. Though

the men coffee drinkers sit in the same space every day, their territoriality is not noteworthy.

The community has gradually been left behind by men who made money; they have been gradually replaced by women interested in combining family and work who must settle for less income. Women's private sphere of home and family has, in some sense, expanded to encompass more community space and a greater range of activities. The community has become part of the private sphere. The men left behind speak about the community's loss of vitality and autonomy. Though a male local decision-making sphere of a sort remains in the community, the public sphere of power has moved beyond the limits of the community. Women have inherited a community but no power to direct its destiny.

How is it that the world of power and decision-making moved from Prospect? The answer undoubtedly lies in a complicated story of the interactions of economics, public policy, ideology, and technology, all suggested by my description of the changes that occurred in Prospect over the past century. The telephone may have played a further, and even more indirect, historical role in this transition than simply affecting the patterns of communication within Prospect.

While the telephone is in one capacity a technology of the private sphere, it is in another capacity a technology of the public sphere of politics and economics. It serves an information function and a productive function that links accomplices and competitors in the activities of vast political and economic organizations and networks.[10] Regardless of how much of the arrangement of contemporary life can be attributed to the effects of the distribution of the telephone, the telephone is now obviously critical to the perpetuation of a world of power connected across time and space. The telephone, along with other technologies extending control over time and space, is implicated in the conditions described by James W. Carey. According to Carey long-distance communication hooks people into longer physical networks at the expense of the emotional closeness of face-to-face neighborhood relations and creates new relations of power and control. "As the authority of long-distance communication improves, the authority of the local community evaporates," he concludes.[11]

The telephone likely had a role in the reorganization of economic and social life that created a dramatic spatial split between public and private, making what had been women's ideological place more than

ever women's physical space. As the boundaries of women's private sphere changed shape, encompassing more physical territory and connecting them in an irregular pattern to people and places across distances, done in part by means of the telephone, the boundaries of men's public sphere receded beyond sight and grasp. The telephone did not bring Prospect women closer to the world of power and decision-making but rather took power and decision-making farther away.

Though the telephone has both a public- and private-sphere capacity, women in Prospect are affected by its use in the public sphere while using it themselves within the private sphere. Their use of the telephone is related to their location, their mobility, their assigned responsibilities, and their spatial perceptions relating to distance and security, but not in any simple pattern of correspondence. The telephone is being used creatively by women to transcend both the barriers of space that once dissolved family ties and the distinction between family and work, but the connections they make and keep with family and friends around the country are private ones and the world of work they have entered is not a site of power or prestige; the boundaries of the private have merely been shifted rather than transcended.

The telephone is gendered differently in the public and private worlds. In Prospect the telephone is an integral component of women's space and an indicator of women's social place. As Nettie, whose story appears in the next chapter, explained to me, illustrating the boundaries that contain women and that the telephone does not transcend: "That's what the telephone is for—to keep you up with the things that are on your level and round about us here."

NOTES

1. Feminist geographers have made the same point. Interesting discussions of the relationship between women's physical space and their social place occur in Mary Ellen Mazey and David R. Lee, *Her Space, Her Place: A Geography of Women* (Washington, D.C.: Association of American Geographers, 1983); Gerda R. Wekerle, Rebecca Peterson, and David Morley, eds., *New Space for Women* (Boulder, Colo.: Westview Press, 1980); and Women and Geography Study Group of the IBG, *Geography and Gender: An Introduction to Feminist Geography* (London: Hutchinson, 1984).

2. My observation that men generally make the decision about where to

live is supported by David Popenoe, "Women in the Suburban Environment: A U.S.–Sweden Comparison," in *New Space for Women,* ed. Wekerle, Peterson, and Morley, 165–74.

3. For a discussion of how unfamiliar places are seen by women as inhospitable and even threatening, and for good cause, see the Women and Geography Study Group of the IBG, *Geography and Gender;* Mazey and Lee, *Her Space, Her Place;* and Wekerle, Peterson, and Morley, *New Space for Women.*

4. In "Blowing the Cover of the Protective Male: A Community Study of Violence to Women," Jalna Hanmer and Sheila Saunders report that women's fear of violence in public places makes them more dependent on men with whom they live, creating conditions that make it easier for some women to be assaulted at home without retaliation. In *The Public and the Private,* ed. Eva Gamarnikow, David H. J. Morgan, June Purvis, and Daphne Taylorson (London: Heinemann, 1983), 28–46.

5. For background see Jessie Bernard, *The Female World* (New York: Free Press, 1981); Elizabeth Janeway, *Man's World, Woman's Place: A Study in Social Mythology* (New York: William Morrow, 1971); Michelle Zimbalist Rosaldo and Louise Lamphere, eds., *Woman, Culture, and Society* (Stanford: Stanford University Press, 1974); Rayna R. Reiter, ed., *Toward an Anthropology of Women* (New York: Monthly Review Press, 1975); and Jean Bethke Elshtain, *Public Man, Private Woman: Women in Social and Political Thought* (Princeton: Princeton University Press, 1981). I find Gamarnikow et al., *The Public and the Private,* particularly useful and relevant to my discussion here.

6. Jos Boys, "Women and Public Space," in *Making Space: Women and the Man-Made Environment,* ed. Matrix (London: Pluto Press, 1984), 40.

7. For a more detailed description of the problems women have with the spatial and temporal split of home and work, see Chaya S. Piotrkowski, *Work and the Family System: A Naturalistic Study of Working-Class and Lower-Middle-Class Families* (New York: Free Press, 1979).

8. Radway, *Reading the Romance.*

9. For more discussion, see Eviatar Zerubavel, *Hidden Rhythms: Schedules and Calendars in Social Life* (Chicago: University of Chicago Press, 1981).

10. See Lionel Nicol, "Communications Technology: Economic and Spatial Impacts," in *High Technology, Space, and Society,* ed. Manuel Castells (Beverly Hills: Sage, 1985), 191–209, for a discussion of the telephone's productive function in an on-line economy.

11. James W. Carey, "Canadian Communication Theory: Extensions and Interpretations of Harold Innis," *Studies in Canadian Communications,* ed. Gertrude Joch Robinson and Donald F. Theall (Montreal: McGill Programme in Communications, 1975), 27–59, quote on 34.

Women's Stories

The following chapters contain transcripts of taped interviews with six women who participated in my study. I have included whole interviews with some participants for two reasons. First, the nature of any individual woman's telephone use is contextually bound to the story of her own life and experiences. I would like readers to be able to see the patterns I have pointed out in previous chapters at work in the lives of individual women. Second, in this section I want to reduce my interpretive authority to the extent possible so that the participants can tell their own stories to the reader, who may have other interpretations to make of them than I have had. (I realize, of course, that I have already exercised considerable interpretive authority in conducting the interviews and selecting certain voices to be represented.)

Out of the forty-three rich and varied interviews I conducted, I have chosen these stories because each illustrates some vivid portion of the different patterns of telephone use and women's life circumstances. The women represented here range in age from among the most elderly women I interviewed to the youngest. Nettie and Ethel are among the older women I interviewed; one is married and one widowed. Carolyn has grown children, Gayle is divorced with young children, and Kristin and Ami are teenage sisters. They represent varying life circumstances, economic situations, and philosophical outlooks. Their use of the telephone varies as widely as it does among all of the women in Prospect.

The transcripts were edited slightly to facilitate reading; for example, some very extraneous material has been left out, as have pauses and false sentence starts, and in some instances a sentence or para-

graph has been reconstructed to make it understandable. I made copies of the transcribed interviews available to the six women for their approval, and the few modifications they requested have been made.

4

Nettie

*Nettie and her husband, retired farmers, now live in Prospect. Nettie was eighty years old at the time I met her; she and her husband had been married sixty years. I visited them on a cold November day. Their house was warm and comfortable, with a fire burning in the woodburning stove in the living room. Books and magazines—*Modern Maturity, *the newsletter of the American Association of Retired Persons, and religious books—were scattered about in a pleasant clutter. A large upright piano with hymnals on it occupied a wall in the living room. Nettie has a round and interesting face and a short, round build. She was wearing a navy-blue-and-white houndstooth check dress and navy anklets when we met. As we talked, she spoke rapidly and with great energy as her quick mind bounced from topic to topic.*

Nettie, who served as an operator for the telephone company for two years, provides a perspective on what the community was like in that time period. The operator was the center for community news in a time when people had little access to a larger world. The large numbers of households on party lines kept social uses of the telephone down; to this day, Nettie frowns upon what she would call idle talk, a reflection perhaps of both those party-line days and her Christian work ethic for women. Despite her active community work and her own strong political opinions, Nettie believes women's place is in the home. She frowns on women's geographic movement away from their homes to workplaces and taverns. She would, however, also like to see men make their families a priority. Nettie's ideas about gender reflect an older ideology in Prospect that is undergoing a change. This ideology is made manifest in her use of and beliefs about the telephone.

Since women's work and women's talk is not as valuable or necessary as men's, business and emergency uses of the telephone should take priority (and is work that is appropriately done by wives for their husbands). Given the high priority for taking care of family assigned to women, carrying on family relationships is the next acceptable use of the telephone for them. A woman with her own home and family work done might take on community work as a final responsibility.

I was born in 1905, one of six kids. There were four girls and two boys. Of the four girls in the family, three of us were telephone operators. I happened to be the first. I wasn't married at that time. I started about 1922 when I was seventeen and worked until 1924. I was making twenty-five cents an hour when I gave it up to go back to finish school.

We had a board to plug into. There was nothing very automatic except your hands. We were required to ask people for the line when it was necessary. There were eight to ten people on one line in the country, possibly four to six on some. Ten minutes was about as long as they should have used the line, but occasionally we had to ask for it. The operator knew quite a bit of what was going on. She had to know the people and she had to know whether she should ask for the line or demand that she have it.

When I heard about your work, I thought about how there was a lady on a certain line in the country who was one of our hard ones to get off and keep off for a few minutes for other people. When I moved into the country, she was on my country line!

So it was only a few people who liked to talk a long time?

Yes. That was just to go over all the things that were going on in the country. They didn't have radio. They didn't have anything but the telephone or an outdated newspaper that came a day or two late. In those days they didn't have transportation. When we moved to the country in the twenties, we didn't have a car until the thirties, but we had the use of my husband's folks' car. Many people didn't have a car, and the horse and buggy were the way they had to travel. And if the horse needed to be out in the field working [laugh], you couldn't go places. I wasn't bothered. I was too busy to be worried about that, but for those who liked to use the phone to keep up their relationships with people, it was very much an improvement in our way of living.

Then they had the fire calls. All you had to do is take down the receiver and wait a moment and they'd tell you where the fire was.

That must have been nerve-racking for the operator.

You bet. It was very exciting for those few minutes because everybody wanted to know if they had to grab up their water pails to put the fire out. There wasn't a fire department in those days.

Another task that we had was at eleven o'clock we had to give out the weather report. The radio was just beginning. I don't know where the people in the city got their weather report. You'd plug in a set of lines and when it stopped clicking you knew almost everyone was on the line. One day, we'd been having weather like we've been having now, rainy and icky for farmers. The report came through the mail (I'm not sure if it came from Washington or the state or the authority of the weather) but it told us beautiful weather that day. I cast it aside and said continued rain today. I'd have had more phone calls than I could handle if I had told them a beautiful sunny day. They'd have said, "Was that an old card you were reading from?" I didn't tell the manager what I'd done that day, but I think he would have preferred it to all the distress calls we would have gotten and to the lack of confidence after that. It was really a rainy day, and I thought, I will not give that one out. We did that at eleven o'clock, before noon. Women, usually, took the phone calls because they would be in the house.

When there was a fire, we'd call those that we knew would be closely affected, and then answer all the calls. That was the early twenties, what everyone calls the Roaring Twenties.

Were they roaring?

Oh, yes and no. We were just beginning to get into the circulation of the country. I remember our lineman working on something in the basement to get something out of the air—that was radio. One day when I was working he came up and said you go down and listen to what is coming over the air. So I went down. Nothing there. After awhile we started to get news. By the time we were married we had a radio to hook up to a battery—we didn't have electricity to plug it in. We couldn't listen to it long because the battery ran down and you had to recharge it again. No danger of our children being overpowered by what they could hear over the air because we couldn't keep it on long enough! [Laugh] Everyone was anxious to have the crudest kind of communication. It was something new and adventurous. What we get

nowadays is coming so fast I can't even keep up with it. My land, I have grandchildren fairly small who can use computers. I hope I never have to run one. That's a bad thing to say, but I'm not interested in trying to learn.

So people were eager to find out about the rest of the country?

Yes, especially in an election year. You didn't have to wait until the mailman brought the paper to hear how the elections came out. There'd be some rallies before that, but those were very primitive. They can't get around now everywhere. But there would be rallies and consensus of opinion by newspaper. I guess the newspaper had plenty of circulation because people had to have something. There was more time to converse with neighbors, but you didn't go that far. You didn't go ten miles every day. That would have been out of proportion to the work you could do and the time you had.

The radio was just beginning. One person in the community was lying on his lawn on a nice warm summer day and gave us a report that he knew we could hear voices in the air. He happened to be up on a hill. And probably that was so. He was a sane man. I thought, well, it's in the air, and it's just a matter of getting it into a machine. He happened to be my brother. We thought it was pretty far out. He wasn't one that would be getting crazy ideas.

Who started the telephone company?

Back at the turn of the century, a man with his wife and two daughters. This man promised to take care of the operating of the telephone company for twenty-four hours a day. There were two daughters. They went back and forth. They lived across the street, two houses away. They were tied down to the business, because someone had to be always there. They were so enthusiastic about it. They wanted it to advance in what the country had for us. Mr. ———, I presume, invested in it, because he also invested in the bank.

Were there complaints about the party lines?

Well, yes, that's why we had to enforce that ten-minute limit. They wanted the lines for themselves. That was a big expense to run lines a mile or two to serve one or two people. I can't say they were disgusted because we had to be the go-between to ask for the line. The girls at the switchboard learned lots of news. They could have been at the center of news flashes if we'd had such a thing. One time, I got to work at seven in the morning. The night operator said, "I had a strange thing happen. A lady called in. She needed a doctor—a distress call. She said

someone tried to murder her husband." We relayed to each new opera-
tor what we learned. After about a week or two the operator that was
on told me when I came on that this woman confessed she had hit her
husband with a flat iron. Between us operators we kept each other
interested in what was unusual.

Did people make many long-distance calls then?

I can't recall, really, any distance that people would make calls that
we would have had to complete—there was no direct dialing. We really
had as good postal service as we have now. One or two people would
get to Chicago, which was a long ways, but they were the people who
had the money, or businesspeople. And other people didn't travel that
far. We had four trains up until the time they took the tracks out of
here—until the sixties anyway. The mail was just as prompt as now.

When did people start traveling more?

Well, in 1940 my husband and I were on the farm and we wanted
to go to California for Christmas to see special relatives. They lost
some members of the family, so our mission was to go and make
connection with them. It took us six days to get there; there were seven
of us in the car. I don't remember calling back here for any informa-
tion. Things were going well at home. We had someone to take care of
the cows. My husband always liked to have his hands behind the wheel
and he still does. He loves to travel. He doesn't like to go by plane or
train. Our wedding trip was quite a few miles, but we were so busy
trying to make money those years that we just did local things.

What about your children?

The youngest is forty-one and they go up to fifty-seven. They are
mostly in the Chicago area. I don't suppose I could have manufactured
four more different types of kids. [Laugh] But they get home and talk
about things together. I'm usually busy in the kitchen, but I said, "I'm
not going to work in the kitchen all the time; I'm going to be in where
you kids are. I want to hear you talk to each other." I guess we didn't
go away because we like this state. I think in a generation of time from
the early twenties when we were married to the sixties and seventies
when they've all been going from home, there's been many oppor-
tunities. The country's just spread. Maybe what they could get out of
schooling, which I approve of, though I hated to see the single-room
school go, but I guess they get more education.

My husband and I, neither one of us got through college, but I was
determined I was going to get through high school. We had to go to

Valley City and stay there, because there was no transportation unless you were wealthy and had a little old Ford, which most didn't have. I wanted to go to college. You didn't usually borrow for schooling like they do now. Now the grandchildren have all had chances. Their parents have seen they have government loans or have put them through college. It wasn't in the picture then, because we went through the first depression, which was long and difficult, in the thirties. It was 1940 before we ever made a payment on our farm. We paid the interest! [Laugh]

I had plenty to do. I had a ten-room house, but my daughter was very good when she was home. She could keep house better than I, because when you get in, you're so tired you don't look to see if there's dust. I helped milk until we got machines. When we got machines and the children were gone, I had to help carry it.

His parents were on the farm right next to us and my parents lived right in the village here. We had phones, but even Prospect didn't have electricity for everyone until the end of the twenties. We didn't have any chance out in the country to have power until the end of the thirties. In fact, you had to give the electric company the poles so they would come across and bring you some power.

Did you talk to your mother much on the phone?

I don't recall it being long. She was a busy woman and I had work to do, too. I wasn't the gal who had time to take a fifteen-minute call and then turn around and take another one. We'd keep track of each other. I never remember any distress of not being able to communicate.

Has your calling increased over the years?

Oh, yes. My husband said, "What did you do last month? We've got to cut that down." I said, "Oh, yes, I know, and then we'll just use the money for something else." But we had five funerals in our personal life here in a month, so we had lots of phone calls. That's what the phone is for anyway. He feels that way, too, only he looked at it and he said, "How did it get this big?" and I said, "We had four children to call long distance when their brother died, plus other calls we were asked to take care of."

Did your husband use the phone on the farm?

Yes, except I might have been the gal in-between who did the phoning for him. He'd say we gotta call the vet, or the milk tester's coming. He was happy to have the phone. We would never have lived without it. It was part of my life, anyway. I don't think there were

many people who didn't have the phone. If they didn't, they'd bother their neighbors. Usually older couples, possibly, where there was one left in the family, might not have a phone. They'd live on in the country by themselves—hermit style. They might come for help, which everyone was glad to give them, because the phone wasn't their business. But I know right down the road everyone had a phone. Occasionally someone would have their phone taken out. I recall there was some little signature in our monthly bill of some numbers not in use. We didn't really bother to call them nonpayment of dues. The depression was long—it lasted eight to ten years. Of course, I think we're in one now.

Did women use the phone more?

Well, as much, but they knew the business of the farm came first. I think it became a matter of keeping in touch with the neighbors. Some just loved to do it and talked long. No, I think when the telephone came in it was considered even more necessary than radio or television, because there was a time when not everyone had good communication with the radio. Perhaps they didn't think they could handle it financially.

I think the Jacks improved many things. In no time at all they had new manners of connecting the switchboards. They were from the telephone business. I don't think there was anyone else interested in the community to take it over.

Did you make many calls on the farm?

No, I guess I wasn't hooked on the telephone. I had work to do. You could tell if someone was listening in; there was a little click, and then you didn't talk the same. You didn't give out your family secrets. [Laugh] But I guess everyone knew if someone was sick and that made the communications amongst the close neighbors too, and that was good. There's some good in everything. I know my folks had a telephone. It was one of those long ones that was so big you could stick your coat on it when you went by. [Laugh] It was in the dining room, because we could hear it in other rooms.

I used one of those calls where you get four or five people together—what do you call that . . . ?

Conference call?

Yes, conference call, and I used that once when there was a sickness in the family, so I could talk to each of the family at one time. I paid a good price for it, but by the time I had satisfied my children with

two or three calls, I saved in cost. I appreciate that. I got the information I wanted about what a surgery was to be and what the children thought of it and notified them and also heard their remarks besides. I'd like to be able to do that more, if I could, for Christmas, when someone isn't able to make it home. At least three out of the four are able to get home and we call the other party.

So it's the best communication I know of, the telephone. You can see things, and learn what the world is doing with your own family.

Do you remember your mother or grandmother using the phone?

One old grandma, she never did get the phone. Her hearing was bad. My mother was hard of hearing also, but we'd get our message, or my dad would be there in the morning to take whatever was the business of the day. My mother was too busy; she never did get hooked on the telephone. I'm sure everyone who has their own phone like we do [uses] the phone very much. I don't stop to think if we're going to be charged for local calls, but I think there's some places that do that. You can make so many calls per week or month. My one brother was anxious about that when he was sick, so we had the task of calling him each day so that he was at ease about the number of calls he could have. It worried him on the financial end.

Where was your phone on the farm?

It was in the second room; the kitchen was the first room. We had just the nicest little wall space so you could reach it from the bath or the bottom of the stairway. I never did any hanging on like that, talking from the kitchen. I couldn't reach it from the stove. I've said maybe I should have a longer cord so that I can reach it from the stove, but I don't like that anyway when you talk so long that you can't do your work. I guess I'm too busy trying to get my work done so I can go some place.

Do you remember any times when the telephone was particularly important to you?

Yes, in times of distress. That's what the telephone is for. My husband went through several years of dizziness, and on a farm, a cow will kick you or around the back of a horse—he wasn't just sitting around idle, you know. I said if I needed to, if I could get him into the back door of the car and get him pushed in and call the doctor or whatever was necessary, I was happy. We didn't have too many real bad accidents. You could always ask for it if it was an emergency and they'd give it up. They might grumble a little, but who cares!

Do you ever wish you didn't have one?

Yes, right now. There are times people will call . . . I know some-
one in the country who will call and (this effects other people more
than I, I usually say my beans are burning) she'd say a few years back,
"Well, we haven't used our ten minutes yet." That is ridiculous. There
are people who are lonesome, I guess. I'm sure it's because she doesn't
get out. She's taken on the care of some elderly people from the county
with no place else to go, so you have a strange life. So we have to be
kind to her.

My husband had three or four cousins who were operators in
Valley City all the way from the supervisors down to the local calls.
They enjoyed those years very much. It was work that women could do
rather than to go out into the world. Now they're putting women—
allowing women—to work in men's jobs. Even in the army. [Laugh] At
that time, a family left with girls to keep the living expenses—there was
no social security—to keep a family in fuel and food, the girls would
take to the telephone business because that was a lady's job and they
could do that more easily than . . . well, housework is hard sometimes
and not everyone can handle that, go clean houses. (Mine could use a
cleaning right now.)

We use our phone more now. It was a great convenience in the first
years when I was too busy raising the family, gardening, canning,
whatever there was. It was used for the purposes it was meant to be, to
aid you in the things that came along in the day. I don't really care to go
to the phone and just stand and visit. But you get some of that from the
other end of the connection so I guess that's why I don't do it.

What kind of traveling do you do?

Well, it's usually to go to our daughter's or west to see someone we
have in mind. Some of our children's friends we see. Probably our
house here, if I could bring out my guest book, would show we've been
a kind of halfway house for many, many college kids. The one son,
when he was in college I would always expect him to bring at least one
carload of people with him. He was so kindhearted he always thought
Mom could put out a thrashers' table for a carload or two of kids, so
they'd have a place to eat on their way home.

Do you think about the past?

No, I don't as much as my husband. I'm always looking for some-
thing new to do. We enjoy the present as much as we can. And there's
so many things to do, help out in organizations, you can just keep

yourself busy. I'm not really interested in history. I enjoy listening to the things uncovered, but we can't live in the past. The kids have come home with some good jokes and memories and ask some questions. My husband says, "I don't want to go back to those cows." On a morning when it's cold he says, "I'm glad I don't have to go out and do this or that."

Do you like to keep up with what's going on?

Well, not particularly. If someone just notifies me of the important things that I might be missing, because I don't even watch the TV like some people. I don't like that grind all the time. I turn it on for the news once a day or twice and the newspaper. I've got the calendar full for the month. It's too heavy and I say I've got to cut something out. I don't believe that either one of us dwells on the future too much, unless we really get feeling physically ill and know that some changes better be made soon. The children have always been able to get home, and we just look forward to that time of the year.

How do you feel about the changes you've seen over the years?

I believe I would say that it's good, though some things irritate you. That's because maybe you see some things in maybe a different light or you know some portion of the people are spending too much on one subject or one item for the country. We've got ourselves in a mess and somebody made a mistake somewhere. Along the line you do form opinions. This is the age of radio, television, air travel, and space. I don't expect that I can solve anything about that. I think it's all been helpful, but we lose many ways. They say these experiments in space aren't doing the atmosphere any good, so maybe we're losing something there but they have to go out and see what's there. It's marvelous, but I don't understand it too well. It's so far beyond what an uneducated person back home can fathom. That's the way I feel. But if they can make the world better for it, or understand it better, find its flaws in it, then they have to abide by that. I think I'd have to study more and understand it before I'd want to remark that we should or shouldn't do this or that. Although we get letters in the mail, what's your opinion on this, and maybe it's of benefit to those of us on earth.

Have you been involved with the community?

Yes, we really are. We keep ourselves so busy I have to get that calendar slashed a little bit when it gets too heavily laden. We try to be helpful, but we're not on the fire department or anything like that— we're too old. But most anything else that comes along—like could you

do some calling. We use the telephone. In fact, I think tonight I'll be getting a phone call about a little two-year-old girl who's undergoing very serious surgery tomorrow, and you get on a shepherding list for that and do calling. That's what the phone is for—to keep you up with the things that are on your level and round about us here. Let the government take care of the other things.

What role do women play in the community?

In auxiliary work they are quite active. I used to take the paper for this cause up and down the street. The younger women do it now. I decided they needed to learn what it's all about. I spent many years helping out 4-H in the country, for instance.

Are women involved in decision-making here?

I really can't think of any that are involved pushing us to do this or that, if that's what you're thinking. They may be and it doesn't happen to get to us. I like to see things, like the new little shop in town. We have some business here in town. The railroad took some things away from us. Never mind, it's not here anymore. You just can't be one to sit down and complain.

What about the women's rights movement? Do you remember when women got the suffrage?

Yes, I've always tried to listen and read what comes along. I personally think it was something we needed to do. Where would we be now, if we didn't put ourselves forward. Though maybe we've taken too much for granted. There are some people you could name across the country who have exposed subjects that I don't agree with. I like to know what's coming up because there are ideas some of us wouldn't even think of in the making and many of them are good and if you help promote them you're busy.

What should be women's place?

I guess I'll answer by, in the home. And if you have time left over, that's marvelous; then you're well-organized and then you can go out and help someone else, help a cause. But they better . . . I like to remember the little grandchildren who smile when they come in the door rather than had to come along with their parents. I like to greet them at the door and know they like to come. It's alright if women work if it's necessary. It's a strange thing when young people go off in the morning and shut the door and lock it and maybe come back at night. That seems awfully strange. If you understand they have problems we don't have, just leave it to those that want to do it. But I hate to see

them leave their children on the streets and not be encouraged to be good citizens. That I think comes partly from working out of the home too much. But I guess they figure they have to. And they like it. There are good women in offices. But I wonder if they need to be that far away from their front door.

What about men?

Well, over there at the taverns, I want to say you ought to be home, just to be with your wife. If they're both there [laugh], that's their business. I think they should be able to appreciate their home in the years when they're older. They should respect their home and make it a good place for friends and have good home relationships, anyway.

How often do you use the telephone?

I'm surprised it hasn't rung once today. Maybe six times. If I have the time during the day I like to use it for catch-up calls, for shut-ins, and people I know I need to call. I don't make more than six, but probably less. Ten to twelve times would be a busy day. That's more than is necessary. Everyone has their own thing, their own work to do, their own jobs. I do have some ladies who come home from their work and they call because they need information. Those people don't bother. You have to tolerate others because they are within walls, their own home walls, and that's your way of serving them with something that should be uplifting to them at least.

You have to use the telephone for your organization work. It's a very useful item. I don't believe a home should be without a phone, even for their own health—accidents can happen—or the work you can do for someone else. I appreciate the telephone. That's the last must. The TV, I just listen to it, I don't really sit down and watch it unless I really get lazy some day. I can see it from the kitchen.

I like to feel, look for the good you can in this world. I may be what you call a family mom; I'm interested in my kids. They're all in business in one way or another, and if they can keep their families in control and the grandchildren blossom out, why, that's what life is for, for me. I don't mean to be selfish; I like to see someone else's children too.

If you could make changes in the country, what would you do?

I'd go to Washington, D.C.—and I don't mean women's lib or anything—and try to get some changes made. We're in a dilemma. I'm not sure I could trust those guys. They've got things up their sleeves we don't know about. I think I'd clean out Washington first. I don't know

if women could help or not. I think their place is in the home, maybe helping keep their husbands sane enough to go. [Laugh] That's a terrible statement to make. But I don't believe the women should run the country. It's not natural.

Do you have any other memories of the telephone?

The girls [operators] would exchange news items. If we'd published them, we could have been called some kind of advanced information officers. [Laugh] The telephone used to absorb a lot of that, but now of course the lines are closed and there isn't supposed to be anyone on it. They have improved much, but they had to have their primitive days. As far back as the twenties is where you have to go back to see where the changes were coming. The very primitive ones were back before World War I, and they didn't even get the messages through as well as they do now. After the twenties everyone thought they had to have one. It's an interesting world now. Those that go up in the air now, and live up in the world up above—what do you call it—examining things, I don't think they have as much fun as we do down here on earth. Someone remarked to me yesterday, every time we send a missile off in space we get another rash of trouble on earth—earthquakes, floods. I don't know but what they are disturbing the atmosphere. But maybe ten years from now we'll find out everything was for the good.

You just can't get down on it. We have friends our age. Everything is wrong with the world. He's read so much, but I think he read too much to himself. Now his wife's gone and I hope he realizes he should have given her a little more consideration. I think in a marriage you just better listen to each other. Both sides have something valuable the other can use. If the family likes to come to you, that's about the best in life, and to help the community. That's your load to carry for the world.

5

Ethel

Ethel was seventy-seven at the time of this interview. In the past few years she has lost her central vision, making it impossible to read and drive, yet she still lives alone on a farm outside of Prospect. The farm is located in gently rolling hills about two-and-one-half miles from town. There is a big frame house with a screened-in porch, a big well-kept barn, and two small outbuildings. The exterior of the house is as well cared for as the interior. It is full of furniture arranged in a comfortable and tasteful way. Ethel is of medium height and build, her hair white, short, and curly. When we met, she wore slacks and shuffled when she walked because of knee surgery on both knees. She spoke slowly and carefully and thoughtfully as she told me about her life and philosophy.

Ethel, one of the few college-educated women in Prospect, trained as a teacher. She gave up teaching to move back to her husband's family farm, which she managed alone after her husband's incapacitating illness in 1952. Ethel describes how little impact the telephone had in earlier days. Women were too busy and party lines too busy to make it of much value to women, and men's needs for the telephone to coordinate their farming activities took priority. It was only private telephone lines that brought Ethel the freedom from guilt to talk at leisure with her mother. Ethel's restricted mobility sets the context for understanding her present telephone usage. The optimism and self-sufficiency she maintains despite her blindness is made possible through her own resourcefulness and the emotional support of a strong network of family and friends. She uses the telephone in lieu of visits, letters, and newspapers. She is able to maintain a close relation-

ship with her children, more important now that her husband is dead, despite the fact that they live halfway across the country. Because of the telephone and airplane, long distances have ironically become almost easier to manipulate than local ones because Prospect has no public transportation or local broadcast stations.

This house was built in 1870. No one else has ever lived here but my husband's family. That will end when I leave here, I presume. I've lived here fifty years this year.

Can you tell me about yourself?

I had two brothers and one sister. This is my sister's eighty-sixth birthday; she lives in a nursing home. Both of my brothers are gone. The one brother died this past October and the other died in 1971. My husband died six years ago. We have a son in Texas and a daughter in Michigan. My daughter was born in 1939 and my son in 1942.

I was born three miles south of Olsonville. When I was eight years old, we moved to the Prospect vicinity, and I lived here until I was in the eighth grade. Then my family moved to Colorado for my brother's health, so I finished the eighth grade there and went to high school and college in Colorado. I majored in the romance languages and taught English and Spanish in high school for three years in Wyoming.

My parents came back to the farm from Colorado when my brother's health improved enough so they could leave; both my brothers stayed out there and went to school. Since my parents were here, I would come back to Prospect in the summers. I had grown up and known Bill, my husband, when we were kids—we went to Sunday School together and so on. He was finishing college nearby. One summer when I came back we started going together. That did it! [Laugh] We were married in 1936.

I was thinking after I knew you were coming, trying to remember what the telephone had meant in my life through the years. I was so homesick out there in Wyoming, but it never dawned on me nor on Bill, to whom I was engaged, to telephone each other. We just wrote letters. And his father died suddenly of a heart attack, and the way he got word to me was by telegram, not telephone. I can't ever remember doing long-distance telephone in those years.

When we lived south of Olsonville, I can remember the telephone on the dining room wall—one of the wooden ones—and I don't ever

remember that we children ever used the telephone. It was a special thing for a special purpose. If you needed to call, you called. We were brought up in our family that it was private, same as a letter. If a letter came to someone, you didn't open that person's mail. The same if you lifted the receiver, or my mother or father did, and someone was talking; you hung up immediately. Sometimes that was really disconcerting, because they would talk a long time and you couldn't make a call. Gradually we learned you could say, "May I have the line for a few minutes, please?"

Do you remember how many were on your line?

I don't remember. I remember only one number. This was a Norwegian community, Olsonville. Everybody spoke Norwegian but about two families. We were Irish and English and over a couple miles from us lived another family who weren't Norwegian, and I can remember my mother and Mrs. B——— were really close friends. If mother and dad had to leave me anywhere, if there was a funeral in the family they didn't want to take me to or something, why I stayed with this lady. To this day I remember her number was 382. [Laugh] You had your ring. At one time ours was two longs and a short, and another time it was a long, short, and a long. When I came to this house fifty years ago the number was 1804.

We changed from a party line where you heard everybody's ring to a party line where maybe there were four on a line and you heard only your own ring to having our lines now, which really is wonderful, because I always—when my mother lived down on the farm where we moved to—I always felt I was talking longer than I should because I didn't want to take the line away from someone else.

Lydia Jacks can tell you exactly when we got a private line when you talk to her next Wednesday.

Word is getting around!

Several people have asked me if I know the work you're doing.

About the only frivolous, fun thing we ever did with the phone was—my dad was Irish, and he loved to play tricks, play jokes. He'd call some neighbor he was good friends with the morning of April Fool's Day and April Fool them. But we were brought up to respect the telephone. It wasn't a toy.

Do you think it would have been different if you'd had a private line?

Oh, I'm sure it would have, but that would have been wishful thinking. It's like evolution. [Laugh] It's a form of evolution. It just had to come step by step, you know.

There were people in town who had private lines then?

Oh, yes, oh, yes, but I'm sure like much of the country, we were fortunate we had lines.

You had a telephone all the time you were in Colorado?

Well, I don't believe when my parents took my brother west for his health that we had a telephone, because we had no one to call and no reason to use one, and we were trying very hard to stay within our budget. My older brother was in college and I was in high school and my younger brother was sick, so I don't recall that we had a telephone there. I worked two years for my room and board at the home of the principal of my high school, and of course all those homes had telephone, so I had access to it. But still I never called my parents. We just didn't spend money that way.

And now . . . My telephone bill just came in my bank account yesterday. I wouldn't dare guess what that bill might be because last month was a really . . . my brother died and I had calls to make, and I talked to my children. Now I just feel—my central vision is gone and I can't read—I just feel that the telephone is what makes it possible for me to live here yet because I depend upon it for support from my friends and my family. It's just a comfort to me to know that any time I want to call them I can. I don't spend money on a lot of other things that people spend money on, and I consider the telephone a part of my physical welfare as well as my emotional welfare because the two are so closely intertwined.

Now I have two phones. Imagine that! That would have shocked my parents. Such an extravagance! But I had the second one when my sister was not well and living by herself, and if she called me at night I couldn't hear the one in the kitchen. So it was for that reason. But once I had it, I got to depend on it.

Just before midday one day I got a call, and it was our son. He sounded just as if he were in the room with me—much clearer than when he calls from Texas—and I noticed the difference the minute he said hello. I said, "Where are you?" and he said "I'm in Switzerland. It's seven o'clock here, and I dialed you to prove that when I tell you I'm always as close as your telephone, I am." He said he just dialed my number and I answered.

How did your mother use the telephone?

The women in those days did not have time to spend on the telephone the way we do now—washing clothes in the tub with the scrub board, cooking for hired men, taking care of the children. There just wasn't time for them to have that enjoyment—really the support—that comes from a friendship like that. But she and Mrs. B——— did keep track of each other and talk. Then after we were all gone from home and they were back on the farm and older, she would visit and talk with her friends. But we were just brought up that you didn't spend money on long-distance calls. Well, we didn't have money a lot of the time. And making calls was more complicated then, too.

We had neighbors down on the farm when we were in the Prospect area who were German people. They spoke very broken English—they were wonderful people and good neighbors—but he couldn't figure out how to use the telephone. He would get so disgusted over the operator. We always called the operator "Central," and in his trying to learn the English language, he called it "the Middle." I can remember being over there—they had a girl just a couple years older—and hearing him over the telephone trying to get someone over the telephone, saying "Is dis de Middle?" [Laugh] And he wanted to know if he were talking to Central: "Is dis de Middle?" [Laugh] I suppose I was ten at the time.

I do remember the part the phones played in World War I. People hated to have the phone ring, those who had sons who hadn't heard from them for a long time. Then when the phone would bring the message, how devastated the whole community would be.

Maybe the other girls will tell you different about it, but I think people only used the telephone for special occasions because they just didn't have the time. They were just so busy with the home and family.

But we hear stories about how women talked a long time on the telephone.

Oh, yes, but I think that came after this. I can remember when we had party lines. You knew just which neighbors it was—over a period of a half an hour it would be the same voice. There was definitely a telephone etiquette that some parents tried to teach in their homes, when we had those large party lines. The children did not play with the phone and try to make calls. And you didn't keep the phone for long periods of time because others might need it.

I remember before we moved from the farm south of Olsonville,

there was a terrible electrical storm and lightning struck our barn and it burned. I can remember my sister, who had long, long hair, which she wore wound around her head in braids—I can remember seeing her out in this awful wind and rain and the barn burning and we couldn't get anyone on the telephone. Maybe the lightning had knocked it out, I don't know. What we resorted to was the dinner bell at the back. I can see her yet, with her hair—it had come down in the wind and rain—flowing around her shoulders and body, ringing that dinner bell. I don't know if the neighbors heard it, but the closest neighbors soon saw the flames. The barn burned to the ground.

Did you talk to your mother a lot on the phone?

Oh, yes. They lived alone and they weren't well. Both of them lived here at different times when they couldn't get along by themselves, and then Mother lived with us after Dad died. I didn't visit with her the way I would now. I wouldn't have thought of it, because someone might be needing the line for an emergency. But I don't think all children were brought up that way. We were brought up to sit on chairs and listen to the adults visit when we went visiting Sunday afternoon. After awhile Mrs. B——— would play the piano for us and later she'd take us into the big hall and play her music box for us. We didn't run around her house. But we loved to go. We always had cookies and milk after. [Laugh] We learned self-control.

Who was doing all the talking on the telephone then?

I know who did, but I don't want to name them. [Laugh] They can talk as long as they want to now as long as they can pay for it.

When I first came here, there was a black phone, one of those upright ones with a black base and the stand and the mouthpiece and the receiver, and that sat on the buffet out in the dining room. That was the first phone here. That was quite classy to have a phone like that then, instead of the old wooden one. Now everybody's clamoring for the wooden ones, just to hang on the wall for enrichment.

Did you ever wish you had it in the kitchen?

No, I don't think I did. No. Lydia has put a long cord on it for me. If I have something cooking and someone calls, why I just go over to the stove and take care of it. [Laugh] All these conveniences.

When you got a phone call, was it a family affair?

No, in later years, when we made long-distance calls, we would do that so we could hear everyone's voice. But then it was mostly used

between the farmers to arrange their work. When the thrashing crews would come, the men would have to talk about their wagons and whether it was dry enough and this sort of thing. That was one reason we were taught to let the phone be free because the men needed it when they needed it.

Then at one time, before my husband died, he wore a pacemaker, and he needed to be monitored more often than we could make the trips to the city. They gave us some sort of EKG kit that we brought home with us, and they set up a schedule where they would call us for an EKG reading. I would have to put clamps on each wrist and a magnetized something on his chest over his heart. I've forgotten the length of time that it took, but they would take the reading. If I noticed any change in him that I was concerned about, I would call and tell them I wanted them to check him. We did that about the last three years he lived.

Have you done a lot of traveling?

Not a lot. I got to Arizona and to Texas and to California.

Have you traveled more in the past few years?

Yes, because my husband was ill a long time. He was stricken with a disease in 1952 and that changed our lives drastically. He made a remarkable recovery really, but still it did alter his life.

Has the telephone changed your feelings about how far away things are?

Oh, yes. Oh, my goodness, yes. My friends will say to me, "Too bad your children are so far away." Well, they are in a way; they aren't next door the way many children are to their parents, but when I can go and dial them or go and get on a plane when I need to and want to . . . No, if it weren't for the telephone, I would have a much different existence here. We talk every week, sometimes twice. Weekends are our longest visit because we like to talk a long time, but if I have something to say, it doesn't bother me to call on a week night. It helps them, too, to know that I'm coping all right.

How long do you talk?

I don't know how long we talk. I'll get my last bill so you can tell how long I talk. I call three cousins. One cousin does my book work. I make long-distance medical calls. I made a long-distance legal call. My brother was in Arizona. My son and daughter call me a lot. I try to jump the gun on them sometimes so they don't always have the bills to

pay. I called my husband's cousin, who had a birthday. My husband always wrote a birthday letter to her every year because she was born two days before he was and they grew up together.

A lady was telling me last evening at our Methodist church women's meeting—we were talking about you and your work—that she still remembers how surprised she was when she moved here and their first telephone bill came and it was handwritten. That would have been ten years ago. Rose at the Prospect Telephone Company did all that. You've met her. Oh, she's a terrific worker.

You talked about the telephone?

[Laugh] Yes, when we were having our lunch.

Do you remember any time periods when the telephone was particularly important to you?

Well, at the time when illness would strike and you would need a doctor.

Any time when you were here with the children and you felt you needed to talk to someone?

I can't say I remember that. Unless they'd get hurt and I had to call a doctor. The only time I really felt isolated was the year I was married, 1936. My husband hadn't intended to farm, but his father and mother died very suddenly, and it was depression time, so to save the family farm we came and stayed with it. We were going to go to another town for a little trip and to see some shows. I suppose that was more money than we should have spent even then, but we could go to a show for maybe fifty cents. But we never got there. We started out Monday morning in the awfulest snowstorm you ever saw. I remember we were glad for a telephone then because we could call my parents and tell them we were all right. And we used the telephone to find out when the roads were cleared enough for us to get through. We did get home that weekend on a Saturday night. Monday night it started to snow again and it snowed for three weeks, and I did feel sort of abandoned here then, because I didn't get away from the place or see anyone. Bill and the hired man would load the milk cans up in the bobsled, and all the farmers would go together with horses and bobsleds and take the milk in. They couldn't take the roads. It would take them all day to take the milk into Prospect. I can remember it would get dark and I would watch and watch for them. [Laugh] Well, I had the chickens and the cows.

Did you get into town when you had children?

Oh, yes, but not in my mother's time. She didn't drive a car. I'm sure she felt lonely at times, but, poor thing, she had so much work to do, hired men to cook for. I can't remember when there wasn't some elderly relative, an elderly aunt or uncle—my great-grandmother lived with us for nine years—and my mother had all that extra care. The reason we left the big farm over there was that her health was gone. Dad had to go to a smaller place where he could do the work without the extra help.

Did women used to help each other do the work?

Oh, yes, we always helped each other when we had thrashers. Our daughter loves to talk about when we had thrashers. They ate out on the big screen porch. The men always loved to have a place to sit in the cool to eat. No refrigerators. I can remember mixing up the dough for fresh rolls. We spread a blanket on the dirt floor in the basement and covered it with thick layers of newspaper, then I put my big bowl of dough down on that and covered it with a clean tablecloth and the dough would rise overnight, ready to bake in the morning. The way we got along, I just don't know. I furnished all the food, but a woman or two, a close neighbor would come and help cook. We'd no sooner get the noon meal cleared away and the dishes done and you had to do it again. They ate supper then, too. The later years it got so they didn't stay for supper. That made it easier for the women. We would have fifteen to eighteen men. We made pies and cakes and salads and meat and potatoes and gravy and vegetables. My daughter still talks about the good food. In fact some of the neighbors still talk about it.

Do you think your feelings about time have changed over the years?

Time, I realize, is a very short thing now. It used to be when I was young, looking ahead seemed a long ways away. But it has to change as we get older. I'm never bored. Time does not drag or hang heavy on my hands at all. Even when we have those dark days and already I can't see too well, even so I never, ever wish an hour away. There's always something you can do. Recently I found out that because I can't read—I just can hardly make out anything at all—I am able to recall many things that were in my mind that I didn't realize were there. I'm using my telephone now much more for greetings of all kinds. I contact people much more by phone where I used to send greeting cards and

write a note. I can still write much better than I can read, because your mind and your hand can do it. I still write a lot of letters, even though I can't read what I've written.

Two weeks ago I had a thrilling experience. I went out to the little woodshed with a bag of garbage. I could hear the geese coming from the north, honking and honking. I love that sound, and I've always loved to watch them. I thought, oh, I wish I could see them. I kept looking up and they kept coming closer and closer this way, but I could tell they were really high up. When they were right above me, I held onto the post out there that protects my evergreen tree so I wouldn't lose my balance, and do you know I could see those geese, way up there in formation, individual spots for the geese, and yet I can't see the fingernails in front of my face. I thought, I will never complain if I can see and hear the geese when they go back and forth.

So you still write letters but you're making more phone calls?

Oh, yes, because unless I know the address or have it written out in big black letters I can't look it up. I have all my telephone numbers, and I keep adding. When someone comes, I have them look up one number for me so that I can call. I have to write it about two inches high.

About how many calls do you make in a day?

Oh, I presume an average of three or four. Now I'm surprised the phone hasn't been ringing this morning, because lots of time I have a call before noon. I go to bed early lots of times—I have to for the sake of my knees (I had surgery on both of them)—and I'll get up two or three times to answer my bedroom phone. But I'm always glad to get up and answer it. That doesn't bother me.

Who do you call?

Ruth down on the corner and Barbara up here on the hill and her mother. Just any of the friends I know. Irene, Effie, and I, we all grew up as kids together. We feel free to call each other up any time we want to about anything. It doesn't have to be about anything specific. Sometimes I call because I just want to reach out and touch them, for my own sake as well as theirs. A dreary day or something.

My sister is the only one I talk to every day. She has her own phone in her room, which I'm so grateful for. I took care of her two years before she went there, so we talk every day. She was the one I was talking to when you came. She calls me, too. She has her phone fixed

so that all she has to do to call me is punch a two. It makes it harder now that I can't drive. I can't depend on getting to see her, where I used to see her about three times a week. So the phone is a wonderful blessing for both of us.

How often do you get out?

I go to church every Sunday; somebody takes me. I hire my yard boy to take me to the grocery store on Saturdays. I don't feel shut in at all. I'm of the disposition that I don't have to go all the time to be happy. I'm content. I love my home. I don't feel that I'm in any way neglected. I just don't feel lonely here. After fifty years it's where all my emotions are. I even feel close to Bill and the children here. They're just everywhere. All the memories. I think as we grow older, if we're wise, we will tend to forget the memories that hurt—the illnesses, the hard times, those that hurt too much—just kind of turn them over to God and forget them and concentrate on the good memories. Otherwise you can get to feeling a little sorry for yourself and it's not the right attitude. I heard a mass for shut-ins and the handicapped on television one morning that had such a good message for me. When I had lost my central vision, it really changed my life quite a bit—not being able to drive, not being able to read, not being able to have any privacy with your finances. He was talking to me, handicapped and shut-in. His thought was we need to concentrate not on the things we've lost—not that I can't drive, not that I can't see to do my checkbook—but live each day thinking about all that I still can do. And there are more things yet that I can do than I can possibly get done in a day. You just have to change your pattern of living.

Does the telephone keep you up on what's happening in Prospect?

Yes, because my friends are responding well to my need to have them tell me. A year and a half ago I had to stop taking the Valley City newspaper because I just could not read any of that. Well, at first I missed the deaths of three or four—not just mere acquaintances, but friends. I didn't know they were gone. Then my circle of friends realized that I had this need to be informed. Now they do call and tell me things. It doesn't have to be a death, but maybe something interesting they'll tell me. Marianne called me that night after you had called me and she said, "Say, there's a girl in town [laughter] and I was wondering if you would like to visit with her," and I said, "Well, she's already called me and we're going to visit on Friday." [Laughter]

Well, of course, we've always been very fortunate. The Jacks family ran a very good telephone service. They really did. Lydia was a shrewd and very fair businessperson.

She wasn't a figurehead?

Oh, mercy, no, mercy, no. She ran it. Her husband traveled and their son did too. You were at their house. You interviewed them, haven't you?

Yes . . . Has the community changed over the years?

Uh-huh. Many new people have moved into Prospect. I don't even know their names. They live here because it's cheaper living here than in the city. They work all over.

I can't imagine a world without the telephone now. Of course, we've gone from the overhead wires to the underground. They're all buried now. It used to be if we had an ice storm or a wind storm we didn't have telephone service. Much of that has been eliminated. Rarely is there any problem.

One thing that changed my attitude about the long-distance calls was when Bill was alive, we had great medical problems and expense, and so I was always conscious of expenditures. Once I was left alone, I needed those calls more because I didn't have Bill with me, and so they really became a necessity to me, and it wasn't long before I realized that my children needed them too. They proved it by their frequent calls. I just felt that this was a part of my life. If I hadn't been given as good health as I have and I were in a nursing home or something, it would take plenty of money for that, and I thought it was just something I owe myself. Because I'm sure it's hard for my daughter and son where they are to think, "Mother is there alone." My daughter has said to me on the phone, "Mother, do you feel awfully lonely?" And I can honestly say to her, "No, I don't, because you and your brother call me so often, and when I want to all I have to do is dial you."

Did your husband like to talk on the telephone?

Yes, he made necessary calls. After he was ill, it changed. Because he was in a coma, we were just very fortunate that he could recover at all. It destroyed his highest level of thinking, his judgment and initiative, plus it took his memory completely. That was in 1952. We worked all through the years on that, and he was still learning things right up to his death. My daughter was thirteen and my son was ten. She milked those cows night and morning for two years after her dad was stricken. They just grew up taking responsibility and helping. I

couldn't have survived without them. We raised corn and oats and hay. It was a small dairy. We rented out the land on shares. After our daughter went off to college and our son developed severe asthma, Bill and I were still trying to milk. Finally my doctor said I had to do something; I was wearing myself out. That was 1965.

Bill had never wanted to farm, but he was needed after his mother and father died so suddenly, to keep the family farm. He needed me so much I didn't mind giving up teaching. Maybe I never had the courage to encourage him to take a risk and do what he wanted. I can remember we were so poor once when we were first married we went upstairs in this house and found some old jewelry that had been in the family and sold it for thirteen dollars. We lived on that for a long time. We never considered taking out the telephone. It just didn't seem to cost that much money.

6

Carolyn

*Carolyn, sixty-two at the time of this conversation, had only re-
cently moved to Prospect. Her husband is a retired school administra-
tor and an elected village official. They live in a small house that had
belonged to Carolyn's mother-in-law. They have modernized it with a
deck and sliding glass patio doors off the kitchen and decorated it with
art objects unusual for Prospect—carved elephants and a bust of an
African. As we sat together in her living room, she with her latch-hook
rug project in her lap, Carolyn spoke frankly. She was wearing jeans,
trendy red-and-white figured socks, and hoop earrings.*

*Carolyn is a member of the coffee klatsch who does not spend
much time on the telephone locally, but the telephone has made it
possible for her to maintain family connections over distance. In ear-
lier days, with the number of moves she made because of her hus-
band's career, she compensated for her restricted mobility and her
loneliness by using the telephone. She did not go to college, and her
husband had never wanted her to work. When her two children were
growing up, they had severe allergies, so she was seriously restricted in
her ability to get out. Carolyn now finds Prospect confining as well.
Accustomed to larger communities with libraries, shopping, medical
services, and other activities, she worries about the possibility of living
in Prospect if she can no longer drive. Since she has not lived in Pros-
pect long, she does not have the long-term friendships, family relation-
ships, and community activities that give shape to the lives of many
Prospect women and connect them to telephone partners and net-
works. Her need for activity (in Prospect having too little to do is
not uncommon for women without children at home) and social in-*

111

teraction is addressed in part by her participation in the coffee klatsch.
The fact that she has lived in so many other places may help
account for Carolyn's liberal notions of gender. Though she herself did
not have a paying job when she was raising her children, she supports
women who do. She seems well aware of the injustices that result from
women's subordinate position in the family, from the lack of oppor-
tunity to attend college, and from the second-class status of being a
professional's wife. While her husband has used the telephone only for
professional calls and calls to their daughters, Carolyn assumed the
work and responsibility of checking on their mothers each day when
they were alive. Now that they are gone and her past identity as wife of
a high-profile professional man is no longer possible or of interest to
her, her relationship with her daughters, maintained through long-
distance telephone calls, provides much of the meaning to her life.

I was born in 1923 in Valley City. My dad was a salesman, so we
moved four or five times, and then we returned to Valley City when I
was in high school. I didn't go to college because girls weren't sup-
posed to have a career. My brother went, but I was supposed to work
and help myself, I guess. I worked as a key puncher for almost five
years. I didn't work after I was married, but then when my husband
went back to work on his Ph.D., I went to a vocational school to brush
up on this because all the machines and everything had changed, and I
went to work for the state department of taxation doing key punching
and verifying.

We were married in 1945. Our first move was to ———. He was
there several years, and where did we move then? Isn't that awful not
to remember? Then he went to his first administrative job, to a little
town called ———. You think Prospect is small! I had lots of fun there.
The people were tremendous. We lived in a church parsonage. I had
two teachers rooming and boarding with us. When they'd have a min-
isterial meeting, they didn't have a bathroom in the church, so they'd
all march in the back door, through my kitchen, up the stairs, to the
bathroom. [Laugh] It was really fun. They fixed this old parsonage up.

In 1950 my first girl was born. Three months later we moved to a
little neighboring town. We were there only one year. That was an
administrative job. Then we moved to ——— in this state. While we
were there, they built us a new little house near the school and our
second daughter was born. We must have been there three years. Each

time now as we're moving we're getting into a bigger school system. From there we moved to ———. They asked my husband if he was interested in moving, which he always was. [Laugh] We usually averaged between four and five years as we got into bigger systems. From there we moved to ———. We were there at least five years. Then he decided maybe he should go back to school. We moved to ——— so he could work on his Ph.D.

I hadn't worked up until that time. We had one daughter in junior high and one in high school, so that was rough on them too. We bought a house. That was in the sixties. We left there after he got his Ph.D., but he got a postdoctoral grant to ——— for a year and I stayed where we were with the girls because I didn't want to pull them out of high school. He didn't like that school situation and there was politics involved in it, so he took a job in ——— near where we were living until my daughter graduated. When she did graduate, we had to decide what to do. He got this offer from a neighboring state. We were there three or four years at least, then we moved to ——— in that state. He was having problems with arthritis starting then, and the first day on the job there he had to walk a picket line. After heart surgery, he decided maybe we should let up a little. The girls were in college, and he thought maybe we should move back to this state. We moved to ———. His arthritis kept getting worse and worse and he had surgery. Finally he decided to take an early retirement.

We moved back to Valley City in about 1981 or 1982, and we'd only been there a year when his mother got very ill here in Prospect. We moved out here to be with her certain days. Nights he was with her and I was with her days. He was called back to ——— school to replace a friend of his who died suddenly of a heart attack. He was there seven or eight months and they wanted him to stay, but with his arthritis it wouldn't work out. Now he substitutes. We've lived here three years in her house since she died.

One daughter lives in this state and the other in the next state. One is a librarian and the younger daughter is a third-grade teacher. One is thirty-two and the older one, who is going to have a baby, is thirty-five. That will be our second grandchild. The other grandchild is only two years old.

How did you like all that moving around?

Each move as you get older is harder. Especially in later years when my husband wasn't well, that was very difficult.

Do you feel like you'll be in Prospect quite a while?

Yes, but if something happens to my husband . . . I have friends here but my family isn't here anymore. My dad is here, but he's eighty-five and he isn't really well. I don't know if I'd spend my remaining years here. I'd have to think about it. You know, when you get older and you can't drive anymore, you can't get out of Prospect. There isn't a tremendous amount to do here. You have to go elsewhere to find it. Well, I have church affiliation and American Legion auxiliary.

I've run the gamut through the years. I've been in . . . You know, the superintendent's wife, she has to belong to most everything or she's trying to run everything. I'm kind of played out on clubs. I kind of pick and choose now. But we have no library here. You can go to Valley City, of course. Everything I do is somewhere else. We doctor in ———, so we go up there.

In fact, at first I was kind of depressed in Prospect. But there's a good church group here, and I'm still able to get around and do things. I belong to the Church of Christ. They're very friendly here, but if you don't belong to something . . . The way I really got to know people other than from church was going down for coffee. They kept asking me to come, and I'd go down with my husband, but then I wouldn't sit with them. I'd chat a little bit, but then I'd sit with my husband. Why, I bet that went on for six months or longer. Finally, one day they said, "Why don't you sit with us?" So I finally thought, "I'm lonely; I'm going to do it." So I did, and that helped a little. And we go out for lunch for special things, for birthdays. Sometimes we shop together. That kind of gave me a lift. The coffee group expands and changes over time, but they've been going on for a number of years.

I'm from the "big city" of Valley City! I used to tell everybody, "I'm never going to live in a small town." I like large towns, where things are available. But there's a friendliness here. When people have any trouble, illness or anything, it's just like family. It's really nice. Sometimes you don't get that even in a next-door apartment somewhere else. It's great for raising children. If you like the quiet life . . . though it's not so quiet here sometimes! [Laugh]

Are more women working?

The younger ones. They go to Valley City and some of the other towns to factories and offices. Among the older women who never had any marketable skills and their job was to take care of the family, you hear from these women that women working should be home. Their

children are in trouble running the streets but they have to have a boat and two cars, that sort of thing. The younger ones are more or less used to the idea. Our own daughters only took a few months off for their babies. They have to have special sessions for superintendents in order to know how to deal with it. The point is, if that's what they want to do, I don't feel that's wrong. If they feel they have to work and they feel fulfilled rather than sitting home scrubbing and cooking and cleaning, and they can manage it, that's fine with me. Women aren't subordinates like they used to be! [Laugh]

It seems like quite a few businesses in Prospect are run by women.

Yeah, that's true. But a lot of them are widows. These older types must do that, from necessity or . . . I didn't mind the working earlier, but that was awfully hard on the nerves, dealing with taxes and everything. If I did anything again, that wouldn't be what I'd want to do. I can see where running your own business would be fine if you could do it. And it's true, I've never thought of that, in Prospect. So many of the men work outside of Prospect. The women are left to do something here, I don't know. I don't know if that's true in Olsonville or not. From what I've heard, Prospect used to be more progressive and larger than Olsonville. But when they held things back here, Olsonville got the high school and everything. We really should be to that level. There are new ones, and they try, but you can only do so much. We have terrible water; I'm sure you've heard about that. We've got to do something about that—a new tower, new wells, new water mains. There's lots to be done. Sidewalks. Everything's kind of gone to pot! [Laugh] Some of them would probably be offended if I said that, but a lot of them know it.

How about the telephone? Do you remember it when you grew up?

We usually had one, but when I was a child, my grandmother didn't have one in Valley City. We lived next door and we didn't have one. That was in the twenties and thirties. When we moved different places I'm sure we always had a phone, and I'm sure Grandma had one because we used to call once in awhile. I'm sure when I was little nobody had one. But I never missed it. When we had one when I was young, I could call my friends, but not long distance. That was something my parents did. They got their message in short order and that was it. You see we were in the depression time, too, and that was practically unheard of. During the Depression I don't know if we had

one or not. I bet we didn't. When we moved to ———, I know we had a telephone because my dad had a better job. When we had one we enjoyed it, but it wasn't used frivolously, like I do now. [Laugh]

Do you remember if your mother would call up her mother or friends?

Uh-huh. She would get lonesome. Locally, but long-distance calls were kept pretty much to a minimum. My grandmother died in her sixties, so my mother just had one sister left in Valley City and one in another state. She would call but usually in case of an illness or if she was coming for a visit. But most everything was done by letters.

What about when you moved around?

I've always had huge long-distance bills. [Laugh] We would get on different programs, you know, for certain areas. But I don't do that anymore. I just call. We call every weekend to our daughters, that's just general, and if there's anything else. Our younger daughter is undergoing a divorce—you can tell all these things that happen the way our bills go up and down. We try to keep her bills to a minimum now that she's on her own. We've done that for years. We've called every weekend and they feel free to call us. And if they can't afford it, they reverse the charges. Our family seemingly to me is much closer than like my mother was to her family. Probably economics, like we said, but not as close, independent. They didn't come together like we do. Maybe because they were scattered.

Sometimes, when we talk downtown, I get the impression from things that are said, like, "Don't baby your children. Let them grow up." But that isn't it! We've always been really close. We come to each other's aid at the drop of a hat. Some of them aren't even speaking to their own children. That's hard for me to understand. The family unit has changed or something. Some of them think once you're eighteen and you're out of the house you're on your own. We feel we're always going to share your problems. They can back off if they want, but so far they haven't. They don't come running to us, I don't want to give you that impression. When their dad has been ill, boy, they've been right there. And that's nice.

Are you a present-minded person? Do you think about the past more now?

I'm present-minded and I'm still looking to the future. I have a dad who lives in the past. Maybe he's lived that many years and it all was better in his past. Sometimes when I get depressed I think that way, but

I'm more of an upbeat person. That's past now, forget it. If you can't set goals for yourself, what are you going to do—just exist? You have to think ahead, the situation isn't always going to remain the same. When my mother was ill and his mother was ill, I hadn't been around anyone that ill for a long time. The day my husband's mother was buried was the day my mother had her first stroke. Was that a trauma day! But that makes you start to think. Things aren't always going to be this way for me, and I have got to plan when I get to this stage. What do I want to be done, where do I want to be taken. My dad says, "You take care of it all, I don't want to talk about that." Then you start to think, I'm not going to be like that. My husband has donated his body to a medical school, so I've had to choose, do I want to be buried alone or do I want to be buried next to my mom and my dad. How can my daughters make these decisions? I don't dwell on these things, but seeing my mother unable to walk or care for herself or talk or feed herself, that gets you pretty level-headed.

Grandchildren make you think ahead. The only regret I have is my daughters started late, getting married and having children, and I think I won't even be here to see them graduate from college or get married. But you have to think positively; maybe I'll be here to see them grow up, so you have to plan on those good things.

Would you have done all that moving around if you could have decided?

It was hard. The only good thing about it was we made a lot of nice friends and met new people and saw new areas. That was the good part. Probably not. I don't know what I would have done instead. We all have talents. These women, when they get together, they say, "Oh, you know, she's so good at this or that," and I say, "What am I good at?" and they say, "Oh, you're so decorative!" Oh, that was so great, wasn't it? Oh, me! Oh, my! That always put me down. Maybe I always served others. I've always been kindhearted. I feel other people's pain a lot. Maybe that was one area I thought I could help. You know when your husband has a doctorate, you're always Dr. ———'s wife. I got along well with people and I was a good clubwoman and all, but you're kind of put in that second notch, always. If I were a young person now I would think, Well, I was a straight-A student, why didn't I go to college, and why didn't I have this career, and why didn't I have this freedom?

I could have taken college courses when we lived certain places.

But both of my children and myself have had terrible allergies and asthma. So I had sick children. I had to give shots; I had to take them to the doctor a couple times a week; I had to keep them away from things so they wouldn't get this or that. So my full-time job was a mother. *He* was always at summer school every summer. He only had his bachelor's when we were married, and then all through the years he kept struggling away. It was for our betterment. But it was lonely too. I raised my children. We'd go to Prospect and then to Valley City a few weeks in the summer. I couldn't drive until I was thirty-two. During the war years gas was rationed, and in World War II I was just learning and nobody was going to teach me on their precious gas. Then when I was married and had my children, finally when we lived near ———— and he was going to all these conventions and all these special things for school, I thought, "This is ridiculous." So I passed my test, and that was *wonderful*. I should have done it much sooner.

I couldn't go to my relatives and leave my children because they were afraid. "What if they have an asthma attack, what if I give them something they're terribly allergic to by mistake?" So I was more or less *there*. That was difficult when you live away, like at Christmas and Thanksgiving, when all the families are getting together and you can't go. I couldn't even go to my grandmother's funeral, and that hurt me, because I had two sick children. And people said, "You could hire somebody to come in." But you can't make those judgments until you're in those same predicaments yourself.

Did you use the telephone quite a bit in those years?

Yes. We've always been phone users. We were never as badly off as my parents were in the Depression, and my husband never wanted me to work. We didn't have children until six years after we were married. I had worked before, and I thought it was wonderful—I can cook and read books. Bliss!

The phone rings much less now. A lot of these ladies call each other back and forth. I haven't gotten into that, unless it's something that needs to be set up or someone's ill or we're going someplace. My husband gets at least two calls a day for teaching school. I don't even get one call a day. When my mother and his mother were alive, you know, I used to call every day to check on them. Sometimes I'm startled when people want to speak to me. [Laugh] Retired, I guess! I don't even think I make one call a day. Maybe it's one every other day. It depends. Right now it's in a lull. Like if I call Valley City for a hair

appointment or for a doctor's appointment, things like that, but it's never anything like just to chitchat. I just haven't started that. Maybe if I didn't go down and chat downtown I'd probably be ready to chat more on the phone. And then I go to Senior Citizens' and I talk.

My husband has used the phone all his life for work, but he doesn't call anybody just to chitchat. It's business, or his children, that's chitchat. He calls them—they're both daddy's girls. [Laugh]

I used to talk to people on the phone more—people I'd met in clubs. But in the later years it seems I'd never call up just to say, "Hi! Whatcha doin' today!" It's tapered off. When you're younger and involved with your families and school, you do more of that type. Sounds dull, doesn't it? [Laugh] You don't think about how things change until you start talking about the past.

7

Gayle

Gayle, thirty-four, is a single parent living in Prospect with her four children. She was living in a rented two-bedroom apartment in a four-plex building when I first met her. Her apartment was sparsely furnished, like the home of someone who has not been living in one place long. She was wearing jeans and a sweatshirt. Her hair is short, dark-brown, and curly; her style of talking, animated and rapid. When we first talked, I learned she was taking college courses—philosophy and criminology at the time—to prepare for a career. Later she told me that she had to put her college courses on hold for the time being.

Gayle's life has taken a complete turnaround from the days of her marriage. As she has been forced to become more independent and mobile, her use of the telephone, a factor in her divorce, has lessened. Her husband resented the orientation of her attention away from him while she talked on the telephone, despite the fact that she spent the time on the telephone in the evenings because he was watching television. She spent so much time at home with her children when they were little that she retreated farther and farther into her private world and was less and less inclined to even go out into public. Gayle now fantasizes about an egalitarian husband-wife relationship in which both have their attention focused on each other, their common interests, and the family.

Gayle describes how her husband, son, and father do not want to talk on the telephone, coaxing the women in their lives to make their calls. Though Gayle is busier now, with more activities that take her out of the house—one reason for the decline in her telephone calling—she also remarks that, with most women working, there are few for

*her to call. In fact, she is highly sensitive to the telephone preferences
of her family and friends and respects those preferences in deciding if
and when she calls and how long she talks. She does enjoy her daily
evening call to her mother, even though they see each other in person
every day. Her discussion of the few women with reputations in Pros-
pect as telephone talkers is illuminating, for it is obvious these women
perform an important (if ridiculed) function of binding the community
together through shared knowledge, making what might elsewhere be
considered "private" information "public," or available to the com-
munity.*

*Gayle might be called a prefeminist—someone who is interested
in learning another interpretation of women's place. The issue for
women that concerns her the most now is financial equality, an out-
growth of her long-term financial dependency on her husband and of
her current precarious financial situation.*

I was born in Prospect, lived eleven years in Olsonville when I got
married, and just moved back about four years ago. I graduated from
high school in 1969 and moved to Olsonville in 1971. My parents have
lived here most of their lives. They live right across the street, down the
street a ways—right on the same block.

I was married in 1970. My husband worked for a gas company
and then later he was an insurance salesman. He died in 1983. I've got
four children—fourteen, thirteen, eight, and six. [Laugh] After John
died, I filled out so many papers for social security and all that death
stuff, I said after awhile I didn't have to stop and think years or any-
thing anymore—you have to fill out so much.

I take college classes two days a week, then two days a week I have
like a cleaning business (another girl and I clean other people's
houses), and I work part-time down at the grocery store if someone's
sick or something. Just odd jobs mostly. Going back to school is sure a
big change after being home, but I just love it. I wanted to go right after
high school, but my dad was one that girls don't go to college. I finally
got enough courage to go back. Not many of my classmates went to
college. A lot of the guys did, but very few of the girls. They just got
married and had kids—all of my group. None of my friends, none of
them, had gone on. It would be nice to go back and start over, I know
that. [Laugh] I would do things different. It's so easy to go in there now

and study and it's so interesting, instead of in high school when you just have to do it. Even after so many years it was easy to go back.

Do you think it has changed now? Are more women going on to college?

I think so. My sister is thirty, and she just went back two years ago; and my other sister who lives next door is twenty-five, she's just finishing up. She's going to be a teacher, too. I think most of them do. Most don't get married right away now. I think they realize they don't have to now. [Laugh] They know there's enough out there. My feelings would sure change if I could go back now. I wouldn't get married until I was thirty, I don't think. Everybody did then, and I could see no other option. I knew I wanted to go to school, but I guess I wasn't smart enough to see that I could work and put myself through. I took the easy way out, I guess, at the time. I think it's really changed, and I think it's great. [Laugh] I know I would never get married again if I had the choice, not until I could support myself.

I was always economically dependent, very. Not that we ever had a lot of money, but it's such a change all of a sudden to know that I am solely responsible now. Even now, I'm on social security until the kids get eighteen; it's looking ahead and knowing now I'll have to do it. My husband and I were divorced a year before he died. That year was awful, but still you had somebody else halfway responsible. Then all of a sudden to know that you were the one solely responsible. That was a real big change for me because I was always real dependent. [Laugh] I would work for Kelly Girl on and off, maybe a month here or a month there, but I hadn't worked for like the last five years.

A lot of women were full-time homemakers, but a lot have gone back to work. A lot my age are having their first babies, too. And that's different. There aren't a lot of young people at home any more. There are a lot of *very* old people in Prospect. [Laugh] Interesting ones, though. A lot of the women work at factories and grocery stores in other towns. I can't think of anybody with a career, like a teacher. I think they get out of Prospect. [Laugh] Really, around here there aren't any opportunities. I have no idea what I'll go into. I just started out taking philosophy and criminal justice. It's one thing to start out at twenty but another at my age. I know what I don't want to do—like nursing or regular things. I know I have to do this the rest of my life, and I have to get a job with a pension. I suppose I'll probably take

whatever comes along at the time. I know I've always been interested even to go and sit in the court room, but I don't know enough about it to even know what fields there could be. Like court reporter wouldn't be of any interest. For this first year I'm just going to take things that are interesting. It's real hard for me to get it through my head that I have to get through this and get a job. [Laugh] I keep putting stuff off, forever.

I did my own divorce, the first thing I *ever* did on my own. After that, things really changed. I never did anything by myself before, and then to have to go in and do that. That was the best thing I ever did.

What kind of a person were you?

Very mousey and dependent. [Laugh] I could *never, never* go back. My husband came first, always, and the kids came first. I could never go back that way again. Ever. A divorce is hard, but it was the best thing for me; I changed so much. After eleven years, that was the hardest. I'd gone with my husband four years before we got married, so it was real hard. I got real tough. I think you just get real tough after that. I just felt like I had nobody else around. I was never one to complain to my parents or anybody else if anything went wrong. You get used to doing everything by yourself. I don't think I could ever remarry. It would be my way this time. [Laugh]

So even with your family here it was still lonely to go through?

My folks are never ones to interfere. I never felt like I could go to them—well, if things got real bad, but just the piddly stuff, they would never have said, "Well, come on home," so I was on my own that way pretty much. It was real hard. Although I don't think it was as hard on the kids as they say—you know everything you read says it's so traumatic. But I don't see that in my kids. I feel bad that I had to go through it, but I'm young. I feel so sorry . . . There were ladies in my divorce class, they were fifty-five and stuff, and they had *never*—I felt so sorry for them. I always felt that I had options; I could get going and do something.

My parents' generation worried what other people thought. A girlfriend who had lived somewhere else, when she moved here, she thought it was just horrible that people would call up and say, you know, "Did you leave your clothes out on the line?" or "Where are you going today?" Stuff that I had always accepted. I have a lady next door, when you pull in the driveway, you expect her to call and say, "Well, where have you been today," or if there's a strange car, "Well, I see you

had company." I was so used to that living here, and my girlfriend was just shocked that people would ask these questions. She never had neighbors. Everybody knows everybody's business and you never think anything of it.

I was surprised how quickly word got around that I was in town.

Oh, yeah. After you called—it's awful to be so suspicious of people, but I really am—I called Mom and said, "Have you heard anything about a lady—" and she said, "Oh, yeah, she's real nice." [Laughter] Once you're accepted, everybody's nice, but outsiders aren't welcome in Prospect. I've seen it. It's too bad. They really don't give people a chance sometimes. Another lady moved into town who had four kids and was divorced, and she was considered bad. We have one colored family in Prospect, and they've just been accepted real well. I just thought for sure this wasn't going to go over, but it's been just fine. The divorced lady had different boyfriends, and Prospect is real moral. [Laugh]

Would you say the town is conservative about women's roles?

Oh, I don't know. There's a lot of tougher women in town. The people with money—their wives all work. They don't seem to be real backwards that way.

What do you think about changes for women?

I think it's great, it's about time. [Laugh] I don't follow it actively; I don't do enough; I don't do the things I should, like try to change things. I try on my kids a little. It's hard to change. For me, not being financially equal is what bothers me the most. If I get a job, I'll still make 60 percent of what they earn. And to me the financial is real important right now. All my sisters are very happily married, no divorces, never any problems. One of my kids is slow, just one thing after another. And they just can't relate to it because it's all been smooth for them. One of my girlfriends, her husband is in prison; her and I have been through so much. She's the only one I'll ever complain to. We were both on social services at the same time. That was *so* traumatic, going through that, applying for it and using food stamps. I was so glad to be off that. To have somebody else who knew that same feeling instead of thinking, "Oh, welfare, they like to be on it." You feel so dependent. It's just degrading, and the thing is you can see no way out. It's all or nothing. That's what I'd like to get into, to straighten out that system. I certainly have more sympathy for people. It seems like people on social services flock to Prospect. We had one family move in here

from Arkansas, and the next year their relatives moved in next door. They're not accepted in Prospect at all. They're called a "tribe." "Oh, a new tribe moved into Prospect," they'll say.

Do you remember how you used the telephone when you were growing up?

I stayed with my grandma a lot; I'd always go down to Grandma's after school and I can remember calling home just to see what was going on at home. Other than that . . . And I don't remember my mother using it much either, not like I do now, to call my friends. They went back and forth, coffee klutches [sic] all the time, instead of using the phone so much. Everybody's working now. There's only one friend of mine, during the day, if I have nothing to do, I can go downtown. Everybody else, they're working or their husband's home and I think I'm interfering. Before the women were home and the kids were going to school. My mom had so many friends back and forth or she went to their house for coffee, just practically every day. Now there's none of that, and I miss that. I would like that real much. They're all working. Even at night, to run out and see them, I think, well, they've worked all day. There's just too much to do to visit. And that's sad to me, to miss all that.

My mother must have had so much work to do; I can't imagine taking time out every day. How she ever got her work done, I can't imagine now. And just even outside, over the clothesline. There's none of that. Except I'm surrounded by old people, and they've always got time to visit. I like that. I do remember my mother calling her brother every night. He lived about two blocks away. For years she hasn't done that. She's out now working; she sees him downtown every day. My mother isn't a talker on the phone anymore. She's a goer. If she wants to see somebody now, she jumps in the car and goes to see them instead of calling. She's changed a lot. My mother was just like I was—you stay home with the kids. After she got the job downtown one day a week, and then full-time, she's totally changed. I can't imagine my mother ironing, and she has me come up and clean her house. She could care less if it ever gets cleaned. She was the type—"Pick up, somebody's coming," or "You clean this and you do it good." Like she said, "I did that enough years, I'm sick of it." She's pretty liberated. [Laugh] Getting out does it. Getting out on my own was the beginning of my becoming real independent. I think I've gone too far now. I have no sympathy for anybody's troubles.

When you were at home, did you call people often, like your mother?

Oh, yeah, every day, and my sisters. And we still do. We see each other probably every day and still, every night after the kids go to bed, we call up and see what's going on. Not so much since I've been back to school, though, I've noticed, since I've been busier. At night I'm studying. If I want to call somebody, fine, but if somebody calls me then I feel real interrupted by it. [Laugh] If it weren't for work—I always feel I'm interrupting. My sister who doesn't work, I could sit and talk to her all night on the phone. Not that she doesn't have work to do, but you can always do it later when you're not working. I'm more organized now that I'm back to school.

I can't remember when I was little calling my friends up on the phone. My kids are on the phone constantly now, just in the last year, back and forth. It's never for me anymore, it seems. I keep saying, "What can you possibly have to talk about, five times a night?" We were outside all the time. Sometimes I say, "Go on *out.*" They're just little houseplants sometime. A lot of their friends live in Olsonville; that makes a difference. I just don't think they know how to do things. I think it's TV, and I just don't have the guts to get rid of it. My son, who is slow, he wants to watch the news or the weather—he wants information. He can entertain himself better than the others. I just wanted to get my work done, I can remember, and go because I knew if I was home there would just be more work to do.

When I do call my one sister, she's always watching TV. You just never call her nights because she's always watching TV. For me there's nothing on TV that I would ever mind being interrupted. My mother and I call back and forth, usually after the kids are in bed. What we talk about I don't know because I see her every single day. We talk about half an hour. I've sat on there for four hours with my girlfriend. During the day we more run back and forth, but at night when you can't leave the kids, that's when you can really gossip and complain. But I haven't even done that as much. I guess you're busier, and I see more people during the day. The lady next door, Helen, she can't get out: she's crippled, she's on the phone. She knows everything in town. If somebody dies, she's the first one to call you, "Did you know this one died?" That's her way; there's no other way for her. Everybody's too busy to stop in and say hi. But she knows *everything,* she knows *everything.* I'm used to it. We lived across the street and she did this to

my mother. You're real used to it with the people you know. And Nelly, she was the main one you got your information from. If you were sick, Nelly was the first one to call you up in the hospital and say "How are you doing?" whether she knew you real well or not. She was always sick. She's dead now.

How would someone like Nelly get to know all this information?

She would just call and ask. She would call anybody whether she knew them or not. The lady in the next apartment, a year ago her little girl was in the hospital. Her name was in the paper, so Nelly called me up and asked what was the matter. I said I didn't know, so Nelly said, "Oh, I think I'll call her." Nobody resented Nelly, but Helen gets a little crabby with people on the phone, so they would resent her more. You *never, ever* resented if Nelly called and asked you anything, because you knew she was concerned and she was never anyone to spread it around. She was the first one to send a casserole if you were sick or needed anything.

Is it usual for certain people to get a reputation?

Oh, sure, I'm sure everybody in town knows which houses are real immaculate and which are messy. You just know that about people in Prospect. I think the men are worse. They meet at the restaurant three times a day. My dad goes since he retired. He comes home and he knows everything that goes on in town. Whereas you never see many ladies down there. Well, they do have a group that meets there every day now. But my dad will drop everything to get down there at two o'clock.

Do you think men use the telephone the same way women do?

I never remember my dad talking on the phone. To this day, if I call up and say, "What are you up to?" he'll say, "Nothin', you wanna talk to Mom?" He's real hard to talk to on the phone. He usually answers it because he's in his chair right next to the phone. But I can't imagine calling up and just visiting with Dad. If I see him on the street or he stops here, we can just talk and talk. But not on the phone. I never remember him calling anybody or talking on the phone.

I wonder why that is?

I think because they don't gossip as much or want to know what's going on. My husband never did. He'd call to make appointments, or what time are we doing this, but that was it. It was never "How're you doing?" or any of that. I think because they got out, too. My dad was

out and he got all the visiting out of his system, and Mom was in the house all day. No, I bet I've never talked to my dad more than five minutes on the phone. The men are usually in a hurry, whereas the women are standing on the corner talking. You see that in Prospect a lot. I never saw that in Olsonville. Here, you could spend the whole morning downtown just visiting in the store or the post office. You never feel anybody's in a hurry in Prospect. [Laugh] It's mainly the older ones, who've never worked. You don't see many of the young ones. They're working.

Do you make many long-distance calls?

Never, never. I used to when my husband lived in another city, but since he's died I don't think I've made a long-distance call at all. Everybody's right here for me. My kids will call an 800 number once in a while. I'm a letter writer, though. I write to a girlfriend and my godson and my sister in Valley City. She's one who works and goes to school, so I don't call because I always think I'm bothering her.

So you think about what your phone call will mean to somebody before you call?

Oh, yeah. Since I've gone back to school, I do all my housework and studying at night. Before I could sit here and the house would be a mess and I'd think, "Oh, I can do that in the morning." Now I know I have to be gone in the morning. My one sister I know is too busy to talk; the other, she doesn't work, she would sit and talk all night. Mother, I can tell if she's tired or not or wants to talk or not. I'm a late person, and I know this one goes to bed at this time so you don't call her, but they know they can call me anytime and I'll be up. But I'll never get up to answer a phone. I just figure nobody would call me in the middle of the night if it was bad news—they'd come and tell me. My mother thinks it's just horrible that I won't. I usually just figure it's one of them and they want to talk. That will change once the kids start going out at night. I would never run in from outside to answer it either.

How many phone calls do you usually get in a day?

Now today, people know I'm home. My sister called this morning; my girlfriend called to have me pick up some coughdrops for her son. I maybe get five or six when I'm home. I don't make very many, anymore. I used to be on the phone quite a bit. Now I've just got too much to do. But always at night after the kids go to bed, I make at least one

or somebody calls me. I don't think there's ever been a night when I haven't talked to somebody. I just find it easier when I am home to just run down than to call them up.

When you lived in Olsonville, did you talk a lot on the phone?

Oh, yeah, constantly. That was one of the things my husband said later: "I hated that. That was one of the things I hated the most was that you were on the phone from nine until I went to bed at night; you were on that phone with your mother." I *never* knew it bothered him, *never.* I said, "John, you never said anything." He said, "I hated that. It was just like you were ignoring me." I'm sure if he had said something I would have cut down at least. I *never* knew that bothered him. I was the type who could sit and read the newspaper front to back. John read what he wanted to know and that was it. I would read anything I could get my hands on. John never read. He always resented me reading, too. If he was there to visit, he was watching TV, and I was never that interested in it. Once the kids went to bed, we just sat and looked at each other. He was interested in the TV, so the phone was my way out. Now I'm out and I don't need it anymore. [Laugh] I think the more dependent you are the more you need that outside hook-up.

Did he use the telephone?

Very seldom, other than to make plans, but never just to visit. I would even say, "Call your mom up." He'd say, "Well, you call her." My son is the same way. He wanted to know who was on the village board and I just couldn't think of the names, so I said, "Well, call Dad up." He said, "You call him." Like I had to make all the appointments; John would never call. Even if he was sick himself, he'd say, "Call the doctor." I'd say, "You call; I can't explain to him." And my dad's the same way with my mother. He cut his hand on the saw and Mom thought it was infected and she said, "Call the doctor," and he said, "You call." My son's quite shy so maybe that explains it, but my dad isn't. That's why I can't see why he can't do this stuff for himself.

So you would call your husband's mother?

Yeah, I'd call and say, "What's up?" and stuff. I was the social director. [Laugh] John would say, "It's Mom's birthday, send her a card," if I'd forget. To even get him to sign his name was hard. He'd say, "Well, you just sign it." And I just wouldn't. Like Christmas cards. I'd get the kids to sign and I'd say, "You can take a minute to sign a card." He never wanted to sign a card, and why that would be I don't know. I always signed it John, Gayle, and then the kids. My sister signs

her name first. I've always thought that was so funny, to see the woman's name first. When I've seen that, it's always been where the woman's the boss or more equal or stuff. I always thought that was kind of neat. Now, I'd just sign my name. Period. [Laugh] But the sad thing is to think so many years were wasted like that and I didn't even know the difference. It's not that I was unhappy at the time—the last year was very bad, going through the divorce—but all the rest of the time I was just as content as could be to be home and with the kids. But now looking back I think I could never do that. But now the kids are older, too, and I can go more. I could never have a little baby around again. I could never be tied down like that again. I was never one to pack all the kids up and go somewhere. I was a home person. I was home all the time. John would go get the groceries lots of times. I never handled any of the money. I never knew how much money we had. I never knew anything but my own little niche. My reading was my way out, too. To me, even now, a fun day is to go and sit at the library. I read anything. I love the *Reader's Digest,* magazines, Harlequins, anything. Boy, my kids know the library, and I want them to be able to read and enjoy that.

It wasn't like a physically bad relationship—beating or stuff—it was nothing like that, just real subtle. John could go do whatever he wanted and I would stay home. And it never even bothered me. I couldn't imagine why any wife would be mad because her husband wanted to go deer hunting. Now, it would be, "Fine, you go and I'll go somewhere, too." It wouldn't be so one-sided. It's real nice when you each have your own things to do and the other one doesn't resent it. It seemed like John did resent everything I *did* do—the telephone, my reading. But I never resented anything he did. I'm sure it must have been boring to live with somebody like I was, though. [Laugh] Toward the end, I had the kids and I got so involved, I didn't want to go anywhere. John would come home and say, "Let's go down to the Legion." I'd say, "Oh, I can't get a babysitter," or "I'm too grubby." But I didn't want to go. So he started going by himself and finally found somebody who would go with him. I got so I didn't want to go anywhere. I didn't want to do anything different, try anything. I think it was my son, being so slow; I never wanted to leave him with anybody. After he was born, I never wanted to go. And he got real dependent on me. He was the kind of kid, if I left him with a babysitter, he'd scream the three hours I was gone. After he went to school, it got better.

Are you somebody who lives in the past or the future?

Past. I would just love to be back in the *Little House on the Prairie* days. I would love to live out on a farm all by myself, the kids and I. It's always that time period I'd like to live, past any real hardship but real backwoods type. If I drive past an old, old farmhouse, I think, Oh, I would just love to do that. When it came right down to the hardships, I might not. It's the family. You were dependent on each other; the kids were right at home all the time. I see it in terms of the kids. The kids were more respectful; there was no outside influences, they had the family's values. I like the idea even of being a farm wife, where the husband's home. Whether he's working or not, he's there, and he'd be in and out. Hopefully, if there's another life, I'll be there. We talk about these things in philosophy class. I think there's something else; I just don't know what it is.

What about the present?

The time goes so much faster. Everything I do now is in terms of social security. Last year I had four more years. Pretty soon it's going to be three years. Now it's just so easy to coast along and not think ahead. I should have started this earlier. I've been lucky, though. I always wanted to stay home with the kids and I've gotten to do that. But on social security I'm much worse off than I was on social services. I don't have medical insurance, and I had a gall bladder operation, and one of the kids had strep throat. I just pay a little every month. At the time I could take it out, I couldn't afford the $150 a month for insurance.

All I think about is until my kids are all on their own. After that I don't care. That's all I care about. I want them to do good. I want them to go on to college and not just settle for what I settled for. It's going to be real interesting to see what kind of dads my sons make. They really didn't know a dad. My daughter's got a real attitude—she's not getting married, she's going to be a veterinarian. I hope I haven't made her real bitter. [Laugh] I hope my kids can get away from me, not like all my sisters and I within five or ten miles. John was the type who could pick up and go anywhere. He always wanted to go out west, but not me; I had to be right here. I want my kids not to pass up opportunities. There just aren't any here. You get too dependent and you live your life around others.

I have an aunt who's probably fifty who was just like me. She was always the one in the kitchen, all those years, just a dumb farm wife, I

thought. Now she works for the FBI, and she's a different person. I just admire her so much. She never said anything; now it's just the opposite. She can call up now and it's so interesting, not just what's going on around here but her job. That's what gives me hope, starting so late.

That's what would be nice is to have somebody your equal, that you could discuss stuff with. What John was interested in, I wasn't, and what I was interested in, he wasn't. The greatest thing would be job-sharing. You'd have so much in common.

Do you think it's good women are getting more involved in politics?

I sure do, but I don't know how to get involved or what to do. I can state my opinions in a group now, and stick up for it where I couldn't before. The only women's groups in Prospect are all Bible groups. I'm a Catholic but I don't follow all the rules. It's hard to buck the system. I still send my kids to catechism. I don't have enough guts yet to take them to different churches and let them decide on their own. Maybe later on I would. I'm not a leader at all.

This is the first thing in sixteen years I've done for myself, ever, what I wanted to do. That's why I think, boy, if they want to go to college, we'll get 'em there somehow. I don't care how poor we are. It's nice to see them have a little ambition, to see that they want stuff and they'll fight for it.

8

Kristin and Ami

Kristin and Ami are sisters who, since moving here in 1976, have lived with their parents in the country outside of Prospect. Kristin was seventeen and Ami fourteen at the time of this interview. They go to high school at the consolidated school in Olsonville. Kristin is tall and slender; Ami is shorter with curly hair, braces, and glasses. They live about a mile from town in a split-level house with a grand piano and other furnishings that indicate a high socioeconomic status for a Prospect family. As the children of a professional couple (their mother is a nurse who is a full-time homemaker now, their father an anesthetist), Kristin and Ami enjoy a comfortable life-style with many options, such as college educations.

Kristin and Ami's parents, particularly their father, carefully control the telephone calling made by the girls, so that they long for the freedom to call when and whom they choose (except boys) and to talk as long as they like. In this regard, they do not believe they are typical teenagers. From movies and other sources they have absorbed the lesson that women are vulnerable, so even in their home they are insecure, imagining elaborate scenarios in which they are attacked. They remember story lines from popular culture in which the telephone is implicated in the terrorizing of a woman.

The girls' interest in careers and families indicates a generational shift in thinking about women's place; however, they do not credit the women's movement with the opportunities they can take for granted. They seem unenchanted with the role of housewife but remain convinced of a biological explanation for women's status in relation to men's presumed superior physical strength.

As we spoke, the voices of the two sisters wove in and around each other in a complex and creative pattern of turn-taking in which each built upon the other's words.

Do you have any memories of the telephone before you moved here?

Kristin: I remember talking to Grandma on the phone or my piano teacher. I didn't talk to my friends much on the phone because I was like in second grade. But like to spend the night or that kind of thing.

Ami: I can't remember talking on the phone.

Kristin: Here I found friends to talk to, but it's hard out here in the country because there's nobody around. I can drive now, so it isn't so hard, but I don't know what I did before that. We don't talk to friends every night because we see them every day. Not very often at all. You call and say, "Can I have a ride tonight," or something or, "Don't forget your cheerleading uniform."

Ami: Or calling about work. I babysit.

Kristin: I work at Pizza Hut. And I'm captain of the cheerleading squad so the night before I have to call everybody and tell them, "Remember your cheerleading uniform."

Ami: If I have a question about a certain something, then maybe I call.

Kristin: We're usually at school until 5:30 at night. I drive every day because I go to ——— College in the morning. Seventy high school seniors take one class—there's four from my school. And since all four of us have things to do after school, like sports and stuff, and we have to be at school the second half of the day, we had to take an eight o'clock class.

 I'm going to go to college and hopefully go to med school after that. I want to be an obstetrician, 'cause I want to be a doctor—I don't know, I've always wanted to be a doctor. So that I can be dependent on myself and I don't have to depend on anybody else. I don't want to be a surgeon-type doctor where you're always dealing with sick people and everything's so sad. People having babies, most of the time it's happy. Even though the hours are going to be pretty bad. [Laugh] You know, you're called in at three o'clock in the morning.

Do you think you'll get married?

Kristin: Probably, but not until after college. Right now I don't have

anybody in mind. [Laugh] I'd like one or two children, no more than that.

Ami: I want to be either a lawyer or a psychologist. I like lawyers because I like to speak in front of people. I've done a lot of that, and I think being in an actual courtroom would be kind of fun. I like psychology because it's fun to help people with their problems. Hopefully I'll get married someday and have one or two kids, or three or four. [Laugh] I don't know.

If you get married, would you want an equal relationship?

Kristin: With my job it would have to be! I wouldn't mind doing the work around the house, but my hours won't allow me to be a full-time housewife. Who knows, maybe I'll hire a maid! I hope he'd do half of it, if we both work. If he doesn't work, he should do more than half of it. I'm not saying it would be equally divided, but we'd both do it.

Do you think you'd leave your job if you had children?

Kristin: I don't know. That's one of the hang-ups about having kids. I don't know if I'd stop work or not. That's what Mom did, but I don't know if I could handle not doing anything. I don't know if there's such a thing as part-time obstetricians! [Laugh] I'd still want to be a mom to the kids, but I couldn't do nothing. It might not be a doctor, but something.

Ami: You gotta get away from those screaming monsters and do something. [Laughter]

Maybe you've been babysitting too much.

Kristin: Right now to me a career's more important than getting married and having kids, because that's so far in the future I can't even imagine what that would be like. But going toward my career is starting in the fall. I think I'm a minority in school who's motivated to a career, but it's not a small minority. You know what I mean? More people are going to get married or are happy to be done with school. More so girls than guys plan to go on to school, but I know more girls than guys.

Have you followed the women's movement?

Ami: No, no. I don't know enough women in Prospect to know if anyone does.

Kristin: We don't talk about it much. I don't even know what the current issues are or anything. I don't really get into it myself. I'm nonpartial, either way.

You don't see what you'd like for yourself in terms of the women's movement?

Kristin: Oh, no, no. I'm just thinking of it in terms of security for myself, something I'd like to do.

Are there different groups of high school students who hang around together?

Kristin: Oh, sure. Our school's real big at that. We've got the druggies and the dirtballs and the people who are pregnant and (we've got two seniors who are pregnant this year) . . .

Ami: . . . and there's the popular and the unpopular and the gumballs and . . .

Kristin: . . . the brains and the speds . . .

The speds?

Kristin: The special eds. And the nerds and the rich people, then the popular people and the people who are right in between.

So where do you two fit?

Kristin: I don't know; we're in the upper-medium to popular type.

Ami: I don't know; mid, I suppose.

Kristin: Some of my friends are medium and a lot of my friends are really, really popular, too. But I'm not really, really popular and I'm not medium. You know what I mean? I'm just kind of right in the middle. I get along with everybody, because I'm interested in so many things. Like track—my best friend in track is real popular and we're good buddies, and in college there's popular people, then cheerleading—there's a mixture. At school my locker is next to my best friend, who's middle. There are a lot of cliques. Too many. None of the other schools around here are like that. I think it's because it's so small; everybody knows everybody.

Ami: I think the biggest class in school right now is 118–120.

Are girls in sports more popular?

Kristin: Kind of, but not necessarily. The people who get involved are popular, but not all who get involved are popular. But then the people who don't even care, who don't do anything except for study aren't that popular, and some people who don't do anything *are*.

Ami: Some kids think that instead of going out for a sport, they're too good for that sport. 'Cause people say that cheerleading and pompon is a popularity thing, and it's really not. There's popular kids on there.

Kristin: You have to try out.

Ami: If it was just by election, the squad wouldn't be that good.

Kristin: In our school it's how well you do, really. They take into account if you have an attitude problem, if you're just in it for the name or if you really want to be a cheerleader or whatever.

What about boys? Do you get phone calls from boys?

Kristin: Yeah. Friends in school will call and say did you get this assignment. One guy goes to college with me and sometimes we talk on the phone about the class. That isn't real often. He's got a girlfriend. My boyfriend calls once in a while. He lives in Valley City. He's real busy.

Ami: He's a hockey instructor.

Kristin: He goes to college and he's a hockey coach . . .

Ami: He's out of school.

Kristin: He works two jobs.

Do you call him?

Kristin: A couple times I have, like when he called here and I wasn't home. We haven't been going out that long. But we see each other at work.

Is it okay for girls to call guys?

Kristin: Oh, sure.

Would you call up a guy and ask him out?

Kristin: [Laugh] No, I don't have the time to go out a lot. There's always, will I be rejected or does he want to go out with me or will I feel really stupid if he says no, and if he does say no is it an excuse for real or just an excuse.

Ami: I know a lot of them who do that at our school.

Kristin: It's just that the girls who do most of the time aren't . . . real tasteful. There are people who call guys and say, "Hey, let's go out." It's no big deal. But a lot of the girls at our school are known as real boy-crazy. Go out with so many guys at one time.

Do you think girls use the phone more than guys?

Kristin: Probably. I don't. For one thing, we have a fifteen-minute limit here. It almost has to be that way with Dad being on call at the hospital. I wish we had that call-waiting thing.

Ami: Sometimes the fifteen-minute limit isn't a fifteen-minute limit. The last phone call I had I was only on the phone five minutes.

Kristin: If someone needs to use the phone . . .

Ami: Well, that person didn't exactly need to use the phone. It depends on who's home.

Kristin: Then if nobody's home, you can always talk a long time.

So you're talking about your mom and dad asking you to get off?

Ami: Dad.

Kristin: Dad.

Ami: We spend more time on the phone when Dad's not home.

Kristin: On the days he's on call he wants to keep the phone free. But on the days he doesn't need to keep the phone free for calls . . .

Ami: . . . he just doesn't want us on the phone.

Do you think your friends talk more on the phone than you do?

Kristin: Yeah.

Ami: Yeah.

Kristin: Another thing is our school district covers so much land area that half the people at our school are long distance from us. If you live in Olsonville, it's great because none of them are long distance. There are lots of people I'd just love to call up and say, "Hey! Guess what happened to me!" But I can't because they're long distance. You're already good friends, but you can't call them. You can't just say, "Oh, I've gotta call Sally." Sally is on my cheerleading club, so I have to make long-distance calls sometimes, but we keep it real short.

Ami: Then there's the problem of people with unlisted numbers.

Are there a lot of those?

Kristin: Not a lot, but I can think of two.

How many phones do you have here?

Kristin: Three, plus a cordless, and then one outside in the workshop, so we've got five. We have a security system hooked to the phone. The cordless isn't used too much because it doesn't work too well; it's so fuzzy.

Ami: That's used like when we're in the bathtub or something and the call's for us . . .

Kristin: . . . or if we're going out to the barn to do chores and nobody's left in the house, we take it along. The cattle are our 4-H project—not all of them. We started out with a couple and Dad thought, "Let's get a whole herd!"

Ami: We did them right before you came.

Kristin: It takes an hour. And we have horses, too.

Ami: And cats. And we have a dog.

Kristin: Three different kinds of cattle. And in the spring we'll have sheep. I like having animals, if they weren't so much work. You just can't give them all they can eat. You have to measure it out. But it's worth it when fair comes around.

Do you think you'll make more phone calls when you're on your own?

Kristin: Oh, yes! I went to Girls' State, and they have a phone in each dorm room. You just dial the last five numbers to dial any room. Man, I went nuts! [Laughter] We figured out that any number that started with 36 or 37 was in the guys' dorm.

Ami: So they'd call . . .

Kristin: We'd just call and say, "Hi! How are you? What's your name? How old are you? What do you look like?" [Laughter] It's fun. And we'd call around to friends on the floor. The big thing was to get a phone list, as long as you can. Just ask all the people on your floor what their phone number is. We even had guys standing outside the girls' dorm asking every girl when they went in, "What's your phone number?"

Ami: Or when they're on free time, walking, they'd yell out, "What's your phone number?"

So it was kind of a competition?

Kristin: Yeah, but it was just fun. The phones are great, 'cause you just talk to people. And up there it's nice because you know you'll never see them again, and you can make a fool out of yourself, and you ought to. You know. My roommate and I talked to one guy for two-and-a-half hours, and we hung up and we didn't even know his name. We didn't even ask. It was fun. I won't go nuts on it after I'm on my own for awhile. I don't even know if there's phones in all the rooms at the college where I'm going or not, but it's small enough. I won't be making any outside calls probably, except to call for a pizza or whatever.

Is it your dream to have your own line and your own phone?

Ami: We could have it now, but we'd have to pay for it, monthly or whatever. If we make long-distance calls, we have to pay for it.

Kristin: I don't even have a phone outlet in my room. She does. It doesn't really bother me. I suppose once I get out of here and I know that I've got a phone that I can use whenever I want to, I won't need it as much. Here, it's something that I can't use very often—I mean I can use it but I can't talk very long—and I always want to talk longer.

Have you ever had any bad experiences with the phone?

Kristin: Not here, but at Girls' State, I got this call who said, "Hi, this is Yoda." It freaked me out. They called twice, and the last time they said, "I know where you live and I'm going to come get you." I ran down the hall and said, "You guys, somebody's coming to get me!" Then somebody came up behind me and scared me and it was her. Some other girls pretended to be a heavy breather, so I got this girl to pretend to be Yoda and call them. They called back and said, "It was us. We're sorry."

Ami: I've had some pretty embarrassing phone calls. You know when no one's home, you're supposed to say they're busy but not say you're home alone. I had this one person on the phone when Mom and Dad weren't home. I had this friend over and we were watching a movie on television. The phone rang, and he wanted to talk to either Mom or Dad. I said they were busy right now, could I take a message. I said, "I think Mom's outside and Dad's in the bathroom." He said, "I'll wait." So I said, "Whoops, somebody just came out of the bathroom and it's not my dad." He said, "Well, is anybody else home?" I said, "Can I *please* just take a message?" I was pretty stuck there for a minute; I thought, Oh, my goodness. I had one call and I picked it up and no one was there.

Kristin: That doesn't bother me too much because we have a pay phone at school. Instead of paying for a call, I'd call here and hang up, then Mom would call back at the pay phone. If people call and hang up, it doesn't scare me or anything; it makes me mad. It's like an insult.

Ami: I've never had that when I was babysitting, but, boy, if I did I would be so scared. Some people just do that to find out if you're home or not.

Do you get scared when you're alone?

Ami: When I'm there, I really don't think about it, but when the kids are asleep and I have the television on real soft and a Dracula movie comes on, I have to turn the TV off, I'm that scared. And I can't wait for the people to get home. If the telephone rings or I go look in on the kids—it's just real scary.

How about here by yourself?

Kristin: I don't get scared as much now, since we've got a security system. But I still don't like being home alone in the dark. When I'm home alone, there's lights on. [Laugh]

Ami: Because this house is so big, it's kind of eerie. When I'm home alone, I always make sure there's five lights on. I sit up in my room. It's weird because you hear the water turn off and on, the stairs creak, the dog runs up and down, and stuff. It scares you to death. You're scared to walk around; you look around, that's what I always do, I just sit there.

Kristin: I stay in one place, my bedroom. I have lights on in all the rooms, and I stay in my bedroom. We used to have a big dog; we had him for thirteen years. If anybody came in, he was right there.

Ami: We always knew if someone was there.

Kristin: This dog will bark . . .

Ami: . . . he barks even if nobody's there . . .

Kristin: . . . but he doesn't know how to bite.

You don't feel as safe here without that dog?

Kristin: Not anymore. I'm starting to get used to it now.

Why do you get scared?

Kristin: 'Cause of scary movies. [Laugh]

Ami: If I'm sittin' home alone and I think of a scary movie, I'm scared all night.

Kristin: I mean, I like scary movies, but they scare me. [Laugh] You'll be in a situation and you'll go, "My gosh, this is the same situation as *Friday the 13th* and the lady got killed," or, you know, the babysitter movie where they call and say, "Are the children okay?"

Ami: That scared me. I was babysitting one night, when a friend told me that the next day. They said, "Did you see that movie last night about the guy who called the babysitter and said, 'Did you check the children?' and they were dead. I thought, 'I'm glad I babysat last night and not tonight.'"

Kristin: I like them because they get your blood going.

Ami: I watched one halfway, *Halloween,* and that was all right. I had a nightmare that night, but it wasn't one of the scariest movies.

Kristin: I watched *The Exorcist.* I like that kind of stuff because it isn't that gory, but the demon was awful. The gory stuff is what gets me. I saw *Friday the 13th, Part V,* and I was grossed out. Everybody was getting slaughtered.

Ami: Yeah. It's funny. Sometimes when I'm home alone, and I think about a movie where somebody's in the bathroom and an ax comes out of the wall and chops their head in two, I'm afraid to walk into the bathroom! So I just kind of sit there.

Does being in the country make that worse?

Kristin: It wouldn't be so bad if there were neighbors close by, but there isn't anybody on this whole road.

Ami: It would also be better if we had a smaller house, too. This house is big—it has four levels, and so many doors, you can hear them creak open. It's scary. Even when Kristin and I are here together when Mom and Dad are out to eat, I can't go to sleep until they get home. When Kristin falls asleep, I think, I'm the only one left!

Kristin: I don't mind being home alone so much as long as I can stay in the house. But we have to let the dog outside. We have to turn off the security system and open the door, and I don't know if there's going to be somebody outside the door or not. I'd really just rather let him wet on the floor [laughter] but Mom doesn't agree, so it's not a good idea.

Do you remember any other scary movies?

Ami: I don't even have to watch the movie. Kids at school will say, "Did you see this, did you see that?" And I'll say, "No, what was it about?"

Kristin: One time I happened to walk through the room and *Halloween* was on or something. Then Dad tells stories about how he and his best friend used to scare their girlfriends when they went out.

Ami: They turned around on a deserted road in the cemetery and they got stuck in the mud, and Dad had to walk to the nearest farmhouse and the girl had to stay in the car. He tells gory stories, like when we're camping, and we're afraid to go to bed.

Kristin: When he gets with his friends he tells stories. Not true ones, but like how there was a hook hanging over the car . . .

Ami: . . . don't look above because her boyfriend was hanging from a tree . . .

Kristin: Just stupid things that you know darn well will never happen, but it's still there. Whenever it's a dark rainy night, I think of those.

Ami: Ooh, scares the liver out of me. Even true ones. Dad says he was over at his grandfather's house and his aunt's nurse uniform was hanging over this lamp and the window was open. He looked up and something was swinging away, and he was scared to death.

Do you think girls and women are more vulnerable to being attacked?

Kristin: Oh, sure. We're not as strong.

Ami: Even Mom says we should take karate lessons or judo lessons or something so we can protect ourselves when we're walking on college campuses. All these rape stories you hear.

Kristin: Where I work somebody always walks with us out to our car. If it's dark out, one of the managers will say, "Will you take so-and-so out to her car?" They say, "Sure." They're gettin' paid to walk some lady out to her car! It's kind of a neat thing, that they think about something like that. I never thought about it until somebody said, "Would you take Kristin out to her car?"

Ami: Their parking lot has a lot of trees around it and it's really dark, and that's scary.

Why do you think women have to worry about violence?

Ami: Probably because guys think women are really weak.

Kristin: When people think of women versus men, everybody always thinks men are the stronger and women are more vulnerable.

Ami: And that women should just be housekeepers and don't have to worry about being strong or going out and pump iron. You don't see many women out pumping iron.

Kristin: People don't expect so much from women.

Do you think men take advantage of that?

Kristin: I mean, seriously, there are more men weirdos than there are women. When people attack other people, you don't very often see a woman come up and attack somebody. [Laugh] Most of the stories you read about or see on TV are guys attacking other guys or women. So it's the guy maniacs that are weird.

Ami: Especially when you hear in the newspapers when they give a description of who they think this guy is. There's a guy running around Olsonville that supposedly some of the teachers and some of the kids saw him actually come in the gymnasium, take a kid, and walk out the door. That's scary. You never know if they're going to get caught, or if you go outside they're not going to be hiding around the corner waiting for ya.

Does that mean you won't live in the country when you're on your own?

Kristin: Oh, no, I'll live in the country, but it won't be *country* country. There'll be people around. I don't think I'd be able to stand having a house three feet away.

Ami: But you don't want your neighbors ten miles down the road.

Kristin: I couldn't stand to live in a city at all. A town, maybe, a city no. I can't stand the smell of it. I'm used to clean country air.

Ami: Your backyard is ten yards wide.

When you're scared at home, do you call somebody up?

Kristin: Yeah! Then no nerd can call you!

Ami: Yes, but unless Mom and Dad are trying to call you to check up on you to make sure you're not using the phone. I don't call people on the phone when I'm home alone, in case Mom and Dad try to call.

Do your folks call to check up on you?

Kristin: They'll leave a phone number.

Ami: Very rarely. They might say, "Well, we'll call you later to see what's up." Even if you let the dog out and somebody's behind the building, all you have to do is shut the door and press the system button and the police are out here within fifteen minutes.

Kristin: It's a combined smoke, fire, and alarm system and it's a burglary system. And it has an emergency button to carry around with you. There are speakers in the house. It's stationed in ———; they can hear what's going on. Like if a guy's having a heart attack, you push this button and the people can hear what's going on, and they'll send an ambulance. Or if you're getting . . .

Ami: Or a guy comes in with a knife and says, "Give me all your money," they can hear . . .

Kristin: . . . and send the police. Or if there's a fire out in the barn and the animals are burning . . .

Ami: Or if you press the alarm, a burglar comes in and you press the alarm and he throws a gag in your mouth and he doesn't say anything and you can't say anything . . .

Together: . . . they'll send out the police.

Ami: If you press the button and it keeps going, they'll call you to see if you're home. If you're not home, they send out the police. If you press the button, then it goes on and you've got two minutes and you can say, "Help! Help!"

Kristin: If you accidentally set off the alarm, you can turn the system off . . .

Together: . . . and then they'll call you . . .

Kristin: And you have to give them your special code.

Thank you for helping me out by answering my questions.

Ami: We probably haven't been very much help to you.

Kristin: We're not exactly typical teenagers when it comes to the phone.

Conclusion

The story about women's relationship to the telephone in the village of Prospect is only one of many possible stories yet to be told about the relationship between women and the telephone and, more generally, gender and technology. The experiences of Prospect women may be similar to the experiences of women in other small rural communities, but perhaps dissimilar to the experiences of women in larger communities, city neighborhoods, inner cities, and other kinds of agricultural communities. These women are almost exclusively white and Christian with relatively few economic and educational opportunities. The experiences of women of color, Jewish women, or more economically and educationally privileged women may be very different. We do not know how women have used the telephone for political and economic networking (such as the National Organization for Women's telephone trees used to alert members to important information), what role it might have in women's coming to critical consciousness through talk with their friends, or all the ways it is used by women's support services. Though these uses of the telephone were not found at work in Prospect, I suspect that some of the patterns of meaning and experience found in Prospect occur in other times and places.

This study suggests the extreme importance of contextualizing any study of gender and technology in an understanding of the meanings of gender held by the woman or group participating, the historical changes that have occurred in social practices and experiences of gender, and the current conditions of women's and men's lives. The telephone runs like a fine thread through the lives of women in Prospect. They generally take the telephone for granted and spend little un-

149

prompted time reflecting upon how they use it. It would seem, then, to be some minor convenience among many others to which they have become accustomed, unrelated to their circumstances and other experiences. But the tales of the lives that encompass the telephone tell a more complicated story.

Once a thriving economic and social center, the community of Prospect gradually lost its autonomy as economic and political opportunities, along with the money and influence of prominent local men leaders, left the town and blended into the larger economic and social world. It is largely women who have remained in the community, serving as business owners and managers, community workers, and caregivers, but without the authority or resources to direct the community's destiny. Meanings about gender in the community, though still based on a core belief in the biological differences of women and men expressed in reproduction and physical strength, seem to be in a state of transition. The chief point of contention is the problem of resolving the split between home and workplace. The idea that women should be care-givers—for the home and family primarily and for other members of the community secondarily—is still strong.

Until recently the telephone company in Prospect has been privately owned by a local family. Management of the company has been oriented to making it a leader among small independent companies, providing the same kind and quality of services as other state-of-the-art companies. (There was, in other words, no attempt to design and put into use any other arrangement of the technology, such as a community line, or to provide equal service to all community residents in the manner of a public utility.) Though the drive was to install a dial system and eventually replace all party lines with private lines, the company lagged behind other parts of the country, primarily because of the economics of servicing rural customers. Consequently, the use women could make of the telephone was related to the kind and quality of service provided by the company, which has changed over the years along with the social practices of using the telephone.

Women's use of the telephone in Prospect should be seen in relation to women's talk and women's place in the community. Though many women find pleasure in their use of the telephone and many use it in creative ways to deal with their circumstances, women's telephone talk nonetheless fits into the appropriate spheres of activity and interests designated for women. Both gendered work and gender work,

their telephone talk is work women do to hold together the fabric of the community: it builds and maintains relationships and accomplishes important care-giving and receiving functions while simultaneously confirming community definitions of women's natural affinity for care-giving roles in the family and community. The meaning of gender—in this case of being a woman—is hence confirmed by the experience of it.

Women's mobility and choices about location are more restricted than men's, implicating the telephone in a complicated way. The telephone may ease the separation from family and friends; it may help transcend the restricted mobility of those confined by small children, the illness of their husbands or other relatives, old age, disabilities, or even fear; but it does not solve these problems. A telephone is not an equal substitute for a full, secure, purposeful life among others. Indeed, in some respects use of the telephone in these cases should be seen as a symptom—of isolation, loneliness, boredom, or fear—rather than as a cure. The spatial separation of home and workplace presents another problem for women—a separation aggravated by the loss of income opportunities within Prospect. Some women have been able to deal with the problem by running their own businesses in town, often making use of the telephone to bridge the boundaries between their two worlds. Others engage in community activities and care-giving, finding a meaningful life in the service they provide for others. Even some of these women, however, talk of their dilemma of being unable to find a solution to their need for economic security that provides flexibility of space and time so they can still provide ample care-giving to their families.

Various aspects of these observations can be found in the interviews with Nettie, Ethel, Carolyn, Gayle, Kristin, and Ami. Nettie's interview reveals how social practices regarding the telephone have changed from the time of the party line and the operator, when talk had a more public—that is, community—character, to the privacy afforded by the private line and the less public nature of talk. She observes how travel and means of communication had a much more local character in the earlier part of the century, when the community itself was more cohesive. Though Nettie disapproves of so-called idle telephone talk (and idleness in general, at least for women), she uses the telephone for community and family work—calling her sick brother, consulting with the family, notifying the family of deaths and making

funeral arrangements, making calls for the church, listening (albeit sometimes impatiently) to the shut-in. Women's place should be in the home, according to Nettie, but in some sense, so should men's. In expressing disapproval of men spending time in the taverns, she indicates that men as well as women should be home- and family-oriented.

Ethel, on the other hand, is someone who appreciates the telephone for its role in keeping her more self-sufficient. She is able to continue living alone in the country because her family and friends provide her companionship and news over the telephone and she is able to call for services she needs. Because Ethel has almost a life-long set of ties to her home, the community, and her friends, disability has had less emotional and physical impact on her than on some others whose mobility is also restricted. She, too, notes how social practices relating to the telephone have changed. While the telephone was once used primarily for emergencies and business purposes—in part because of party lines and because women were too busy to use it for companionship—it has now become integrated into the maintenance of social relations on a daily basis. Private lines may help account for the gradual change of habits, but other changes in the social life of the community and in the activities and responsibilities of women should also be suspected.

Carolyn has been a clubwoman and an administrator's wife. Her locations have been determined by her husband's career moves and her mobility restricted by ailing children. Now that her children are grown, she finds herself living in a little town that has few of the services and conveniences she would like to be close to—a library, shopping, medical help. Her loneliness and boredom have been helped by joining the coffee klatsch at the cafe, but she no longer develops the telephone relationships she did when she was younger. Her relationship to her daughters has provided her a stable link bridging the new faces and locations over the years. She is aware of her own missed opportunities.

Gayle, too, has regrets about missed opportunities. Her desire to stay at home with her young children grew into a crippling emotional and financial dependency. In those years her constant use of the telephone to transcend the boundaries of the household was a symptom of how her home had become both her prison and her refuge. Gayle's husband relegated telephone work—including maintenance of family ties—to her, and her father declines to talk on the telephone, as do so

many men in Prospect. Despite the amount of visiting with her family and friends she still does by telephone, Gayle misses an era when women visited back and forth in each other's houses. Though older women are still likely to be oriented to a pattern of home and community life that can be more easily shared with other local women, women around Gayle's age are engaged in a diversity of activities and schedules that prevents a network of women developing within the community, suggesting community cohesiveness may decline even further in the future if the network of women now holding it together disappears.

Kristin and Ami are members of the youngest generation of Prospect women. Though they intend to take advantage of the economic and educational opportunities now more available to women, not all young Prospect women have such aspirations. As the children of parents with professional training and with a high income for the area, they are more attuned to opportunities and encouraged to pursue them. Their telephone use is restricted by their father's profession—he is occasionally on call at home—and by their father's dislike of their telephone conversations. Despite the economic position of their family, their calls to friends, most of whom are long distance (another instance of a discrepancy between a preferred social community and an imposed telephone community), are also curtailed. Their ability to elaborate in detail different possible scenarios for assault in their own home illustrates the early and ugly lessons women are taught about their vulnerability to attack and their need for male protection. The telephone may serve as some solace against such fear, or it may be feared itself as a source of intrusion and betrayal. But regardless of its role in either case, the telephone does not erase the socially constructed differences of women's and men's free movement and sense of spatial security.

Gender as a set of social practices and as a system of cultural meanings, in sum, does not constitute a seamless and uncontradictory system of social relations in Prospect. There is some recognition and resentment of the lack of opportunities that have been available to women. There is some awareness of the unhealthy aspect of restricting women to their homes and children. There is a widespread concern about the split between home and workplace that divides the attention and interests of women *and* men. In addition, disapproval of the coffee klatsch at the cafe and of "idle" telephone talk can be seen as a symp-

tom that old ideologies of womanhood are no longer viable. Disapproval of idle talk, for example, is not about idleness but about purpose. If women have time for talk—not as a break from a busy day but as a major activity in an otherwise empty day—and if women need talk and are willing to express that need publicly, the fulfilling purpose of women's lives—to be constantly busy with the material and emotional sustenance of their families—can be seen to be no longer adequately time-consuming and meaningful. School-age children are increasingly self-reliant. Goods and services are no longer produced at home but purchased. Women have fewer opportunities to work together. In response, some women put themselves at the service of the church and other community members, particularly the sick and elderly. Some look for work. Some talk on the telephone. Others go to the coffee klatsch.

Though the telephone has the technical capacity to level social hierarchies, to end feelings of isolation and loneliness, to provide the liberating function for doing whatever we want with it, technical possibility has not translated into social practice. In part this is because the telephone was introduced into a gendered world, within which it became embedded, and hence it has become a site at which gender relations are organized, experienced, and accomplished in both the family and the larger community and political world. If women have distinguished themselves as telephone talkers, as popular mythology has it, we need to ask why women feel the need to talk on the phone, what work they are doing, what opportunities or limitations give shape to their lives, and what being women means to them and others.

The telephone is symptom, possibility, weapon, companion, tool, and lifeline. For the women of Prospect it has essentially altered the shape of their private lives while a larger world of public participation lies beyond their grasp. It will take their critical awareness of the possibilities for transforming the arrangement of social relations (which is already a point of disagreement) to put the telephone to a different, perhaps political, use. Certainly women in other times and places have done so.

Bibliography

Anderson, Kathryn, Susan Armitage, Dana Jack, and Judith Wittner. "Beginning Where We Are: Feminist Methodology in Oral History." *Oral History Review* 15 (Spring 1987): 103–27.

Ardener, Shirley. "Ground Rules and Social Maps for Women: An Introduction." In *Women and Space: Ground Rules and Social Maps,* edited by Shirley Ardener, 11–34. New York: St. Martin's Press, 1981.

Babcock, Barbara A. "Taking Liberties, Writing from the Margins, and Doing It with a Difference." *Journal of American Folklore* 100 (October/December 1987): 390–411.

Baldwin, Karen. " 'Woof!' A Word on Women's Roles in Family Storytelling." In *Women's Folklore, Women's Culture,* edited by Rosan A. Jordan and Susan J. Kalčik, 149–62. Philadelphia: University of Pennsylvania Press, 1985.

Ball, Donald. "Toward a Sociology of Telephones and Telephoners." In *Sociology and Everyday Life,* edited by Marcell Truzzi, 59–75. Englewood Cliffs, N.J.: Prentice-Hall, 1968.

Beaulieu, Lionel J., and Vernon D. Ryan. "Hierarchical Influence Structures in Rural Communities: A Case Study." *Rural Sociology* 49 (Spring 1984): 106–16.

Beniger, James R. "Personalization of Mass Media and the Growth of Pseudo-Community." *Communication Research* 14 (June 1987): 352–71.

Bernard, Jessie. *The Female World.* New York: Free Press, 1981.

Boettinger, Henry M. *The Telephone Book: Bell, Watson, Vail and American Life, 1876–1976.* Croton-on-Hudson: Riverwood, 1977.

Bowles, Gloria, and Renate Duelli-Klein, eds. *Theories of Women's Studies.* London: Routledge & Kegan Paul, 1983.

Boys, Jos. "Women and Public Space." In *Making Space: Women and the Man-Made Environment,* edited by Matrix, 37–54. London: Pluto Press, 1984.

Bristow, Ann R., and Jody A. Esper. "A Feminist Research Ethos." *Humanity and Society* 8 (November 1984): 489–96.

Brooks, John. *Telephone: The First Hundred Years.* New York: Harper & Row, 1976.

Carey, James W. "Canadian Communication Theory: Extensions and Interpretations of Harold Innis." In *Studies in Canadian Communications,* edited by Gertrude Joch Robinson and Donald F. Theall, 27–59. Montreal: McGill Programme in Communications, 1975.

Danielian, N. R. *AT&T: The Story of Industrial Conquest.* New York: Vanguard Press, 1939.

Daniels, Arlene Kaplan. "Good Times and Good Works: The Place of Sociability in the Work of Women Volunteers." *Social Problems* 32 (April 1985): 363–73.

———. *Invisible Careers: Women Civic Leaders from the Volunteer World.* Chicago: University of Chicago Press, 1988.

Dégh, Linda. "Dial a Story, Dial an Audience: Two Rural Women Narrators in an Urban Setting." In *Women's Folklore, Women's Culture,* edited by Rosan A. Jordan and Susan J. Kalčik, 3–25. Philadelphia: University of Pennsylvania Press, 1985.

Di Leonardo, Micaela. "The Female World of Cards and Holidays: Women, Families, and the Work of Kinship." *Signs* 12 (Spring 1987): 440–53.

Dordick, Herbert S. "Social Uses for the Telephone." *Intermedia* 11 (May 1983): 31–35.

Douglas, Jack D. *Creative Interviewing.* Beverly Hills: Sage, 1985.

Elshtain, Jean Bethke. "Feminism, Family, and Community." *Dissent* 29 (Fall 1982): 442–49.

———. *Public Man, Private Woman: Women in Social and Political Thought.* Princeton: Princeton University Press, 1981.

Enzensberger, Hans Magnus. *The Consciousness Industry: On Literature, Politics and the Media.* New York: Seabury Press, 1974.

Finch, Janet. " 'It's Great to Have Someone to Talk to': The Ethics and Politics of Interviewing Women." In *Social Researching: Politics, Problems, Practice,* edited by Colin Bell and Helen Roberts, 70–87. London: Routledge & Kegan Paul, 1984.

Finch, Janet, and Dulcie Groves, eds. *A Labour of Love: Women, Work and Caring.* London: Routledge & Kegan Paul, 1983.

Fischer, Claude S. "Educating the Public: Selling Americans the Telephone, 1876–1940." Paper presented to the Social Science History Association, Washington, D.C., October 1983.

———. "Gender and the Residential Telephone, 1890–1940: Technologies of Sociability." *Sociological Forum* 3 (1988): 211–34.

Fishman, Pamela. "Interaction: The Work Women Do." In *Language, Gender and Society,* edited by Barrie Thorne, Cheris Kramarae, and Nancy Henley, 89–102. Rowley: Newbury House, 1983.

Gallaher, Art, Jr., and Harland Padfield, eds. *The Dying Community.* Albuquerque: University of New Mexico Press, 1980.

Gamarnikow, Eva, David H. J. Morgan, June Purvis, and Daphne Taylorson, eds. *The Public and the Private.* London: Heinemann, 1983.

Geiger, Susan N. G. "Women's Life Histories: Method and Content." *Signs* 11 (Winter 1986): 334–51.

Glazer, Barney G., and Anselm L. Strauss. *The Discovery of Grounded Theory.* Chicago: Aldine, 1967.

Gluck, Sherna. "What's So Special about Women: Women's Oral History." *Frontiers* 2, no. 2 (1977): 2–17.

Graham, Hilary. "Surveying through Stories." In *Social Researching: Politics, Problems, Practice,* edited by Colin Bell and Helen Roberts, 104–24. London: Routledge & Kegan Paul, 1984.

Hanmer, Jalna, and Sheila Saunders. "Blowing the Cover of the Protective Male: A Community Study of Violence to Women." In *The Public and the Private,* edited by Eva Gamarnikow, David H. J. Morgan, June Purvis, and Daphne Taylorson, 28–46. London: Heinemann, 1983.

Illich, Ivan. *Tools for Conviviality.* New York: Harper & Row, 1973.

Imray, Linda, and Audrey Middleton. "Public and Private: Marking the Boundaries." In *The Public and the Private,* edited by Eva Gamarnikow, David H. J. Morgan, June Purvis, and Daphne Taylorson, 12–27. London: Heinemann, 1983.

Janeway, Elizabeth. *Man's World, Woman's Place: A Study of Social Mythology.* New York: William Morrow, 1971.

Jones, Deborah. "Gossip: Notes on Women's Oral Culture." In *The Voices and Words of Women and Men,* edited by Cheris Kramarae, 193–98. Oxford: Pergamon Press, 1985.

Jordan, Brigitte. "Studying Childbirth: The Experience and Methods of a Woman Anthropologist." In *Childbirth: Alternatives to Medical Control,* edited by Shelly Romalis, 181–216. Austin: University of Texas Press, 1981.

Kerr, Stephen. *The Culture of Time and Space, 1880–1918.* Cambridge: Harvard University Press, 1983.

Kramarae, Cheris. "Gotta Go Myrtle, Technology's at the Door." In *Technology and Women's Voices: Keeping in Touch,* edited by Cheris Kramarae, 1–14. New York: Routledge & Kegan Paul, 1988.

Krieger, Susan. *The Mirror Dance: Identity in a Women's Community.* Philadelphia: Temple University Press, 1983.

158 Gender on the Line

Lovejoy, Stephen B., and Richard S. Krannich. "Rural Industrial Development and Domestic Dependency Relations: Toward an Integrated Perspective." *Rural Sociology* 47 (Fall 1982): 475–95.

MacNeal, Harry B. *The Story of Independent Telephony.* Chicago: Independent Pioneer Telephone Association, 1934.

McLuhan, Marshall. *Understanding Media.* 2d ed. New York: Mentor, 1964.

McRobbie, Angela. "The Politics of Feminist Research: Between Talk, Text and Action." *Feminist Review* 12 (October 1982): 46–57.

Martin, Michèle. " 'Rulers of the Wires'? Women's Contribution to the Structure of Means of Communication." *Journal of Communication Inquiry* 12 (Summer 1988): 89–103.

Marvin, Carolyn. *When Old Technologies Were New: Thinking about Electric Communication in the Late Nineteenth Century.* New York: Oxford University Press, 1988.

Mazey, Mary Ellen, and David R. Lee. *Her Space, Her Place: A Geography of Women.* Washington, D.C.: Association of American Geographers, 1983.

Morley, David. *Family Television: Cultural Power and Domestic Leisure.* London: Comedia Publishing Group, 1986.

Moyal, Ann. "The Feminine Culture of the Telephone: People, Patterns and Policy." *Prometheus* 7 (June 1989): 5–31.

Nicol, Lionel. "Communications Technology: Economic and Spatial Impacts." In *High Technology, Space, and Society,* edited by Manuel Castells, 191–209. Beverly Hills: Sage, 1985.

Oakley, Ann. "Interviewing Women: A Contradiction in Terms." In *Doing Feminist Research,* edited by Helen Roberts, 30–61. London: Routledge & Kegan Paul, 1981.

Peshkin, Alan. "Virtuous Subjectivity: In the Participant-Observer's I's." In *Exploring Clinical Methods for Social Research,* edited by David N. Berg and Kenwyn K. Smith, 267–81. Beverly Hills: Sage, 1985.

Piotrkowski, Chaya S. *Work and the Family System: A Naturalistic Study of Working-Class and Lower-Middle-Class Families.* New York: Free Press, 1979.

Pool, Ithiel de Sola, ed. *Forecasting the Telephone: A Retrospective Technology Assessment.* Norwood, N.J.: Ablex, 1983.

———, ed. *The Social Impact of the Telephone.* Cambridge: MIT Press, 1977.

Popenoe, David. "Women in the Suburban Environment: A U.S.–Sweden Comparison. In *New Space for Women,* edited by Gerda Wekerle, Rebecca Peterson, and David Morley, 165–74. Boulder, Colo.: Westview Press, 1980.

Radway, Janice. "Identifying Ideological Seams: Mass Culture, Analytical Method, and Political Practice." *Communication* 9 (1986): 93–123.

————. *Reading the Romance: Women, Patriarchy, and Popular Literature.* Chapel Hill: University of North Carolina Press, 1984.

Rakow, Lana F. "Gendered Technology, Gendered Practice." *Critical Studies in Mass Communication* 5 (1988): 57–70.

————. "Rethinking Gender Research in Communication." *Journal of Communication* 36 (Autumn 1986): 11–26.

————. "Women and the Telephone: The Gendering of a Communications Technology." In *Technology and Women's Voices: Keeping in Touch,* edited by Cheris Kramarae, 207–28. New York: Routledge & Kegan Paul, 1988.

Reinharz, Shulamit. *On Becoming a Social Scientist.* San Francisco: Jossey-Bass, 1979.

Reiter, Rayna R., ed. *Toward an Anthropology of Women.* New York: Monthly Review Press, 1975.

Rosaldo, Michelle Zimbalist, and Louise Lamphere, eds. *Woman, Culture, and Society.* Stanford: Stanford University Press, 1974.

Sattel, Jack W. "Men, Inexpressiveness, and Power." In *Language, Gender and Society,* edited by Barrie Thorne, Cheris Kramarae, and Nancy Henley, 119–24. Rowley: Newbury House, 1983.

Schudson, Michael. "The Ideal of Conversation in the Study of Mass Communication." *Communication Research* 5 (July 1978): 320–29.

Semyonov, Moshe. "Community Characteristics, Female Employment and Occupational Segregation: Small Towns in a Rural State." *Rural Sociology* 48 (Spring 1983): 104–19.

Smith, Dorothy. "A Sociology for Women." In *The Prism of Sex: Essays in the Sociology of Knowledge,* edited by Julia A. Sherman and Evelyn Torton Beck, 135–87. Madison: University of Wisconsin Press, 1979.

Spender, Dale. *Man Made Reality.* London: Routledge & Kegan Paul, 1980.

Stanley, Liz, and Sue Wise. *Breaking Out: Feminist Consciousness and Feminist Research.* London: Routledge & Kegan Paul, 1983.

Taylor, Steven, and Robert Bogdan. *Introduction to Qualitative Research Methods.* 2d ed. New York: John Wiley & Sons, 1984.

Thorne, Barrie, ed., with Marilyn Yalom. *Rethinking the Family: Some Feminist Questions.* New York: Longman, 1982.

Tiger, Virginia, and Gina Luria. "Inlaws/Outlaws: The Language of Women." In *Women's Language and Style,* edited by Douglas Butturff and Edmund L. Epstein, 1–10. Akron, Ohio: L & S Books and University of Akron, 1978.

Treichler, Paula, and Cheris Kramarae. "Women's Talk in the Ivory Tower." *Communication Quarterly* 31 (Spring 1983): 118–32.

Ungerson, Clare. *Policy Is Personal: Sex, Gender, and Informal Care.* London: Tavistock Publications, 1987.

Wekerle, Gerda R., Rebecca Peterson, and David Morley, eds. *New Space for Women.* Boulder, Colo.: Westview Press, 1980.

Westkott, Marsha. "Feminist Criticism of the Social Sciences." *Harvard Educational Review* 49 (November 1979): 422–30.

Whipp, Richard. "Labour Markets and Communities: An Historical View." *Sociological Review* 33 (November 1985): 768–91.

Whisman, Vera. "Lesbianism, Feminism, and Social Science." *Humanity and Society* 8 (November 1984): 453–60.

Whitehead, Tony Larry, and Mary Ellen Conaway, eds. *Self, Sex, and Gender in Cross-Cultural Fieldwork.* Urbana: University of Illinois Press, 1986.

Women and Geography Study Group of the IBG. *Geography and Gender: An Introduction to Feminist Geography.* London: Hutchinson, 1984.

Young, Iris Marion. "The Ideal of Community and the Politics of Difference." *Social Theory and Practice* 12 (Spring 1986): 1–26.

Zagarell, Sandra A. "Narrative of Community: The Identification of a Genre." *Signs* 13 (Spring 1988): 498–527.

Zerubavel, Eviatar. *Hidden Rhythms: Schedules and Calendars in Social Life.* Chicago: University of Chicago Press, 1981.

Index

164 Index

Whitehead, Tony Larry, 13
widowhood, 63, 68, 115
Wilder, Laura Ingalls, 76
Wise, Sue, 13
Wittner, Judith, 13
woman's sphere. *See* private sphere
womantalk, 36, 37, 59. *See* women's talk
Women and Geography Study Group of
the IBG, 79, 80
women business owners, 26, 31, 53, 73,
74, 115
women leaders: resistance to, 26–27, 29,
93, 95; support for, 27
women of color, 71, 149. *See also* race
women's crisis center, 69
women's friendships, 47, 101, 107, 126,
127, 140, 153
women's mobility, 151; lack of control
over, 63; relationship to telephone
use, 71; restrictions on, 44–46, 62,
67–69, 72, 97, 111, 152
women's movement, 27, 28, 72, 93, 94,
125, 133, 135, 137, 138
women's place, 61, 79, 150; claiming
new spaces, 77; fears about, 69–71,

80, 135, 142–46; feelings about, 107,
114, 132; in the home, 72, 83, 93,
152; security of, 66, 69
women's resistance, 41, 154
women's talk, 2, 58, 153; as community
work, 33–34, 122; disapproval of,
41; notions about, 2, 154; restrictions
on, 4, 34, 48; where appropriate, 40.
See also telephone talk
women's work, 101, 126; as care-giving,
57, 60, 68, 103, 128; child care, 27,
52, 67, 93–94, 118, 121, 131;
combining home and business,
74–75; coordinated by telephone,
69; for pay, 26–28, 31, 72, 91, 114–
15, 123, 137; maintaining families, 64,
84, 130, 151; maintaining
relationships, 55. *See also* telephone
calling, telephone talk

Yankee capitalists, 18
Young, Marion, 12

Zagarell, Sandra A., 12
Zerubavel, Eviatar, 80